NIK
D7000
THE EXPANDED GUIDE

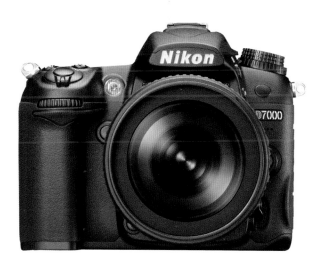

NIKON
D7000

THE EXPANDED GUIDE

Jon Sparks

AMMONITE
PRESS

First published 2011 by
Ammonite Press
an imprint of AE Publications Ltd
166 High Street, Lewes, East Sussex, BN7 1XU, UK

Text © AE Publications Ltd, 2011
Images © Jon Sparks, 2011 (unless otherwise specified)
Copyright © in the Work AE Publications Ltd, 2011

ISBN 978-1-907708-11-4

British Library Cataloging in Publication Data: A catalog
record of this book is available from the British Library.

Editor: Ian Penberthy
Series Editor: Richard Wiles
Design: Fineline Studios

Typefaces: Giacomo
Color reproduction by GMC Reprographics
Printed and bound by Maurice Payne Colourprint Ltd,
Berkshire, UK

« PAGE 2
FONTANA NEPTUNA,
GDANSK, POLAND
When you unpack a new
camera, it's tempting to start
shooting right away—and
taking pictures is the best way
to learn. However, it still makes
sense to peruse this book first,
to ensure you don't miss out
on new features and functions.

» CONTENTS

Chapter 1 Overview 8

Chapter 2 Functions 22

Chapter 3 In the field 124

Chapter 4 Flash 156

Chapter 5 Close-up 178

Chapter 6 Movies 188

Chapter 7 Lenses 202

Chapter 8 Accessories 222

Chapter 9 Connection 232

Chapter 10 Care 244

 Glossary 250

 Useful web sites 253

 Index 254

» EVOLUTION OF THE NIKON D7000 8–9

» ABOUT THE NIKON D7000 10

» MAIN FEATURES OF THE D7000 10–11

» FULL FEATURES & CAMERA LAYOUT 12–15

» VIEWFINDER DISPLAY 16

» LCD CONTROL PANEL 17

» MENU DISPLAYS 18–21

Chapter 1
OVERVIEW

1 OVERVIEW

The D7000 occupies an intriguing position in Nikon's range of DX-format cameras, slotting in between the "pro" D300s and the "enthusiast" D90. It combines an impressive feature set and rugged build while remaining relatively compact and lightweight. Its versatile and durable nature makes it ideal for keen amateur and semiprofessional photographers, while it has all the features and functions to meet the needs of many professionals.

» EVOLUTION OF THE NIKON D7000

Nikon has long been admired for marrying innovation with continuity. When the main manufacturers were introducing their first viable autofocus 35mm cameras in the 1980s, most jettisoned their existing lens mounts, but Nikon stayed true to its established F-mount system. It's still possible to use many classic Nikon lenses with the latest digital cameras such as the D7000, although some camera functions may be lost.

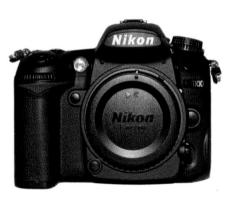

For this and other reasons, "evolution" is an appropriate word to describe the development of Nikon's digital cameras. Nikon's first digital SLR was the E2s, introduced in 1994. Sporting a then-impressive 1.3-megapixel sensor, its body design was based on the F-801 35mm SLR. However, the true line of descent of the D7000 begins with the 2.7-megapixel D1, in 1999. Its sensor adopted the DX format, which was a constant with every Nikon DSLR until the introduction of the "full-frame" D3 in 2007.

Steady evolution of Nikon's pro oriented DSLRs culminated in the introduction of the 12.2-megapixel D2x in 2005, while models like the D100, D70, and D40 made DSLRs ever more affordable and attractive to the enthusiast. Two years after the D2x appeared, the D300 matched its pixel count and equaled or excelled most of its other abilities in a lighter and much cheaper body. A year later, the D90 became the first digital SLR from any

manufacturer to offer movie capture. That was as recently as 2008; now movie capture is standard on most DSLRs.

In 2009, the D300s added movie shooting to the already formidable specification of the D300, along with other enhancements, including a second memory card slot and a faster maximum shooting rate, many of which found their way into the D7000.

› Nikon DX-format sensors

The DX-format sensor, measuring approximately 23.6 x 15.8mm, was used in every Nikon DSLR from the D1 onward, until the arrival of "full-frame" FX-format cameras (D3, D3x, D700). However, the number of pixels on that sensor has risen from 2.7 million (D1) to the D7000's 16.2 million. The format dictates a 1.5x magnification factor, relative to the same lenses used on 35mm and FX cameras. CMOS (Complementary Metal Oxide Semiconductor) sensors are now used across Nikon's DSLR range. Although significantly cheaper to manufacture and less power-hungry, CMOS sensors were once considered inferior in image quality to CCD, and intensive research and development have gone into making them suitable for critical use. The D7000's CMOS sensor produces images at a native size of 4928 x 3264 pixels, making them suitable for demanding large prints, and book and magazine reproduction.

2008—Nikon D90 ⨯
Although aimed more at enthusiasts than professionals, the D90 is a highly capable camera, but its headline feature was its ability to shoot movies—the first DSLR from any maker to do so.

2009—Nikon D300s ⨯
Aimed squarely at professionals and the most demanding enthusiasts, the D300s is an extremely rugged camera suitable for high-speed shooting in all conditions.

1 » ABOUT THE NIKON D7000 » MAIN FEATURES

Externally, the D7000 is similar in size and general configuration to the D90, but its overall feel and heft point to an inner kinship with the D300s. Like the latter, it is built around a tough magnesium-alloy body. Like both precursors, it has a bright, crisp, 3in (7.6cm) rear LCD panel. However, it beats both of them in its pixel count of 16.2 million on a CMOS sensor with 14-bit image conversion and self-cleaning function. It also makes a big advance in offering Full HD movie capture, previously only seen on FX-format Nikons, at 1920 x 1080 pixels rather than 1280 x 720. There are significant enhancements in its movie shooting functions, too, compared to the pioneering D90, notably the availability of full-time autofocus.

The D7000 incorporates a new focus module with 39 autofocus points and a new 2016-pixel RGB metering sensor. The standard ISO range runs from 100 to 6400, with extensions to 12,800 and 25,600, the widest yet seen on a DX-format Nikon DSLR. The maximum shooting rate is six frames per second.

Like all Nikon SLRs, the D7000 is part of a vast system of lenses, accessories, and software. This book will guide you through all aspects of the camera's operation and its relation to the system as a whole.

Sensor
16.2 effective Mp, DX format, RGB CMOS sensor measuring 23.6 x 15.8mm and producing a maximum image size of 4928 x 3264 pixels; self-cleaning function.

Image processor
EXPEED 2 image processing system featuring 14-bit analog-to-digital (A/D) conversion with 16-bit image processing.

Focus
39-point autofocus system covering most of the image area, supported by Nikon Scene Recognition System, which tracks subjects by shape, position, and color. Three focus modes: (S) Single-servo AF; (C) Continuous-servo AF; and (M) Manual focus. Three AF-area modes: Single-area AF; Dynamic-area AF with option of 3D tracking; and Auto-area AF. Rapid focus point selection and focus lock.

Exposure
Three metering modes: matrix metering; center-weighted metering; spot metering. 3D Color Matrix Metering II uses a 2016-segment color sensor to analyze data on brightness, color, contrast, and subject distance from all areas of the frame. With non-G/ D type lenses, Standard Color Matrix Metering II is employed. Two fully auto modes: auto and auto (flash off). Four user-controlled modes: (P) Programmed auto with flexible program; (A) Aperture-priority auto; (S) Shutter-priority auto; (M) Manual. Nineteen Scene Modes: portrait;

landscape; child; sports; close-up; night portrait; night landscape; party/indoor; beach/snow; sunset; dusk/dawn; pet portrait; candlelight; blossom; autumn colors; food; silhouette; high key; low key. Two user-settings modes. ISO range between 100 and 6400, with extensions to 12,800 and 25,600. Exposure compensation between -5 Ev and +5 Ev; exposure bracketing facility.

Shutter

Shutter speeds from 1/8000 sec. to 30 sec., plus B. Maximum frame advance: 6 frames per second (fps). Quiet mode, self-timer, remote control, and mirror-up modes. Viewfinder and Live View Bright viewfinder with 100% coverage and 0.94x magnification. Live View available on rear LCD monitor.

Movie mode

Continuous feed in Live View mode allows 24 fps movie capture in MOV format (MPEG-4 compression) with image size (pixels) of: 640 x 424, 320 x 216, 1280 x 720, or 1920 x 1080. 30 fps capture possible at smaller image sizes.

Buffer

Buffer capacity allows up to 100 frames (JPEG) to be captured in a continuous burst at 6 fps, approximately 18 NEF (RAW) files.

Built-in flash

Pop-up flash with Guide Number of 12 (meters) or 39 (feet) at ISO 100 supports i-TTL balanced fill-flash for DSLR (when matrix or center-weighted metering is selected) and Standard i-TTL flash for DSLR (when spot metering is selected). Five flash-sync modes: Front curtain sync; Red-eye reduction; Slow sync; Red-eye reduction with slow sync; Rear curtain sync. Flash compensation to +/- 3 Ev; FV lock.

LCD monitor

High-definition 3in (7.6cm), 920,000 pixel (VGA) TFT LCD display with 100% frame coverage.

Custom functions

Over 50 parameters and elements of the camera's operations can be customized through the Custom setting menu.

File formats

The D7000 supports NEF (RAW) (14-bit and 12-bit) and JPEG (Fine/Normal/Basic) file formats.

Storage

Dual Secure Digital (SD) card slots; accepts SDHC and SDXC cards.

System backup

Compatible with more than 60 current and many more non-current Nikkor lenses (functionality varies with older lenses); SB-series flashguns; Multi-Power Battery Pack MB-D11; Wireless transmitter WT-4; and many more Nikon system accessories.

Software

Supplied with Nikon Transfer and Nikon View NX2; compatible with Nikon Capture NX2 and many third-party imaging applications.

1 » FULL FEATURES & CAMERA LAYOUT

FRONT OF CAMERA

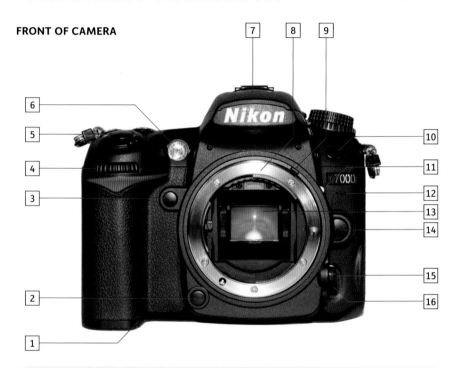

1	Power connector cover	**9**	Meter coupling lever
2	Depth-of-field preview button	**10**	Infrared receiver (front)
3	Fn button	**11**	Mounting mark
4	Sub-command dial	**12**	Built-in microphone
5	Shutter-release button	**13**	Mirror
6	AF-assist illuminator/Self-timer/Red-eye reduction lamp	**14**	Lens-release button
7	Built-in flash	**15**	AF-mode button
8	Lens mount	**16**	Focus mode selector

BACK OF CAMERA

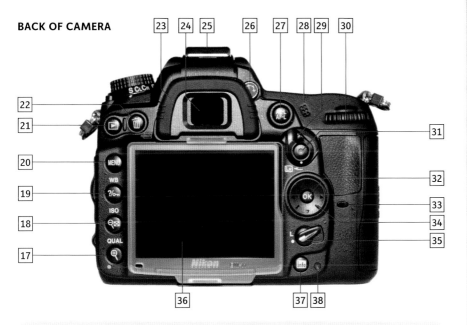

17	Playback zoom in/image quality/image size/two-button reset button	28	Speaker
18	Thumbnail/playback zoom out button	29	Live view switch
19	Help/protect/white balance button	30	Main command dial
20	MENU button	31	Movie record button
21	Playback button	32	OK button
22	Delete/format button	33	Infrared receiver (rear)
23	Eyecup	34	Multi selector
24	Viewfinder eyepiece	35	Focus selector lock
25	Accessory hotshoe	36	LCD monitor
26	Diopter adjustment dial	37	INFO button
27	AE-L/AF-L button	38	Memory card access lamp

1 » FULL FEATURES & CAMERA LAYOUT

TOP OF CAMERA **LEFT SIDE**

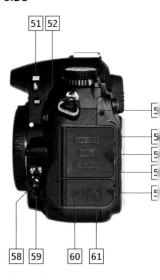

39	Camera strap mount	45	Mode dial
40	Metering/Format button	46	Release mode dial
41	Power switch	47	Accessory hotshoe
42	Shutter-release button	48	Control panel
43	Exposure compensation/ two-button reset button	49	Focal plane mark
44	Release mode dial lock release	50	Camera strap mount

51	Flash mode button
52	Bracketing button
53	AV connector
54	USB connector
55	Connector cover
56	HDMI mini-pin connector
57	Accessory terminal cover
58	AF-mode button
59	Focus mode selector
60	External microphone connector
61	Accessory terminal

BOTTOM OF CAMERA

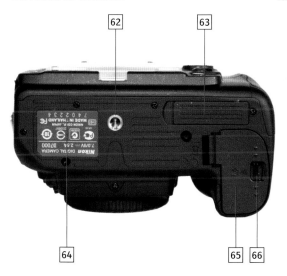

62 63

64 65 66

RIGHT SIDE

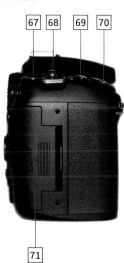

67 68 69 70

71

62	Tripod socket (¼in)
63	Contact cover for optional MB-D11 battery pack
64	Camera serial number
65	Battery compartment
66	Battery compartment release lever

67	Focal plane mark
68	Camera strap mount
69	Exposure compensation/ two-button reset button
70	Shutter-release button
71	Memory card slot cover

1 » VIEWFINDER DISPLAY

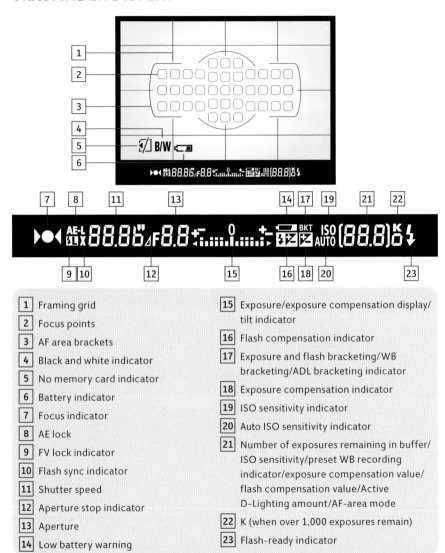

1	Framing grid	15	Exposure/exposure compensation display/ tilt indicator
2	Focus points	16	Flash compensation indicator
3	AF area brackets	17	Exposure and flash bracketing/WB bracketing/ADL bracketing indicator
4	Black and white indicator		
5	No memory card indicator	18	Exposure compensation indicator
6	Battery indicator	19	ISO sensitivity indicator
7	Focus indicator	20	Auto ISO sensitivity indicator
8	AE lock	21	Number of exposures remaining in buffer/ ISO sensitivity/preset WB recording indicator/exposure compensation value/ flash compensation value/Active D-Lighting amount/AF-area mode
9	FV lock indicator		
10	Flash sync indicator		
11	Shutter speed		
12	Aperture stop indicator		
13	Aperture	22	K (when over 1,000 exposures remain)
14	Low battery warning	23	Flash-ready indicator

» LCD CONTROL PANEL

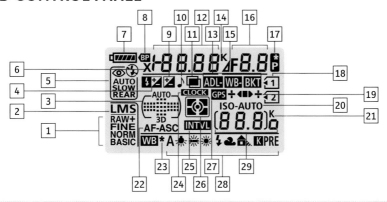

1	Image quality
2	Image size
3	Auto-area AF/AF-area mode/3D-tracking indicator
4	Flash compensation indicator
5	Flash mode
6	Flash sync indicator
7	Battery indicator
8	MB-D11 battery indicator
9	Exposure compensation indicator
10	Beep indicator
11	Multiple exposure indicator
12	Shutter speed/exposure compensation/flash compensation value/WB fine tuning/color temperature/WB preset

number/shots remaining in WB sequence/intervals for interval timer photography/focal length (non-CPU lenses)

13	Exposure /flash bracketing/WB bracketing/ADL bracketing indicator
14	Color temperature indicator
15	Aperture stop indicator
16	Aperture/bracketing increment/no. of shots per interval/maximum aperture (non-CPU lenses)/PC mode indicator
17	Flexible program indicator
18	Memory card indicators
19	Bracketing progress indicator
20	ISO/Auto ISO sensitivity indicator
21	K (when over 1,000 exposures remain)
22	Autofocus mode
23	WB fine-tuning indicator
24	Clock not set indicator
25	Interval timer indicator
26	Metering
27	GPS connection indicator
28	White balance
29	No. of exposures remaining/no. of shots remaining in buffer/capture mode/ISO indicator/preset WB recording indicator/Active D-Lighting amount/manual lens no./HDMI-CEC connection indicator

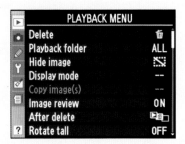

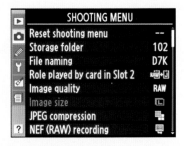

The Playback Menu
> Delete
> Playback folder
> Hide image
> Display mode
> Copy image(s)
> Image review
> After delete
> Rotate tall
> Slide show
> Print set (DPOF)

The Shooting Menu
> Reset shooting menu
> Storage folder
> File naming
> Role played by card in Slot 2
> Image quality
> Image size
> JPEG compression
> NEF (RAW) recording
> White balance
> Set Picture Control
> Manage Picture Control
> Auto distortion control
> Color space
> Active D-Lighting
> Long exp. NR
> High ISO NR
> ISO sensitivity settings
> Multiple exposure
> Movie settings
> Interval timer shooting
> Remote control mode

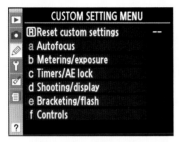

CUSTOM SETTING MENU

- ⊡ Reset custom settings --
- a Autofocus
- b Metering/exposure
- c Timers/AE lock
- d Shooting/display
- e Bracketing/flash
- f Controls

The Custom Setting Menu

- › Custom setting bank
- › Reset custom settings
- › **a: Autofocus**
- › a1 AF-C priority selection
- › a2 AF-S priority selection
- › a3 Focus tracking with lock-on
- › a4 AF Point illumination
- › a5 Focus point wrap-around
- › a6 Number of focus points
- › a7 Built-in AF-assist illuminator
- › a8 Live view/movie AF
- › **b: Metering/Exposure**
- › b1 ISO sensitivity step value
- › b2 EV steps for exposure control
- › b3 Easy exposure compensation
- › b4 Center-weighted area
- › b5 Fine tune optimal exposure
- › **c: Timers/AE Lock**
- › c1 Shutter-release button AE-L
- › c2 Auto meter-off delay
- › c3 Self-timer
- › c4 Monitor-off delay
- › c5 Remote on duration

- › **d: Shooting/display**
- › d1 Beep
- › d2 Viewfinder grid display
- › d3 ISO display and adjustment
- › d4 Viewfinder warning display
- › d5 Screen tips
- › d6 CL mode shooting speed
- › d7 Max continuous release
- › d8 File number sequence
- › d9 Information display
- › d10 LCD illumination
- › d11 Exposure delay mode
- › d12 Flash warning
- › d13 MB-D11 battery type
- › d14 Battery order
- › **e: Bracketing/flash**
- › e1 Flash sync speed
- › e2 Flash shutter speed
- › e3 Flash control for built-in flash
- › e4 Modeling flash
- › e5 Auto bracketing set
- › e6 Bracketing order
- › **f: Controls**
- › f1 ❄: Switch
- › f2 **OK** button (shooting mode)
- › f3 Assign Fn. button
- › f4 Assign preview button
- › f5 Assign **AE-L/AF-L** button
- › f6 Customize command dials
- › f7 Release button to use dial
- › f8 Slot empty release lock
- › f9 Reverse indicators
- › f10 Assign MB-D11 **AE-L/AF-L** button

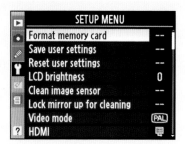

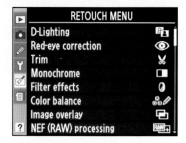

The Setup Menu
> Format memory card
> Save user settings
> Reset user settings
> LCD brightness
> Clean image sensor
> Lock mirror up for cleaning
> Video mode
> HDMI
> Flicker reduction
> Time zone and date
> Language
> Image comment
> Auto image rotation
> Image dust off ref photo
> Battery info
> Wireless transmitter
> Copyright information
> Save/load settings
> GPS
> Virtual horizon
> Non-CPU lens data
> AF fine tune
> Eye-Fi upload
> Firmware version

The Retouch Menu
> D-Lighting
> Red-eye correction
> Trim
> Monochrome
> Filter effects
> Color balance
> Image overlay
> NEF (RAW) processing
> Resize
> Quick retouch
> Straighten
> Distortion control
> Fisheye
> Color outline
> Color sketch
> Perspective control
> Miniature effect
> Edit movie
> Side-by-side comparison

My Menu/Recent Settings

OUTWARD BOUND BACKUP �
Dual card slots enable instant backup, useful on trips far afield, such as this ramble at Walkers, near Saariselkä, Finland. Use the **Role played by card in Slot 2** item in the Shooting menu (or Recent Settings) to enable this function.

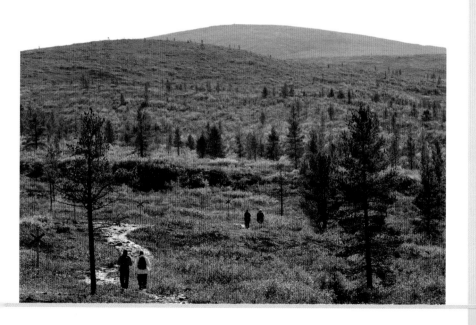

» CAMERA PREPARATION 24–28

» BASIC CAMERA FUNCTIONS 29–33

» EXPOSURE MODES 34–35

» FULL AUTO MODES 36–37

» SCENE MODES 38–47

» USER CONTROL MODES/USER SETTINGS 47–53

» METERING MODES 54–55

» EXPOSURE COMPENSATION/BRACKETING 56–58

» FOCUSING/AF-AREA MODES 59–61

» FOCUS POINTS 61–63

» IMAGE QUALITY/SIZE 64–66

» WHITE BALANCE/ISO SETTINGS 66–71

» COLOR SPACE 71–72

» LIVE VIEW 73–77

» IMAGE PLAYBACK/ENHANCEMENT 78–84

» THE D7000 MENUS/THE PLAYBACK MENU 85–89

» THE SHOOTING MENU 90–94

» THE CUSTOM SETTING MENU 95–109

» THE SETUP MENU 110–114

» THE RETOUCH MENU 115–121

» MY MENU/RECENT SETTINGS 122–123

Chapter 2
FUNCTIONS

2 FUNCTIONS

A camera like the D7000, bristling with buttons and dials, naturally appears complex and perhaps daunting to those more familiar with digital compacts or 35mm SLRs. Complex it certainly is, but a better word would be "powerful." You can do a lot with the D7000, and much of its power is on the surface. You can access most key functions instantly through the buttons and dials, without having to delve into menus. If you know what you want to do, this is a big advantage.

To ease the transition, however, it may be comforting to know that you don't have to use all the buttons straight away; there's a fully automatic mode that lets the camera make nearly all the decisions for you. The D7000 will be set to this mode when you unpack it, and you can reset it at any time by simultaneously pressing the 🖾 and 🔍 buttons (marked with green dots). Of course, simply leaving the camera at its default settings fails to exploit all that imaging power.

This chapter provides a step-by-step introduction to the D7000's key features and functions. It would be impossible, even in a book of twice the length, to fully explore every last detail, however, so we'll focus on the areas that will be of most interest to the majority of photographers.

When you unpack a new camera, it's tempting to start shooting right away—and taking pictures is the best way to learn. It still makes sense to study this book first, however, to ensure you make the most of its features and functions.

» CAMERA PREPARATION

Tasks such as changing lenses or memory cards may seem trivial, but being able to perform them efficiently in awkward situations or when time is short is not. With practice, they can be performed safely and surely, even working by touch alone. Your first task should be to attach the strap and get into the habit of using it to lessen the risk of dropping the camera.

› Attaching the strap

To attach the strap, ensure the padded side will face inward. Attach one end to the appropriate mount, located at top left and right of the camera. Loosen the strap where it runs through the buckle, then pass the end through the mount. Bring the end of the strap back through the buckle, at the side farthest from the mount, then double back through the other side of the buckle. Adjust the length as required, but leave a good "tail" for security. When

satisfied with the length, tighten the strap firmly and slide up the sleeve to keep the "tail" neatly tucked away. Repeat for the other side.

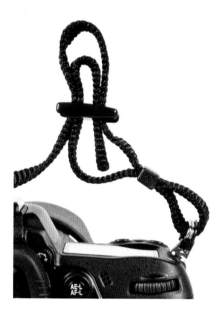

> # Adjusting the diopter

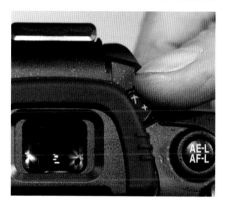

ADJUSTING THE DIOPTER ☆
Turn the dial to adjust the diopter until the viewfinder display is sharp.

The D7000 offers dioptric adjustment, between -3 and +1 m^{-1}, to allow for individual variations in eyesight. Make sure this is optimized for your eyesight (while wearing glasses or contact lenses if you normally do so) before using the camera. The diopter adjustment control is just to the right of the viewfinder, partly masked by the rubber eyepiece cup. With the camera switched on, rotate this control until the viewfinder display appears sharpest.

ATTACHING THE STRAP ☆
The strap is shown correctly threaded, but not yet fully tightened.

2 › Mounting lenses

Switch off the camera before changing lenses. Remove the rear lens cap and the camera body-cap (or the lens already mounted). To do this, press the lens release button and turn the lens clockwise (as you face the front of the camera). Align the index mark on the lens with the white dot on the camera body *(below)*, insert the lens gently, and turn it anticlockwise until it clicks home. Do not use force; if the lens is correctly aligned, it will mount smoothly.

Most Nikon F-mount lenses can be used on the D7000—*see page 204* and the maker's manual for detailed information. For lenses with an aperture ring, rotate this to minimum aperture before use on the D7000. The effective focal length of all lenses will be 1.5x the true figure (e.g., a 50mm lens will be an effective 75mm).

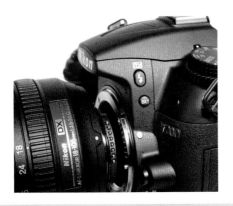

› Inserting and removing a memory card

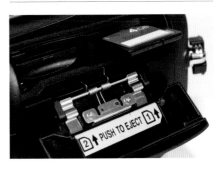

The D7000 has dual slots for Secure Digital (SD) cards, including high-capacity SDHC and SDXC cards.

1) Ensure that the camera is switched off and that the green access lamp on the back (to the right of the multi-selector) is not lit.

2) Slide the card slot cover on the right side of the camera gently rearward until it springs open.

Common errors

Take care when changing lenses in dusty environments and beware wind that could introduce dust or sand while the camera's interior is exposed. Avoid touching the electrical contacts on lens and camera body, since dirty contacts can cause a malfunction. Replace lens/body caps as soon as possible.

3) To remove an SD card, press the card gently into its slot; it will spring out slightly. Pull the card gently from its slot.

4) Insert an SD card into the chosen slot, with its label toward you and the "cut off" corner at top left. Slide the card into the slot until you feel slight resistance. Push more firmly—but without excessive force—and the card will click fully home. The green access lamp will light briefly.

5) Close the card slot cover.

› Formatting a memory card

Always format a new memory card, or one that has been used in another camera, before using it in the D7000. This is also the quickest way to erase existing images, but for this reason, formatting needs to be done with caution—always make sure that images have been saved elsewhere first.

One way to format a card is to press and hold the two **FORMAT** buttons (🗑 and 🔳) for about two seconds. A blinking **FOR** appears in the viewfinder and Control Panel. If both card slots are occupied, the card in Slot 1 will be formatted first, and its icon will blink in the displays. Turn the main command dial to select Slot 2 if required. Release the two buttons and press them again to format the card. Press any other button to exit without formatting the card.

You can also format a card through the

Setup menu *(see page 110)*. This method makes it immediately obvious which card slot will be formatted.

Warning!

There is no lock on the card slot cover and it can be opened accidentally—e.g., when lifting the camera out of a bag. Take care when handling the camera in this way, lifting it by the strap rather than the body. The cover is secure in normal shooting.

› Inserting the battery

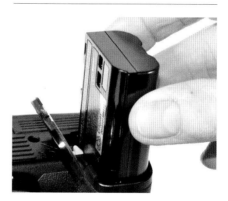

The D7000 is supplied with an EN-EL15 li-ion rechargeable battery. The battery should be fully charged before first use.

Turn the camera upside down and locate the battery compartment below the handgrip. Release the latch and insert the

battery, contacts first, with its flat face toward the lens. Push the battery gently down until the latch locks into position. The green access lamp on the camera back will light briefly. Shut the battery compartment cover, ensuring it clicks home.

To remove the battery, switch off the camera and open the compartment cover. Press the orange latch to release the battery and pull it gently from the compartment.

› Battery charging

Use the supplied MH-25 charger to charge the battery. Connect the power cord to the charger and insert the plug into an AC outlet. Align the battery, terminals first, with the slot on the charger. Slide the battery into the slot until it snaps home. The charge lamp will blink while the battery is charging, and shine steadily when charging is complete. A fully discharged battery will take around 2½ hours to recharge fully.

› Battery life

Battery life depends on various factors. Nikon does not recommend use at temperatures below 32°F (0°C) or above 104°F (40°C). Other important factors that can reduce battery life include prolonged use of the LCD screen; use of the built-in flash; long auto meter-off delays; and continuous use of autofocus (as when tracking a moving subject). Extensive use of Live View or movie shooting are particularly demanding of the battery.

Under standard (CIPA) conditions, you can expect around 1000 shots from a fully charged EN-EL15 battery. The Control Panel gives an approximate indication of how much charge remains; for more detail, see Battery Info in the Setup Menu. The control panel icon blinks when the battery is exhausted, and a low battery icon appears in the viewfinder when it is approaching exhaustion.

For information on alternative batteries and AC adapters, *see pages 228–9.*

Tips

Even when not in use, your camera battery will gradually lose charge over a period of time. If the camera is to remain unused for a long period, it is best to remove its battery. Storing the battery after it is fully recharged may lower the battery's performance.

The battery charger can be used abroad (100–240v AC 50/60 Hz) with a commercially available travel plug adapter. Do not attach any form of voltage transformer, since this may damage the charger.

» BASIC CAMERA FUNCTIONS

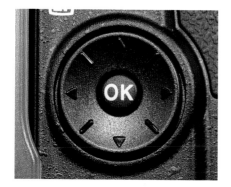

While the D7000 can be as simple to operate as any point-and-shoot camera, it offers far more power and flexibility. When exploring these, it makes sense to start with the most basic camera functions. These are principally accessed through the two command dials: the Mode dial and Release Mode dial. Menu navigation is mainly via the Multi-selector *(above)*.

› Switching on the camera

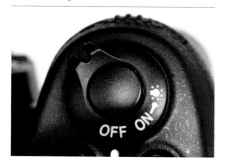

The power switch *(below left)* comprises three settings:

OFF The camera will not operate.

ON The camera operates normally.

:☀: Move the power switch beyond the **ON** setting and release (it will not stay in this position on its own). This illuminates the Control Panel for about 10 sec. Custom setting d10 allows you to keep the panel illuminated whenever the camera is active, which may be useful for night shooting, although it reduces battery life.

› Operating the shutter

The shutter-release button operates in two stages. Pressing it lightly, until initial resistance is felt, activates exposure and focus functions. Depressing it fully releases the shutter and takes the picture, using the focus and exposure settings established by the initial pressure. If image playback or camera menus are active, these are canceled by initial pressure on the release button, making the camera instantly ready to shoot.

› Release mode

The Release mode dial has seven positions, and to prevent accidental switching between modes, the dial features a lock button. Depressing the button allows the dial to rotate.

2

RELEASE MODE OPTIONS

Setting	Description
S Single Frame	The camera takes a single shot each time the shutter release is fully depressed.
CL Continuous Low-speed	The camera fires continuously as long as the shutter release is fully depressed. The default frame rate is 3 fps, but this can be varied between 1 and 5 fps using Custom Setting d5.
CH Continuous High-speed	The camera fires continuously at the maximum possible frame rate as long as the shutter release is fully depressed. The maximum frame rate is 6 fps, but this may not be attained if, for example, longer shutter speeds are selected.
Q Quiet mode	The camera shoots as normal, but there are no alert beeps and the mirror return after each shot is damped to provide a quieter release.
⟳ Self-timer	The shutter is released at a set interval after the release button is depressed. Can be used to minimize camera shake and for self-portraits. The default interval is 10 sec., but 2 sec., 5 sec., or 20 sec. can be set using Custom Setting c3.
▤ Remote control	Allows the camera to be triggered using the optional ML-L3 remote control. Further options for use of the ML-L3 are set from the Shooting menu.
Mup Mirror up	The mirror is raised when the shutter-release button is fully depressed; press it again to take the picture. Useful to minimize vibration caused by "mirror slap," but now superseded in many circumstances by Live View mode

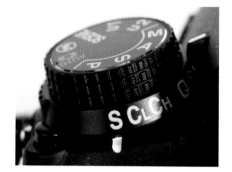

The Release mode dial, showing the single- « frame advance setting.

been transferred to the memory card to free up space in the buffer. Normally this will only be an issue when shooting long continuous bursts in Continuous High-speed release mode. Even then, it is more likely to be noticed as a slowdown to 1 or 2 fps rather than a complete halt.

The maximum shooting rate for all file formats is around 6 fps. This is not always attainable: any difficulty in focusing can slow things down, as can the use of slower shutter speeds. The write-speed of the memory card(s) is also a factor.

The buffer

Images are held initially in the camera's internal memory (the buffer) before being written to the memory card(s). The maximum number of images that can be recorded in a continuous burst depends upon file quality, drive mode, card speed, and how much buffer space is available. The figure for the number of burst frames possible at current settings is shown at bottom right of the viewfinder when the shutter-release button is depressed halfway. This figure assumes Continuous High-speed shooting and is displayed even if another release mode is selected. If (0) appears, the buffer is full and the shutter will be disabled until enough data has

› The Control Panel and Information display

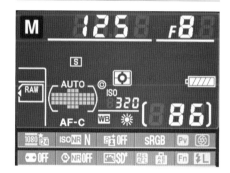

All key shooting information is displayed in the Control Panel on the top right side of the camera. Much the same information can also be viewed on the rear LCD screen by pressing the **INFO** button. The larger display makes the information easier to read. The Information display can be particularly helpful when working on a tripod.

The Main and Sub-command dials are fundamental to the operation of the D7000. Their functions are flexible, varying according to the operating mode selected. Although the plethora of options may appear daunting at first, operation is much more intuitive than a printed description might suggest.

By default, when used on their own, the dials operate as follows:

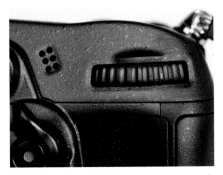

The Main command dial. ↟

The Sub-command dial. ↡

Main command dial

In Shutter-priority or Manual mode, rotating the Main command dial selects the shutter speed. In Program mode, it will engage Program shift, changing the combination of shutter speed and aperture. In Aperture-priority mode, it has no effect.

Sub-command dial

In Aperture-priority or Manual mode, rotating the Sub-command dial selects the aperture. In Shutter-priority or Program mode, it has no effect.

Both dials, but especially the Main command dial, have a range of additional functions when used in conjunction with other buttons. Hold down the appropriate button while rotating the dial to make your selection.

The principal uses of the Command dials in conjunction with other buttons are shown in the chart opposite.

QUICK CONTROL »
The command dials provide the quickest way to control settings like White Balance (set to Direct Sunlight to avoid "neutralizing" the warm hues in this view of Whitbarrow Scar, Cumbria, UK).

Command dial	Other button	Function
Main	Mode dial (set to SCENE)	Select Scene mode *(see pages 38–47)*
Main	🇿	Select level of exposure compensation *(see pages 56–57)*
Main	𝟒	Select the flash mode *(see page 164)*
Sub	𝟒	Select the level of flash compensation *(see page 166)*
Main	⊕	Select the image quality *(see pages 64–65)*
Sub	⊕	Select the image size *(see page 66)*
Main	⊖▣	Select the ISO sensitivity *(see pages 70–71)*
Main	⊙━	Select the white balance setting *(see pages 66–69)*
Sub	⊙━	Select white balance preset *(see page 66–69)*

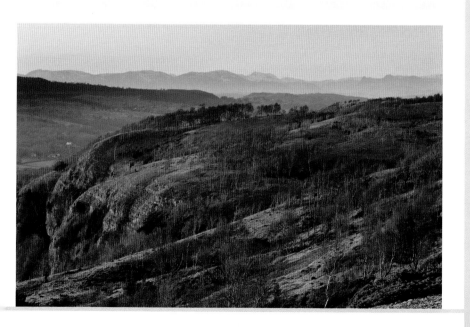

2 » EXPOSURE MODES

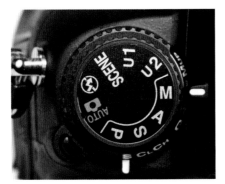

Exposure modes, selected with the Mode dial, are fundamental to the camera's operation, and the choice of exposure mode makes a significant difference to the amount of control you can—or can't—exercise. The D7000 has a very wide range of exposure modes, which can be divided into three main groups:

Full Auto modes
Scene modes (Digital Vari-program)
User-control modes.

In Full Auto modes and Scene modes, most settings are controlled by the camera. These not only include basic shooting settings, but also such decisions as whether flash can or can't be used, plus most aspects of how the camera processes the shot. The difference is that Full Auto modes employ general settings

to cover most eventualities, while Scene Mode settings are tailored to particular shooting situations. By contrast, User-control modes give you complete freedom to control virtually everything on the camera.

> **Note:**
> The Mode dial also has two extra positions: U1 and U2. These allow instant access to predetermined User settings. These cover many other parameters as well as Exposure modes, so will be dealt with separately.

> **Warning!**
>
> The Mode dial does not have a lock button, so it is quite easy to switch to a different mode accidentally.

Mode Group	Exposure Mode	
Full Auto modes	AUTO ● Auto	Leave all decisions about settings
	⑤ Auto (flash off)	to the camera.
Scene modes (Set Mode dial to **SCENE** and use Main command dial to select)	❀ Portrait	Choose the mode to suit the
	▲ Landscape	subject, and the camera
	❀ Child	employs appropriate settings
	❀ Sports	
	❀ Close-up	
	❀ Night portrait	
	❀ Night landscape	
	❀ Party/indoor	
	❀ Beach/snow	
	❀ Sunset	
	❀ Dusk/dawn	
	❀ Pet portrait	
	❀ Candlelight	
	❀ Blossom	
	❀ Autumn colors	
	❀ Food	
	❀ Silhouette	
	❀ High key	
	❀ Low key	
User-control modes	**P** Program	Allow much greater control
	S Shutter-priority	over the full range of camera
	A Aperture-priority	settings.
	M Manual	

2 » FULL AUTO MODES

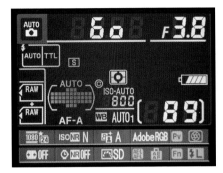

Nikon calls the Full Auto modes "Point and Shoot" modes, which is a reflection of the way they're likely to be used. Left to itself like this, the camera can obtain acceptable shots under most conditions, but the results may not always match what you had in mind. Although suitable for snapshots, it stifles creative control and hardly exploits the D7000's potential.

CANALSIDE RIDE ⌄
Full Auto mode is ideal when shots need to be grabbed quickly, but can diminish the sense of control and creativity.

There's only one difference between the two Full Auto modes. In ◘ Auto mode, the built-in flash activates automatically if the camera senses that light levels are too low (unless a separate accessory flashgun is attached and switched on, which overrides the built-in unit). In ⊛ Auto (flash off) mode, the flash stays off irrespective of light level. This is useful in situations where flash is banned or would be intrusive, or when you just want to discover what the D7000 can do in low light.

Taking the picture

Basic picture taking is essentially the same in all Full Auto and Scene modes.

1) Select the desired mode by rotating the Mode dial to the appropriate position; for scene modes, set it to **SCENE** and then use the Information display and Command dial as described on page 38.

2) Frame the picture.

3) Depress the shutter-release button halfway to activate focusing and exposure. The focus point(s) will be displayed in the viewfinder image, and shutter speed and aperture settings will appear at the bottom of the viewfinder.

4) Fully depress the shutter-release button to take the picture.

› Exposure warnings

In all modes except Manual, if the camera detects that light levels are too low or, more rarely, too high for an acceptable exposure, a warning will be shown in both the viewfinder and the Information display (if active). The exposure indicators in the viewfinder flash on and off, and **Hi** or **Lo** is also displayed. **Hi** = subject too bright; **Lo** = subject too dark. A flash symbol also blinks. Similar warnings appear in the Information display.

The camera will still take pictures under these conditions, but they may be underexposed or subject to camera shake (assuming the warning arises because it's too dark). Possible solutions include using flash, adjusting the ISO sensitivity, or fitting a lens with a wider maximum aperture.

FEATURE WINDOW ⌄
Auto (flash off) mode is suitable where flash is banned or—as in the case of this fine window in Hotel Schatzalal, Davos, Switzerland—it would destroy the balance of tones.

2 » SCENE MODES

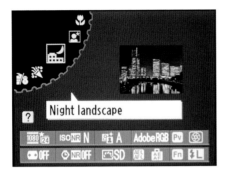

Nikon calls these "Creative" modes, a term calculated to irritate experienced photographers, since these modes still take many decisions away from the user. Even the most experienced may find them handy on occasion, however, as a very quick way to set the camera for shooting a particular kind of image.

Newcomers to DSLR photography will find Scene modes perfect for discovering the different ways the camera can interpret the same scene. This makes them a great steppingstone to using the full range of options offered by the D7000. The first step is to understand how the various Scene modes work and to be aware of the difference they can make to your photographs.

Scene modes are selected by first setting the Mode dial to **SCENE**, activating the Information Display with **INFO**, then rotating the Main command dial. The monitor shows a "virtual mode

dial," with the selected mode's icon highlighted. The name of the mode is also shown, and a small thumbnail image gives an example of an appropriate subject and the way it should turn out when this mode is used. The "virtual mode dial" disappears after a few seconds, but the mode icon remains in the top left corner of the Information display.

Switching between Scene modes naturally affects basic shooting parameters, such as how the camera focuses, and how it sets shutter speed and aperture. The modes also determine how the camera processes the image—at least for JPEGs. For instance, Nikon Picture Control settings *(see pages 83–84)* are predetermined. In 🗝 Portrait mode, for example, the camera applies a Portrait Picture Control for natural colors and flattering skin tones. Most Scene modes also employ Auto white balance, but in some cases the white balance setting is predetermined to suit specific subjects.

In some Scene modes, the built-in flash will operate automatically if the camera senses that light levels are too low. There's no evident way to turn it off, but attaching a separate flashgun will override the built-in unit—and often improve results dramatically. If you don't want flash at all, you'll have to select a different mode.

In other Scene modes, the built-in flash remains off regardless of the light level. If you attach a separate flashgun, however, this will operate normally. If you want flash, switch to a different mode.

› 🄯 Portrait

In Portrait mode, the camera sets a wide aperture to reduce depth of field, helping subjects to stand out from their background. The camera also selects the focus point,

which can't be overridden, except by focusing manually. The built-in flash deploys if the camera determines light levels are too low, despite the limitations of built-in flash for portraits. Attaching a separate flashgun usually improves results.

› 🄯 Landscape

In Landscape mode, the camera sets a small aperture to maximize depth of field. The camera also selects the focus point(s) automatically, which can't be overridden. Small apertures mean that shutter speeds can be on the slow side, making a tripod advisable. A Landscape Picture Control is applied for vibrant colors. The built-in flash remains off.

› 🏃 Child

› 🚴 Sports

Child mode is broadly similar to Portrait mode, but one obvious difference is that the camera tends to set a higher shutter speed, no doubt because children are less likely than adults to sit still when required. Colors are also handled slightly differently to produce results that are more vivid overall, but that still give pleasing skin tones. The flash activates automatically.

Tip

If you regularly use one or two particular Scene modes, you could assign them to positions U1 and U2 on the Mode dial. This will be the quickest way to select them.

Sports mode is suitable for shooting a range of fast-moving subjects. The camera sets a fast shutter speed to freeze the action, but this usually implies a wide aperture and therefore shallow depth of field. The camera initially selects the central focus point; if it detects subject movement, it will track the target using the remaining focus points. (This initial selection can be overridden.) The flash remains off, so if you want fill-in flash or mixed lighting *(see Chapter 4)*, you'll have to use a different mode (try 🏃 Child or one of the User-control modes). Alternatively, fit a separate flashgun.

› 🌷 Close-up

Close-up mode is intended for shooting at really close range. The camera sets a medium to small aperture for good depth of field, making a tripod useful to avoid camera shake. The built-in flash activates automatically in low light, but it is a poor choice for close-up shots; a separate flashgun is a better option. The camera automatically selects the central focus point, but this can be overridden, using the Multi-selector.

› 📷 Night portrait

Night portrait mode is broadly similar to regular Portrait mode, but when ambient light is low, the camera will set a long shutter speed to allow an image of the background to register. For this reason, a tripod or other solid camera support should be used. The built-in flash operates automatically; while results may be less harsh than in regular Portrait mode, an accessory flashgun is a better choice. Red-eye reduction flash is employed, complete with enforced shutter delay *(see pages 164–5)*.

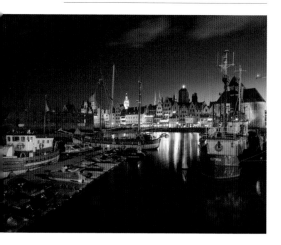

Night landscape mode allows long exposures to be used, so a tripod is a necessity. The built-in flash remains off. Images are processed to reduce noise and preserve colors, including the varied colors of artificial light. When exposures exceed 8 sec., Long Exposure noise reduction is applied, which creates a delay before another shot can be taken *(see page 92)*. The maximum exposure time is 30 sec.; if a longer time is required, use Manual (**M**) mode.

This mode appears similar to Night portrait in seeking to record both people and their background, but it does not allow such long exposures to be set, making it more suitable for handheld shooting. Again, Red-eye reduction flash is employed.

› ⛷ Beach/snow

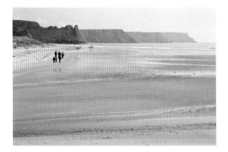

› 🌅 Sunset

Beach and snow scenes are notorious for disappointing results; the subject is full of bright tones, yet all too often photographs turn out relatively dark. The D7000 works to counteract this, partly by applying exposure compensation *(see pages 56–57)* and partly through the way it processes the image. The flash remains off.

Sunset mode is broadly similar to Night landscape mode. The flash stays off, long exposure times are possible, and a tripod is recommended. White balance is predetermined, with the aim of preserving the vivid tones of the sky.

› 🌄 Dusk/dawn

Dusk/dawn mode is similar to Sunset mode, but allows for the more muted colors and lower contrast usually experienced before sunrise and after sunset; again, white balance is predetermined. A tripod is recommended.

› 🐾 Pet portrait

› 🕯 Candlelight

This mode is recommended for portraits of active pets. The built-in flash will fire automatically in low light, but the AF-assist illuminator turns off, presumably to avoid disturbing the creature before the shot. In other respects, this mode is very similar to Child mode.

As the name suggests, the mode is recommended for portraits taken by candlelight. Because the light is quite weak, exposure times are usually long, making a tripod invaluable; the subject will need to keep still. The built-in flash does not fire. White balance is predetermined to allow for the red hue of the candlelight. This mode could be used with other dim light sources, but because the camera expects the light to be red, the results may appear excessively blue.

› ❀ Blossom

› ❀ Autumn colors

Use this mode for trees in blossom, fields of flowers, and similar subjects. Because the colors are intense and blooms reflect a lot of light, detail is often lost. In this mode, the D7000 employs Active D-Lighting *(see page 82)* to retain detail in these highlight areas. Image processing aims to produce vivid, but not garish, colors. The built-in flash remains off; a tripod may be required in poor light.

This mode tackles similar issues as Blossom mode, aiming to preserve the colors in autumn foliage, but processing favors the red and yellow parts of the spectrum. Again, the built-in flash remains off and a tripod may be needed.

2

› ¶¶ Food

› 🌋 Silhouette

Recommended for detailed and vivid photos of food, this mode is unique among the D7000's Scene modes in that the built-in flash does not operate automatically, but can be activated manually. Because such photos are taken at close range, however, the built-in flash may produce unwanted shadows; it is usually better to use a separate flash or to employ a tripod. This mode can be useful for shooting other close-up subjects without flash.

In Silhouette mode, the camera's metering favors bright backgrounds, such as vivid skies, while foreground subjects record as silhouettes. The built-in flash does not operate; a separate flash can be used, although this could undermine the graphic silhouette effect.

› 🖽 High key

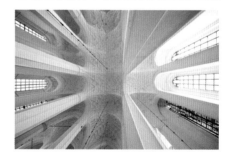

The terms "high key" and "low key" are familiar in traditional photography, but hardly self-explanatory. High key

» USER CONTROL MODES

describes images intentionally filled with light tones and lacking blacks or very deep tones; ideally, however, bright highlights retain detail and do not "burn out" to pure white.

› Lo Low key

Low key is basically the opposite to High key. In both modes, the built-in flash remains off; although an external flashgun can be used, use it with moderation, since it could easily destroy the desired effect.

› (P) Programmed auto

Programmed auto mode allows a quick response, but also lets users tailor camera settings to suit their own creative ideas.

In **P** mode, the camera sets a combination of shutter speed and aperture that will give correctly exposed results in most situations. In this respect, it is similar to Full Auto and Scene modes, but there is much greater scope for user intervention through flexible program, exposure lock and exposure compensation, and auto bracketing. It also gives you freedom in selecting Picture Controls, using flash, and much more.

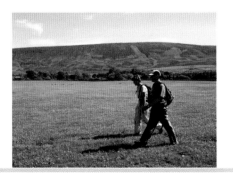

WALKERS IN WYRESDALE,　　　　**»**
LANCASHIRE, UK
Programmed auto is a good all-purpose mode that allows plenty of fine tuning for specific purposes.

2

Setting Programmed auto mode

1) Rotate the Mode dial to position P.

2) Frame the picture.

3) Depress the shutter-release button halfway to activate focusing and exposure. The focus point(s) will be displayed in the viewfinder, and shutter speed and aperture settings will appear below the viewfinder image.

4) Fully depress the shutter-release button to take the picture.

Flexible program

Without leaving **P** mode, you can vary the combination of shutter speed and aperture by rotating the Main command dial to engage flexible program. While flexible program is engaged, the **P** indication in the Control Panel (but not the viewfinder) changes to **P***.

> **Note:**
> Programmed auto mode is not available with older lenses lacking a CPU. If such a lens is attached, the camera will switch to Aperture-priority mode. The **P** indicator in the Control Panel will blink and **A** will be displayed in the viewfinder

› (A) Aperture-priority auto

In Aperture-priority (**A**) mode, you control the aperture, and the camera sets a shutter speed that will give correctly exposed results in most situations. Control of aperture is particularly useful for controlling depth of field. The range of apertures that can be set is determined by the lens that's fitted, not by the camera. Fine-tuning of exposure is possible through exposure lock and exposure compensation, and possibly auto bracketing.

Setting Aperture-priority auto

1) Rotate the Mode dial to position **A**.

2) Frame the picture.

3) Depress the shutter-release button halfway to activate focusing and exposure. The focus point(s) will be displayed in the viewfinder, and shutter speed and aperture settings will appear below the viewfinder image. Rotate the Sub-command dial to alter the aperture; the shutter speed will adjust automatically.

4) Fully depress the shutter-release button to take the picture.

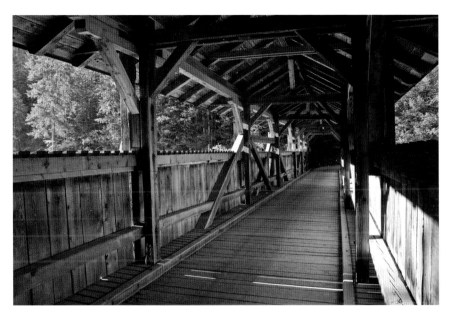

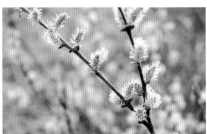

COVERED BRIDGE, LECHTAL, AUSTRIA ⩔
Aperture-priority mode is ideal for control over depth of field; I wanted the woodwork to be sharp from front to back.

WILLOW CATKINS AT OXWICH, ⩕
SOUTH WALES
Aperture-priority auto enables control of depth of field.

Note:
Aperture-priority auto is available with older lenses lacking a CPU. To get the best results when using such lenses, specify the maximum aperture of the lens using the Non-CPU lens data item in the Setup menu.

> **(S)** Shutter-priority auto

In Shutter-priority (**S**) mode, you control the shutter speed, and the camera sets an aperture that will give correctly exposed results in most situations. Control of shutter speed is particularly useful when dealing with moving subjects. Shutter speeds between 30 sec. and 1/8000 sec. can be set. Fine-tuning of exposure is possible through exposure lock and exposure compensation, and possibly auto bracketing.

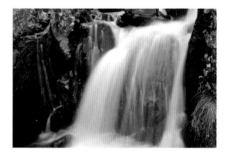

WATERFALL AT CAUTLEY, HOWGILL FELLS, CUMBRIA, UK ✕
Long exposure times are best controlled in shutter-priority or Manual mode.

Setting Shutter-priority auto

1) Rotate the Mode Dial to position **S**.

2) Frame the picture.

3) Depress the shutter-release button halfway to activate focusing and exposure. The focus point(s) will be displayed in the viewfinder, and shutter speed and aperture settings will appear below the viewfinder image. Rotate the Main command dial to alter the shutter speed; the aperture will adjust automatically.

4) Fully depress the shutter-release button to take the picture.

> *Note:*
> Shutter-priority auto is not available with non-CPU lenses.

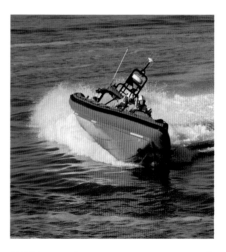

LIFEBOAT EXERCISE, SILLOTH, CUMBRIA, UK ✕
I set a fast shutter speed to freeze both the boat and the spray.

› (M) Manual mode

In **M** mode, you control both shutter speed and aperture for maximum creative flexibility. The Main command dial controls shutter speed, and the Sub-command dial adjusts aperture. Manual mode is best employed when shooting without pressure of time or in fairly constant light conditions. Many experienced photographers use it habitually to retain complete control.

Shutter speeds can be set between 30 sec. and 1/8000 sec., plus **B** or "bulb," when the shutter remains open indefinitely while the shutter-release button is depressed.

The range of apertures that can be set is determined by the lens that's fitted.

Using Manual mode

1) Rotate the Mode dial to position **M**.

2) Frame the picture.

3) Depress the shutter-release button halfway to activate focusing and exposure. The focus point(s) will be displayed in the viewfinder, and shutter speed and aperture settings will appear below the viewfinder image. Check the analog exposure display in the viewfinder (and/or the playback histogram); if necessary, adjust the settings to achieve the correct exposure.

4) Fully depress the shutter-release button to take the picture.

> **Note:**
> The **B** (bulb) setting, with its unlimited exposure duration, is only available in **M** mode, making that the only possible choice for really long exposures.

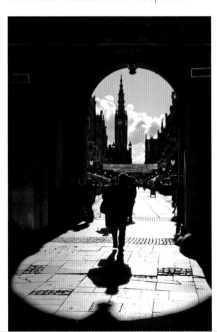

HIGH CONTRAST **«**
This shot, taken in Gdansk, Poland, was challenging for the exposure meter. I used Manual mode and studied the histogram display on playback to check the exposure.

› Using the Analog exposure displays

» USER SETTINGS

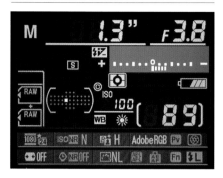

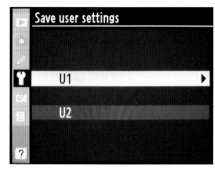

In Manual mode, an analog exposure display appears in the center of the viewfinder readouts and in the Information display. This shows whether the photograph would be under- or overexposed at the current settings. Adjust shutter speed and/or aperture until the indicator is aligned with the 0 in the center of the display: the exposure now matches the camera's recommendations. The D7000's metering is good enough that generally this will be correct, but if time allows it is worth reviewing the image and checking the histogram *(see page 81)* after taking a shot. Then, if necessary, further adjustments can be made to achieve the desired result.

The D7000's Mode dial features two extra positions: U1 and U2. These allow instant access to predetermined combinations of a wide range of settings.

User settings store most settings from the Shooting and Custom settings menus, but that's not all. They also link to a selected Exposure mode, including the full range of Scene modes. They could serve as shortcuts to one or two Scene modes that you use regularly. The versatility of User

> **Note:**
> When you are shooting in U1 or U2 mode, the stored settings are just a starting point. You can adjust them as normal, except that you can't change the Exposure mode because that would require the Mode dial to be moved off the U1/U2 position.

settings is only revealed, however, when used in conjunction with **P**, **S**, **A**, or **M** mode, since these allow many other settings to be selected and stored as well.

You could think of User settings as creating your own tailored Scene modes, but they go beyond even that, since they store such values as shutter speed and/or aperture, ISO, flash compensation, and many more. User settings will be particularly valuable to photographers who regularly shoot at a particular location or under clearly defined conditions. For instance, a sports photographer who regularly operates in a particular venue could establish ISO, white balance, and all the other settings that produce the best results. Having saved these as a User setting, a single turn of the Mode dial will restore them on the next visit to the venue.

› To store User settings

Storing User settings is straightforward.

1) Ensure the camera is set up as required.

2) Press **MENU**, select the Setup menu, and then select **Save user settings**. Press ▶.

3) Highlight U1 or U2 and press ▶.

4) Highlight **Save settings** and press **OK**.

› To reset User settings

To create a new User setting for either dial position—to replace an earlier set—simply repeat the procedure given. The Reset user settings item in the Setup menu will restore all relevant settings to the camera's default values—e.g., exposure mode to Auto, image quality to JPEG Normal, white balance to Auto (Normal), and so on. Proceed with caution!

REUSE, RECYCLE ⌄⌄
User settings allow a full range of settings for a specific situation to be reused repeatedly and consistently, as demonstrated in the image at the National Cycling Centre, Manchester, UK.

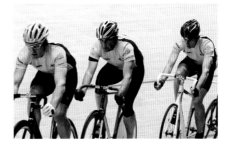

Note:
Settings such as ISO, white balance, image size, and image quality can be set either from the Shooting menu or by button and dial; either way, the current setting will be stored.

2 » METERING MODES

Metering mode selector

The D7000 provides three different metering modes that should cover any eventuality. Switch between them by pressing the ▦ button and rotating the Main command dial; the Control Panel shows the mode selected. This is only possible in **P**, **S**, **A**, or **M** modes: in Full Auto and Scene modes, the metering mode (usually matrix) is automatically selected.

› 3D color matrix metering II

▦ Using a 2016-segment color sensor, 3D color matrix metering II analyzes data on the brightness, color, and contrast of the scene. With Type G or D Nikkor lenses, the system also considers subject distance to further refine its reading. With other CPU lenses, this range information is not used (Color matrix metering II). If non-CPU lenses are to be used, Color matrix

metering II can still be employed, provided the focal length and maximum aperture have been specified using the Non-CPU lens data item in the Setup menu.

Matrix metering is recommended for the vast majority of shooting situations and generally will produce excellent results.

› Center-weighted metering

◉ With center-weighted metering, the camera meters from the entire frame, but gives greater importance to the central area. At the default setting, this area is a circle 8mm in diameter. Provided a CPU lens is attached, this can be changed to 6, 10, or 13mm using Custom setting b4. You can also choose Average metering, which meters equally from the whole frame area.

Center-weighted metering is useful for photography such as portraiture, where the subject occupies the central portion of the frame.

› Spot metering

⊡ In this mode, the camera meters from a circle 3.5mm in diameter (just 2.5% of the frame). If a CPU lens is fitted, this circle will be centered on the current focus point, allowing you to meter from an off-center subject.

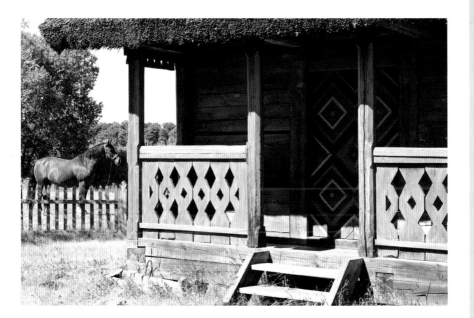

With a non-CPU lens, or if Auto-area AF is in use, the metering point will be the center of the frame.

To use spot metering effectively requires some experience, but in critical conditions it does offer unrivaled accuracy. It is important to understand that spot metering attempts to reproduce the subject area as a mid-tone, which must be allowed for (e.g., by using exposure compensation) if the subject is significantly darker or lighter than a mid-tone.

LATVIAN ETHNOGRAPHIC ⨀
OPEN-AIR MUSEUM, RĪGA, LATVIA
A simple looking shot, but contrast was very high and I wanted to ensure there was good detail in both the shadowed woodwork and the horse's shiny coat. Spot metering helped me strike that balance.

2 » EXPOSURE COMPENSATION

Exposure compensation button

The range of metering options, and the sophistication of matrix metering, means that the D7000 will produce accurate exposures under most conditions. But no camera is infallible, nor can it read your mind or anticipate your creative intent.

All metering systems are partly based on the assumption that key subject areas have a middling tonal value and should be recorded as a mid-tone. You may have seen the results that sometimes arise, such as snow scenes appearing unduly dark. Where very light tones predominate, the metering will tend to reproduce them as mid-tones, i.e., darker than they should be. The converse applies where very dark tones predominate.

In the days of film, experience was needed to accurately anticipate the need for exposure compensation. With their instant feedback on exposure, digital cameras smooth the learning curve. Time permitting, it's always worth checking the image, and specifically the histogram, after shooting *(see page 81)*. The basic principle is simple enough: to make the subject lighter (to keep light tones looking light), increase exposure—use positive compensation. To make the subject darker (to keep dark tones looking dark), reduce exposure—use negative compensation.

If this judgment proves difficult, or lighting conditions are extreme, an extra level of insurance is available through exposure bracketing. Shooting RAW gives extra room for maneuver in post-processing, both to adjust overall tonal values and to recover detail apparently lost in shadows and highlights.

› Using Exposure compensation

1) Exposure compensation can be applied in increments of ⅓ Ev (default), ½ Ev, or 1 Ev. Use Custom setting b3 to change the increment. (this change will also apply to flash compensation.)

2) Press the 🄬 button and rotate the Main command dial to set the negative or positive compensation required; the chosen value is displayed in the Control Panel and viewfinder. Compensation can be set between -5 Ev and +5 Ev, although you'll hardly ever need these extremes.

» EXPOSURE BRACKETING

3) Release ⊞. The ⊞ symbol appears on the Control Panel and the **O** at the center of the analog exposure display flashes. The chosen exposure compensation value can be confirmed on the Control Panel by pressing ⊞ again.

4) Take the picture as normal. If time allows, check that the exposure achieved is satisfactory.

5) To restore normal exposure settings, press ⊞ and rotate the Main command dial until the displayed value returns to 0.0.

Bracket button

A convenient way to ensure that an image is correctly exposed is to take a series of frames at differing exposures and select the best later. Exposure bracketing allows this to be done quickly, especially when using **CH** (Continuous High-speed) release mode.

Setting Exposure bracketing

1) Select exposure bracketing in Custom setting e5: set to **AE** only to ensure that only exposure values are varied.

2) While pressing the **BKT** button, rotate the Main command dial to select the number of shots (2 or 3) required for the bracketing burst; the selected number is displayed in the Control Panel. If two shots are selected, you can choose between normal plus underexposure and normal plus overexposure.

3) Still pressing the **BKT** button, rotate the Sub-command dial to select the exposure increment between each shot in the

Tips

Always reset exposure compensation when you've finished shooting a particular scene; otherwise, it will be applied to later shots that don't need it. Exposure compensation is not reset automatically, even when the camera is switched off. However, it will be restored to neutral by a two-button reset (see page 71).

Don't use exposure compensation in Manual mode. It doesn't affect the actual shutter-speed/aperture values, but can give misleading exposure readouts.

-1 Ev

0 Ev

1 Ev

BAINES CRAG, LANCASHIRE, UK ⌃
A sequence of exposures captured using the
D7000's bracketing setting, showing their
respective values.

sequence. Possible values run from 0.3 Ev
to 2 Ev. This increment is displayed in the
Control Panel. A **BKT** icon is displayed in
the viewfinder and Control Panel.

4) Frame, focus, and shoot normally.
The camera varies the exposure with
each frame until the sequence is
completed. A progress indicator appears
in the Control Panel, with a segment
disappearing as each frame is taken.

5) To cancel bracketing and return to
normal shooting, press the **BKT** button and
rotate the Main command dial until **OF**
appears in the Control Panel. The
increment you chose will remain in effect
next time you initiate bracketing.

Note:
If the memory card(s) become full
before the sequence is complete, the
camera will stop shooting. Replace a
card or delete images to make space;
the camera will then resume the
sequence. If the camera is switched
off before the sequence is finished, it
will resume when next switched on.

In addition to AE only, the D7000
offers other forms of bracketing,
selected through Custom setting e5.
AE and flash varies both exposure and
flash level. Flash only varies flash level
without changing the base exposure.
WB bracketing varies the white
balance setting. ADL bracketing varies
the level of Active D-Lighting applied.

» FOCUSING

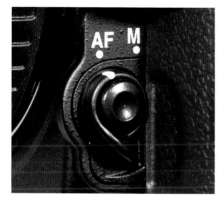

Focus selector switch

To switch between manual focus and autofocus, use the focus selector switch on the front of the camera near the lens mount. To choose the AF mode, press the AF-mode button in the center of the focus mode switch and rotate the Main command dial. The viewfinder and Control Panel show which mode is in operation.

› (AF-S) Single-servo AF

The camera focuses when the shutter-release button is depressed halfway. Once focus is acquired, the focus indicator appears in the viewfinder. Focus remains locked on this point as long as the shutter release is depressed halfway. By default, the shutter cannot release to take a picture until focus has been acquired (**focus priority**). This can be changed to

release priority in Custom setting a2, allowing the camera to take a picture even if perfect focus has not been acquired.

› (AF-C) Continuous-servo AF

In this mode, the camera continues to seek focus as long as the shutter release is depressed halfway; if the subject moves, the camera will refocus. The default setting is **release priority**, allowing the camera to take a picture even if perfect focus has not been acquired. This can be changed to **focus priority** in Custom setting a1.

The D7000 employs predictive focus tracking: if the subject moves while AF-C is active, the camera analyzes the movement and attempts to predict where the subject will be when the shutter is released.

› (M) Manual focus

The D7000's sophisticated AF capabilities might seem to make manual focus redundant, but many photographers still appreciate the extra level of control and involvement. Moreover, certain subjects and circumstances can bamboozle even the best AF systems. The D7000's bright, crisp viewfinder makes manual focusing straightforward: set the focus mode selector to **M** and use the lens focusing ring to bring the subject into focus.

› The electronic rangefinder

» AF-AREA MODES

When focusing manually, you can still take advantage of the camera's focusing technology thanks to the electronic rangefinder, which confirms when a subject is in focus. Focusing in this way can be more precise than just relying on the viewfinder image. It requires a lens of f/5.6 or faster and light levels that would allow AF to be used.

The rangefinder requires an appropriate focus area to be selected, as if you were using one of the AF modes. When the subject in that area is in focus, a green dot appears at the far left of the viewfinder.

When using autofocus, the AF-area mode determines which focus point or points the camera will employ. To select, press the AF-mode button in the center of the focus selector switch and rotate the Sub-command dial. The viewfinder and Control Panel show which mode is selected.

› Single-area AF [⟨·⟩]

In this mode, you select the focus area, using the Multi-selector to move through the 39 focus points. The chosen focus point is illuminated in the viewfinder. This mode is best suited to relatively static subjects.

> **Note:**
> Some lenses have an A/M switch: make sure this is set to **M**.

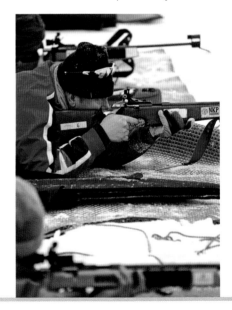

BIATHLON PRACTICE, GÅLÅ, NORWAY »
The ability to select focus points is most helpful with off-center subjects, and when the camera does not automatically recognize the intended subject—in this case, the eye of the middle shooter.

› Dynamic-area AF [⊡]

This mode is slightly more complicated, since its operation differs depending on whether AF-S or AF-C is selected. In AF-S, its operation is essentially the same as Single-area AF. Dynamic-area AF really comes into its own when using AF-C.

The initial focus point is still selected by the user, as in Single-area AF, but if the subject moves, the camera employs other focus points to maintain focus. You can choose the number of focus points that will be used: 9, 21, or all 39. Employing fewer points can make focusing faster, while using more tends to make it more precise. The final option is 3D tracking, which utilizes a wide range of information, including subject colors, to track subjects that may be moving erratically.

› Auto-area AF [■]

This mode makes focus point selection fully automatic; in other words, the camera determines the subject. When type G or D lenses are fitted, the camera can even distinguish a human subject from the background. The active focus points are briefly illuminated in the viewfinder after focusing.

» FOCUS POINTS

Early autofocus cameras were rightly criticized for limiting focus to the center of the frame or to a small number of points. With 39 focus points covering most of the frame, the D7000 has no such limitations, and it's usually possible to make a quick and precise selection to focus accurately on any subject.

› Focus point selection

1) Make sure the focus selector lock (below the Multi-selector) is in the unlocked position opposite the white dot.

2) Using the Multi-selector, move the active focus point to the desired position. The chosen focus point is briefly illuminated in red in the viewfinder and then remains outlined in black. (Illumination can be switched off using Custom setting a4.) Pressing **OK** selects the central focus point.

3) Depress the shutter-release button halfway to focus at the desired point; press it fully to take the shot.

BICYCLE ASSEMBLY LINE, HALIFAX, ʌ
YORKSHIRE, UK
Shifting the focus point gives a very different
emphasis with two similar subjects.

D7000 VIEWFINDER «
The viewfinder displays the available focus areas
as well as an in-focus indicator at the left of the
menu bar.

› Focus lock

Although the D7000's focus points cover a wide area, they do not extend to the edges of the frame. If you need to focus on a subject that does not naturally coincide with any of the focus points, proceed as follows.

Using Focus lock

1) Adjust framing to bring the subject within the available focus area.

2) Select a focus point and focus on the subject in the normal way.

3) Lock focus. In AF-S mode, this can be done by depressing the shutter-release button halfway, or by pressing and holding the **AE-L/AF-L** button. In AF-C mode, only the **AE-L/AF-L** button can be used.

4) Reframe the image as desired and press the shutter-release button fully to take the picture. If the shutter-release button is kept depressed halfway (in AF-S), or **AE-L/AF-L** is held down (in either AF mode), focus will remain locked for further shots.

> **Note:**
> At default settings, **AE-L/AF-L** locks exposure as well as focus, but this can be changed using Custom setting f5.

› The AF-assist illuminator

The AF-assist illuminator

An AF-assist illuminator is incorporated to help the camera focus in dim light. If the camera is in AF-S, with either the central focus point selected or Auto-area AF engaged, it illuminates automatically when required. For effective operation, the lens should be in the range 24–200mm. The AF-assist illuminator can be turned off using Custom setting a7.

> **Note:**
> A lens hood may block AF-assist illumination on close subjects, while some lenses are incompatible with the illuminator—see the camera manual for details.
>
> The AF-assist illuminator can become hot with repeated use and may turn itself off for a short period to protect the lamp.

2 » IMAGE QUALITY

The D7000 offers a choice of two file types: NEF and JPEG. The essential difference is that JPEG files undergo significant processing in-camera to produce files that should be usable right away (for instance, for direct printing from the memory card), without further processing on a computer.

Conversely, NEF files record the raw data directly from the camera's sensor, leaving much greater scope for processing on a computer to achieve exactly the desired pictorial qualities. This processing requires appropriate software, such as Nikon Capture NX2 or Adobe Photoshop. This kind of file is generically called RAW or Camera RAW; NEF is the specific file format of Nikon's RAW files.

RAW files can be recorded at either 12-bit or 14-bit depth. The latter captures four times more color information, but produces larger file sizes and (possibly) longer write times. This potential slowdown is rarely an issue, except when shooting long, high-speed sequences.

The D7000 allows two versions of the same image to be recorded simultaneously, one NEF (RAW) and one JPEG. The JPEG serves immediate needs, while the RAW version can be processed later for the best result. You can opt to save the two to separate memory cards via the Shooting menu.

Setting image quality

There are two ways to set image quality:

1) Hold down the ⊕ button and rotate the Main command dial until the required setting is displayed in the Control Panel.

2) In the Shooting menu, select **Image quality**, then highlight and select the required setting.

> *Note:*
> To determine whether NEF (RAW) files are recorded at 12-bit or 14-bit depth, select **NEF (RAW) recording** in the Shooting menu, choose **NEF (RAW) Bit Depth**, then select the desired option.

Image quality options

NEF (RAW)	12- or 14-bit NEF (RAW) files are recorded for the ultimate quality and creative flexibility. There are two further options: compressed or lossless compressed. Select with **NEF (RAW) recording** in the Shooting menu.
JPEG fine	8-bit JPEG files are recorded with a compression ratio of about 1:4; should be suitable for prints of A3 size or even larger.
JPEG normal	8-bit JPEG files are recorded with a compression ratio of about 1:8; should be suitable for modest-sized prints.
JPEG basic	8-bit JPEG files are recorded with a compression ratio of about 1:16; suitable for email or website use, but not recommended for printing.
NEF (RAW) + JPEG fine	Two copies of the image are recorded simultaneously, one NEF (RAW) and one JPEG.
NEF (RAW) + JPEG normal	Two copies of the image are recorded simultaneously, one NEF (RAW) and one JPEG.
NEF (RAW) + JPEG basic	Two copies of the image are recorded simultaneously, one NEF (RAW) and one JPEG.

2 » IMAGE SIZE

Except for NEF (RAW) files, which are always recorded at the maximum size, the D7000 offers three options for image size:

• **Large** is the maximum available size from the sensor, i.e., 4928 x 3264 pixels.

• **Medium** is 3696 x 2448 pixels, roughly equivalent to a 9-megapixel camera.

• **Small** is 2464 x 1632 pixels, roughly equivalent to a 4-megapixel camera.

Even Small size images exceed the maximum resolution of an HD TV and most computer monitors, and can yield good prints of around 12 x 8in (30 x 20cm) at 200 dpi.

Setting image size

There are two ways to set image size:

1) Hold down ⊕ and rotate the Sub-command dial until the required setting is displayed in the Control Panel.

2) In the Shooting menu, select Image size, then highlight and select the required setting.

» WHITE BALANCE

Light sources, both natural and artificial, vary enormously in color. The human eye and brain compensate for this well, seeing objects in their "true" colors under widely varying conditions, so that we nearly always see grass as green and so on. With film, obtaining accurate color often required use of filters. Digital imaging allows extensive compensation for the varying colors of light: the D7000 can produce natural-looking colors under almost any conditions.

The D7000 has a sophisticated system for determining white balance, which produces good results most of the time. For finer control, or for creative effect, when using **P**, **S**, **A**, or **M** modes, the D7000 also offers a wide range of user-controlled settings.

Notes:
When shooting RAW, although the in-camera WB setting is not crucial because white balance can be adjusted in post-processing, it's worth making the effort to get it right, since it affects how images look on playback and review.

Sometimes "correct" color is not desirable. An example is shooting a landscape by the warm light of early morning or late evening, where the reddened hue of the sunlight is part of the appeal. Auto White Balance may neutralize this effect. To avoid this, try the Direct sunlight setting, or better still, shoot RAW images.

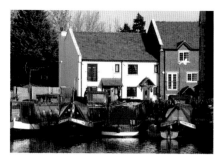

Incandescent

Flash

Cool-white fluorescent

Cloudy

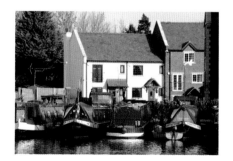

Direct sunlight

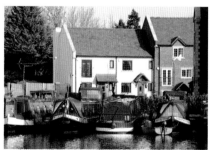

Shade

EFFECTS OF WHITE BALANCE SETTINGS

Six otherwise identical shots, taken seconds apart, demonstrate how radically White Balance settings can change the overall effect.

2

Setting white balance

There are two ways to set white balance:

1) Hold down ⬛ and rotate the Main command dial until the required symbol is displayed in the Control Panel.

2) In the Shooting menu, select **White balance** using the Multi-selector, then highlight the required setting. In most cases, a graphic display appears, with which you can fine-tune the setting using the Multi-selector. Or just press **OK** to accept the standard value.

When you select **Auto** in the Shooting menu, there are two sub-options: **Normal (A1)**, which maintains correct colors as far as possible, and **Keep warm lighting colors (A2)**, which does not correct the warm hues generated by incandescent lighting (and could be worth experimenting with for sunsets as well). When you select **Fluorescent**, a submenu appears from which you can choose the appropriate variety of fluorescent lamp.

Notes:
If you use the ⬛ button and Main command dial to select Fluorescent, the precise value will be whatever was last selected in the submenu under the Shooting menu. (The default is 4: Cool-white fluorescent.)

Energy-saving lamps, which have extensively replaced traditional incandescent (tungsten) lamps in domestic use, are compact fluorescent units. Their color temperature varies, but many are rated around 2700°K, equivalent to Fluorescent setting 1 Sodium-vapor lamps. With any unfamiliar light source, it's always a good idea to take test shots or allow for adjustment later by shooting RAW files.

Icon	Menu option		Color temperature	Description
AUTO	Auto	Normal Keep warm lighting colors	3500–8000	Camera sets WB automatically, based on information from imaging and metering sensors. Most accurate with Type G and D lenses.
☀	Incandescent		3000	Use in incandescent (tungsten) lighting, e.g., traditional domestic lamps.
	Fluorescent:		Submenu offers seven options:	
		1 Sodium-vapor lamps	2700	Use in sodium-vapor lighting, often employed in sports venues
		2 Warm-white fluorescent	3000	Use in warm-white fluorescent lighting
		3 White fluorescent	3700	Use in white fluorescent lighting
☀		4 Cool-white fluorescent	4200	Use in cool-white fluorescent lighting
		5 Day white fluorescent	5000	Use in daylight white fluorescent lighting
		6 Daylight fluorescent	6500	Use in daylight fluorescent lighting
		7 High temp. mercury-vapor	7200	Use in high color temperature lighting, e.g., mercury vapor lamps.
☀	Direct sunlight		5200	Use for subjects in direct sunlight
ϟ	Flash		5400	Use with built-in flash or separate flashgun. Value may require fine-tuning with large-scale studio flash.
☁	Cloudy		6000	Use in daylight, under cloudy/overcast skies.
⌂	Shade		8000	Use on sunny days for subjects in shade.
K	Choose color temp.		2500–10,000	Select color temperature from list of values.
PRE	Preset Manual		n/a	Derive white balance direct from subject or light-source, or from an existing photo.

2 » ISO SENSITIVITY SETTINGS

The ISO sensitivity setting governs the sensor's response to greater or lesser amounts of light. At higher ISO settings, less light is needed to capture an acceptable image. Higher ISO settings are also useful when you need to use a small aperture for increased depth of field or to use a fast shutter speed to freeze rapid movement. Conversely, lower ISO settings are useful in brighter conditions, and/or when you want to use wide apertures or slow shutter speeds. The D7000 offers ISO settings from 100 to 6400. Inevitably, image noise increases at higher settings, although the D7000 manages this very well. In addition, there are **Hi** settings beyond the standard range, but noise is often more obvious. These settings are +0.3 (equivalent to 8000 ISO), +0.7 (equivalent to 10,400 ISO), +1.0 (equivalent to 12,800 ISO), and +2.0 (equivalent to 25,600 ISO).

OLD MINE LEVEL, LAKE DISTRICT, UK ❯❯
Some daylight was filtering in from the tunnel mouth, but I was far enough in for the candlelight to balance it. A high ISO allowed a reasonably fast shutter speed.

› Setting the ISO

The usual way to set ISO is by pressing on the camera back and rotating the Main command dial until the desired setting is shown in the Control Panel and viewfinder. Alternatively, use the **ISO sensitivity** settings item in the Shooting menu.

Easy ISO is another option. If enabled in Custom setting d3, this allows the ISO to be set simply by rotating the Main command dial (in Aperture-priority mode) or Sub-command dial (in Shutter-priority or Program mode).

› Auto ISO sensitivity control

Under the **ISO sensitivity** settings item in the Shooting menu is a submenu called **Auto ISO sensitivity control**. If this is set to **ON**, the D7000 will automatically depart from the ISO you have selected if it determines that this is required for correct exposure. Extra options allow you to limit the maximum ISO and minimum shutter speed that the camera can employ when applying Auto ISO sensitivity control.

» COLOR SPACE

The D7000 offers sRGB and Adobe RGB color spaces, which define the range of colors that are recorded. The default setting, **sRGB**, has a narrower range, but images often appear punchier. It's typically used on the Internet and by photo printing outlets, and is suitable for images that will be used or printed with little or no post-processing.

Adobe RGB has a wider range and is a better choice for images that are destined for professional applications or where significant post-processing is anticipated. Use the Color space item in the Shooting menu to select the color space.

› Two-button reset

The D7000 offers a quick way to reset many camera settings to their default values (see table). Hold down the ⌦ and ⊕ buttons (marked with green dots) for at least two seconds. The Control Panel becomes blank while the reset is completed.

2

Default setting

Image quality	JPEG Normal	
Image size	Large	
ISO sensitivity	Auto and scene modes	Auto
	User-control modes	100
White balance	Auto (Normal)—Fine tuning off	
Nikon Picture Controls	Standard settings only	
Autofocus mode (normal shooting)	AF-A	
AF-Area mode (normal shooting)	♣, 🍴, ▲, 🍴, Hi, Lo	Single point
	✿, 🐕	Dynamic Area (39 Points)
	AUTO, ⚘, 🌼, 🏔, 🖼, ☀, 🌆, 🌃, 🗻, ☀, 🌇, P, S, A, M	Auto-area
Autofocus mode (Live View)	AF-S	
AF-Area mode (Live View)	♣, 🍴, ▲, 🍴, Hi, Lo	Wide-area
	✿, 🐕	Normal area
	AUTO, ⚘, 🌼, 🏔, 🖼, ☀, 🌆, 🌃, 🗻, ☀, 🌇, P, S, A, M	Face priority
Focus point	Center	
Metering	Matrix	
AE/AF lock hold	Off	
Active D-Lighting	Off	
Flexible program	Off	
Exposure compensation	Off	
Flash compensation	Off	
FV lock	Off	
Bracketing	Off	
Flash mode	AUTO, ⚘, ♣, ☀, 🐕	Auto
	🖼	Auto slow sync
	🌆	Auto with red-eye reduction
	🗻, P, S, A, M	Front-curtain sync
Multiple Exposure	Off	
Picture Controls	Original settings	

» LIVE VIEW

Live View activation switch

Live View mode allows you to frame pictures using the LCD screen rather than the viewfinder. However, the SLR is designed around the viewfinder, which is far superior for most photography. That said, Live View can prove invaluable under certain conditions, particularly where it's difficult to use the viewfinder—when working very close to the ground for instance, or when ultra-precise focusing is required.

Live View is also essential for shooting movies with the D7000 *(see Chapter 6).*

› Using Live View

To activate Live View, release the **Lv** switch on the rear of the camera. The mirror flips up, the viewfinder blacks out, and the rear monitor screen displays a continuous live view of the scene. Shooting information is displayed at the top and bottom of the screen.

Pressing **INFO** changes the information display, cycling through a series of screens *(see table below)*;

Live View info	Details
Show photo indicators (default)	Information bars superimposed at top and bottom of screen
Show movie indicators	Information bars superimposed at top and bottom of screen
Hide all indicators	Top information bar disappears, key shooting information still shown at bottom
Virtual horizon	Displays a horizon indicator on the monitor to assist in leveling the camera.
Framing grid	Grid lines appear, useful for critical framing

pressing **INFO** again returns you to the starting screen.

Options include a virtual horizon indicator. When you press the shutter-release button fully, the mirror flips down again briefly to allow exposure to be set. This makes a pronounced, and initially disconcerting, double click, which occurs even in Manual exposure mode. Inevitably, this slows the camera's response slightly. If you're shooting in **CH** or **CL** release mode, the mirror stays up and the monitor remains blank between shots, making it hard to follow moving subjects.

To exit Live View, flick the **Lv** switch again.

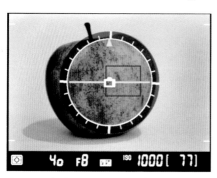

Live View display

› Focusing in Live View

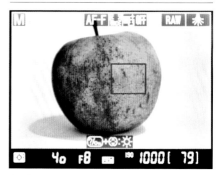

The focus area (red rectangle) can be positioned anywhere on screen.

Focusing in Live View operates differently from normal shooting; because the mirror is locked up, the usual focusing sensor is unavailable. Instead, the camera takes its focus information directly from the main image sensor. This is significantly slower than normal AF operation—another reason why Live View is not suitable for fast-moving subjects—but it is very accurate. You can zoom in on the scene for a critical focus check, which can be extremely useful when ultra-precise focusing is required, as in macro photography. Because Live View focusing works in this way, a different set of autofocus modes are available. There are two AF modes and four AF-area modes.

› Live View AF mode

The AF-mode options are Single-servo AF (AF-S) and Full-time servo AF (AF-F). AF-S corresponds exactly to AF-S in normal shooting: the camera focuses when the shutter release is depressed halfway, and focus remains locked all the time the shutter release is held down.

AF-F corresponds roughly to AF-C in normal shooting. However, the camera continues to seek focus as long as Live View remains active. When the shutter-release button is depressed halfway, the focus will lock and remain locked until the button is released or a shot is taken.

Selecting Live View AF mode

1) Activate Live View with the **Lv** switch.

2) Press the AF-mode button in the center of the focus selector and use the Main command dial to toggle between **AS-F** and **AF-F**, highlighted in yellow on the monitor screen. Alternatively, select Live View AF mode using Custom setting a8.

AF Mode	Description
◙ Face priority	Uses face detection technology to identify portrait subjects. Double yellow border appears outlining such subjects. If multiple subjects are detected, the camera focuses on the closest. Default in most Scene modes.
WIDE Wide-area	Camera analyzes focus information from area approximately ⅙ the width and height of the frame; area is shown by red rectangle. Default in 🌷 and 🍴.
NORM Normal area	Camera analyzes focus information from a much smaller area, shown by red rectangle. Useful for precise focusing on small subjects. Default in 🏃, 🏔, 🐈, 🏔, 🎆, 🌙.
⊕ Subject tracking	Camera follows selected subject as it moves within the frame.

2 > **Live View AF-area mode**

AF-area modes determine how the focus point is selected, but Live View AF-area modes do not correspond to those used in normal shooting.

Selecting Live View AF-area mode

1) Activate Live View with the **Lv** switch.

2) Press the AF-mode button in the center of the focus selector and use the Sub-command dial to select the AF-area mode (highlighted in yellow) on the monitor screen. Alternatively, select Live View AF-area mode using Custom setting a8.

> **Using Live View AF**

Wide-area AF and **Normal area AF**
In both AF-area modes, the focus point (outlined in red) can be moved anywhere on the screen, using the Multi-selector.

Tip

The ability to move the focus point anywhere on screen is useful for off-center subjects, especially when using a tripod. In normal handheld shooting, it's quicker and easier to use the viewfinder and employ focus lock (see page 63).

Pressing 🔍 zooms the screen view—press repeatedly to zoom closer. Helpfully, the zoom centers on the focus point. This gives ultra-precise focus control, which is best exploited when shooting on a tripod and is ideal for macro photography. When the focus point is set, autofocus is activated as normal by depressing the shutter-release button halfway. The red rectangle turns green when focus is achieved.

Face-priority AF
When this mode is active, the camera automatically detects up to five faces and selects the one that's closest, marking it with a double yellow border. You can override this and focus on a different person by using the Multi-selector to move the focus point. To focus on the selected face, depress the shutter-release button halfway.

REINDEER AT SALLA, FINLAND ⌄
Normal area AF is the best choice for precision and accuracy.

Note:
Subject tracking can work very effectively, but it isn't fast enough for rapidly moving subjects. Using the viewfinder is much more effective in this situation.

⊕ Subject tracking

When Subject tracking is selected, a rectangle outlined in white (the focus target) appears at the center of the screen. Align this with the desired subject using the Multi-selector. When the focus area covers the subject, press **OK**. The camera "memorizes" the subject and the focus target turns yellow. It will now track the subject as it, or the camera, moves, and can even reacquire the subject if it temporarily leaves the frame. To focus, depress the shutter-release button halfway; the target rectangle blinks green as the camera focuses and then becomes solid green. If the camera fails to focus, the rectangle blinks red. Pictures can still be taken, but focus may not be correct. To end focus tracking, press **OK** again.

Manual focus

Manual focus is engaged as in normal shooting. However, the Live View display continues to reflect the selected Live View AF mode. It's helpful to have Wide-area AF or Normal-area AF selected,

since the display still shows a red rectangle of the appropriate size. You don't have to focus manually on this point, but if you zoom in for more precise focusing, the zoom centers on the area defined by the rectangle.

Screen brightness

Press and hold ⊙ⁿ, and use **MSU** / **MSD** to alter screen brightness in Live View.

Notes:

This only affects screen brightness; it has no effect on the exposure level of images. To verify exposure, stop shooting and use playback review.

Because you hold the camera away from you when using Live View, there's an increased risk of camera shake, which can easily negate the benefits of precise focusing that Live View offers. High shutter speeds and VR lenses are helpful, but the inescapable conclusion is that Live View is often best on a tripod.

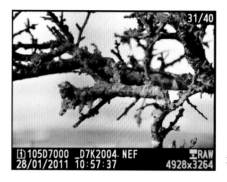

The D7000's large, bright, high-resolution LCD screen makes image playback a pleasure. The most recent image taken is displayed immediately whenever ▶ is pressed. If **On** is selected under **Image Review** in the Playback menu, images are displayed automatically after shooting. In CH or CL release modes, playback begins when the last image in a burst has been captured, and images are shown in sequence.

› Viewing additional pictures

To view images on the memory card, apart from the most recent, scroll through them using the Multi-selector. Scroll right to view images in the order of capture; scroll left to see them in reverse order.

› Viewing photo information

The D7000 records masses of information (metadata) about each image taken, which can also be viewed on playback. Use the Multi-selector to scroll up or down through up to nine pages of information *(see table opposite)*. To determine which of these options will be visible, use the Display mode item in the Playback menu. If the additional options are unchecked, just two pages will be available: a full-screen view and an overview page, which includes basic information and a simplified histogram.

Playback pages	Selection	Details
Overview data	Always available	Displays small image, simplified histogram, summary information. Focus point used can also be shown: select using **Playback menu>Display mode>Focus point.**
Full screen	Always available	Displays large image, basic file information shown at bottom of screen.
Highlights	Playback menu> Display mode> Highlights	See below.
RGB histogram	Playback menu> Display mode> RGB histogram	See below.
Shooting data (3 or 4 pages)	Playback menu> Display mode>Data	Pages 1–3 are always available. Page 4 only appears when copyright Information is recorded *(see page 112)*.
GPS data		Only appears when a GPS device was attached during shooting *(see page 243)*.

› Playback zoom

To assess sharpness, or for other critical viewing, you can zoom in on a section of an image. For RAW and JPEG Large images, the maximum magnification is approximately 27x.

Using Playback zoom

1) Press 🔍 to zoom in on the image displayed (or selected image in thumbnail view). Press again to increase magnification. A navigation window appears briefly, with a yellow outline indicating the area visible.

2) Use the Multi-selector to view other areas of the image, scrolling in any direction, including diagonally.

3) Rotate the Main command dial to view other images at the same magnification.

4) To return to full-frame view, press **OK**. Or exit playback by pressing ▶.

› Viewing images as thumbnails

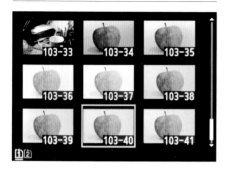

Q▣ repeatedly to display 72 images, press once more to reach the first calendar page, with the most recent date highlighted, and pictures from that date in a strip on the right (the thumbnail list). Use the Multi-selector to navigate to different dates. Press Q▣ again to enter the thumbnail list and scroll through pictures taken on the selected date. Press Q to see a larger preview of the currently selected image.

To view multiple images, press Q▣ repeatedly to display 4, 9, or 72 images. Use the Multi-selector to scroll up and down to bring other images into view. The currently selected image is outlined in yellow. To return to full-frame view, press **OK**.

› Calendar view

An extension of thumbnail view, Calendar view displays images grouped by the date on which they were taken. Having pressed

Tip

*If you press **OK** in either variant of Calendar view, you get a full-frame view, but pressing **OK** again takes you to the Retouch options screen. There seems to be no quick way back to Calendar view from this point (pressing ▶ followed by four presses on Q▣ appears to be the only way).*

› Deleting images

To delete the current image, or the selected image in thumbnail view, press 🗑. A confirmation dialog appears. To proceed with deletion, press 🗑 again; to cancel, press ▶.

› Protecting images

To protect the current image, or the selected image in thumbnail view, against accidental deletion, press [⌷⟳]. To remove protection, press [⌷⟳] again.

Warning!

Protected images will be deleted when the memory card is formatted.

› Histogram displays

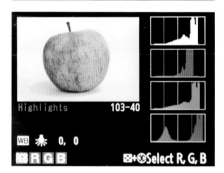

RGB HISTOGRAM DISPLAY ⏫
This histogram is biased to the right, showing a preponderance of light tones.

The histogram is a graphic depiction of the distribution of dark and light tones in an image. As a means of assessing whether images are correctly exposed, it's much more precise than simply examining the full-frame playback—especially in bright conditions, when it's difficult to see the screen image clearly. A single histogram is always available during playback, on the overview page. Checking **RGB histogram** under **Playback mode** in the Playback menu gives access to a detailed display showing individual histograms for the three color channels (red, green, blue). The histogram display is a core feature of image playback, and learning to read it is the key to obtaining optimum results from your D7000.

› Highlights display

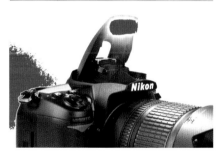

HIGHLIGHTS DISPLAY ⏫
This image is taken from Adobe Lightroom, and the highlights are shown in red; in the camera display, these areas would flash black, but this would not show up on a printed page.

The D7000 can display a flashing warning for areas of the image that have "clipped" highlights, i.e., completely white areas with no detail recorded *(see page 148)*. This is another quick and effective means of checking that an image is correctly exposed.

2 » IMAGE ENHANCEMENT

The D7000 offers a range of in-camera image adjustment and enhancement in two categories. First, there are settings that are applied before shooting, which affect how the camera processes the image. Second, changes can be made to existing images on the memory card; these don't alter the original, but create a retouched copy.

Don't be confused by Active D-Lighting (applied pre-shoot) and D-Lighting (applied post-shoot). D-Lighting and a number of other post-shoot controls are accessed from the Retouch menu *(see page 115)*.

› Pre-shoot controls

Many user-controlled settings affect the qualities of the final image, including exposure and white balance. The D7000 provides other methods of controlling the qualities of the final image, notably Nikon Picture Controls and Active D-Lighting.

> **Note:**
> Image enhancement settings are useful for improving the quality of JPEG images. When shooting RAW files, however, they have no effect on the basic raw data. Picture Control settings can be applied as presets to RAW files when they are opened using Nikon View NX2 or Nikon Capture NX2, but software from other manufacturers will not recognize them.

› Active D-Lighting

Active D-Lighting enhances the D7000's ability to capture detail in both highlights and shadows, in scenes with a wide range of brightness (dynamic range). In simple terms, it reduces the overall exposure to improve highlight capture, while mid-tones and shadows are boosted as the camera processes the image.

Setting Active D-Lighting

1) In the Shooting menu, select **Active D-Lighting.**

2) From the list of options, select **Off**, **Low**, **Normal**, **High**, **Extra high**, or **Auto** to determine the strength of the effect. Press **OK**.

CATHEDRAL QUARRY, LAKE DISTRICT, UK ⌃
With daylight beyond the pillar and deep shadows behind, contrast was very high: a shot ripe for Active D-Lighting.

› Using Nikon Picture Controls

Nikon Picture Controls allow you to determine how JPEG files will be processed by the camera, at least when shooting in **P**, **S**, **A**, or **M** modes. In Full Auto and Scene modes, the Picture Control is predetermined. In all modes, the current Picture Control is shown at the bottom of the Information Display.

The D7000 offers six Picture Controls: **Standard**, **Neutral**, **Vivid**, **Monochrome**, **Portrait**, and **Landscape**. Each has preset values for Sharpening, Contrast, and Brightness. For color images, there are also settings for Saturation and Hue; the **Monochrome** Picture Control has Filter effects and Toning instead.

It's possible to fine-tune the values of the various settings within each Picture Control. You can also create your own custom Picture Controls, while additional Picture Controls are available for download from Nikon web sites.

Neutral Picture Control

Vivid Picture Control

2

› Selecting Nikon Picture Controls

1) From the Shooting menu, select **Set Picture Control**.

2) Use the Multi-selector to highlight the required Picture Control and press **OK**. This Picture Control will apply to all images taken in **P**, **S**, **A**, or **M** modes until the setting is changed. Scene modes continue to apply their preset Picture Controls.

› Modifying Picture Controls

Both the preloaded Nikon Picture Controls and custom Picture Controls from other sources can be modified in-camera. Use **Quick Adjust** to achieve global changes, or make manual adjustments to specific parameters (Sharpening, Contrast, etc).

1) From the Shooting menu, select **Set Picture Control**.

2) Use the Multi-selector to highlight the required Picture Control and press ▶.

3) Scroll up or down with the Multi-selector to select Quick Adjust or one of the specific parameters. Use ▶ or ◀ to change the value as desired.

4) When all parameters are as required, press **OK**. The values will be retained until that Picture Control is modified, or you carry out a two-button reset *(see page 71)*.

› Creating Custom Picture Controls

You can create up to nine additional Picture Controls, either in-camera or by using the Picture Control Utility included with Nikon View NX2. Custom Picture Controls can also be shared with other Nikon DSLRs. For further details, see the Help menu in Picture Control Utility.

› Creating Custom Picture Controls in-camera

1) From the Shooting menu, select **Manage Picture Control**.

2) Select **Save/edit** and press ▶.

3) Use the Multi-selector to highlight an existing Picture Control and press ▶.

4) Modify the Picture Control as described previously. When all parameters are as required, press **OK**.

5) On the next screen, select a destination for the new Picture Control. By default, its name will be derived from the Picture Control on which it is based, plus a 2-digit number (e.g., VIVID-02), but you can apply a new name of up to 19 characters, using the Multi-selector to choose text.

6) Press **OK** to store the Picture Control. To exit this process at any time press **MENU**.

» USING THE D7000 MENUS

Although numerous, the options you can access through the camera's buttons and command dials are only the tip of the iceberg. By delving into its menus, you can customize almost every aspect of the D7000 to suit your needs exactly. There are six main menus:

• Playback
• Shooting
• Custom Settings
• Setup
• Retouch
• My Menu/Recent Settings.

There isn't a separate Help menu, but you can access help from within the other menus by pressing [O⌐]. Help information is available when a **?** icon appears in the bottom left corner of the monitor.

The Playback menu, underlined in blue, is used to control functions related to playback, including viewing, naming, and deleting images. The Shooting menu, underlined in green, is used to control shooting settings, such as ISO speed and white balance (also accessible via buttons and dials) as well as Picture Controls and Active D-Lighting. The Custom Settings menu, underlined in red, is where you can fine-tune and personalize many aspects of the camera's operation. The Setup menu, underlined in orange, is used for a range of other functions that you may need to

change less often, such as LCD brightness, and language and time settings. The Retouch menu, underlined in purple, is used to create modified copies of images already on the memory card. My menu/Recent Settings, underlined in gray, allows quick access to favorite or recently used items from other menus.

› Navigating the menus

1) To display the menu screen, press **MENU**.

2) Scroll up or down with the Multi-selector to highlight the different menus. To enter the desired menu, press ▶.

3) Scroll up or down with the Multi-selector to highlight the different menu items. To select a particular item, press ▶. In most cases, this will take you to another set of options.

4) Scroll up or down with the Multi-selector to choose the desired setting. To select, press ▶ or **OK**. In some cases, you may need to scroll up to **DONE** and then press **OK** to make any changes effective.

5) To return to the previous screen, press ◀ or **MENU**. To exit the menus completely without making any changes, depress the shutter-release button halfway.

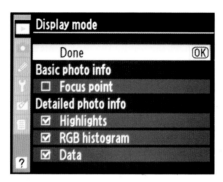

The D7000's Playback menu contains options that affect how images are viewed, stored, deleted, and printed. It is only accessible when a memory card is in the camera.

› Delete

Images stored on the memory card can be deleted, either singly or in batches.

1) In the Playback menu, highlight **Delete** and press ▶.

2) In the menu options screen, choose **Selected**, **Date**, or **ALL**.

> **Note:**
> Individual images can also be deleted from the normal playback screen, which is usually more convenient *(see page 80).*

3) If **Selected** is chosen, images in the active playback folder or folders are displayed as thumbnail images. Use the Multi-selector to scroll through the displayed images, pressing and holding ℚ to view a highlighted image full-screen. Press **OK** to mark the highlighted shot for deletion. It will be tagged with a 🗑 icon. If you change your mind, highlight a tagged image and press **OK** again to remove the tag.

4) Repeat steps 1–3 to select further images. To exit without deleting any images, press **MENU**.

5) Press **OK** to see a confirmation screen. Select **YES** and press **OK** to delete the selected image(s); to exit without deleting any images, select **NO**.

6) If Date is chosen, you'll see a list of dates on which images on the memory card were taken. Use the Multi-selector to scroll through the list. Press **OK** to mark a highlighted date for deletion. It will be checked in the list. Repeat to select further dates. If you change your mind, highlight the date and press **OK** again to remove the tag.

7) Press **OK** to see a confirmation screen. Select **YES** and press **OK** to delete the image(s) taken on the selected date(s); to exit without deleting images, select **NO**.

Playback folder options

D7000 (default)	Displays images in all folders created by the D7000
All	Displays images in all folders on the memory card
Current	Displays images in the current folder only.

› Playback folder

By default, the D7000's playback screen will only display images created on the D7000: if a memory card is inserted that contains images from a different model of camera (even another Nikon DSLR), they will not be visible. This can be changed in the Playback folder menu.

› Hide image

Hidden images are invisible in normal playback and are protected from deletion. They can only be viewed through this menu.

1) In the Playback menu, highlight **Hide image** and press ▶.

2) In the next screen, choose **Select/set**. Images in the active playback folder or folders are displayed as thumbnails.

3) Use the Multi-selector to scroll through the displayed images, pressing and holding ⊕ to view a highlighted image full-screen. Press **OK** to mark the highlighted shot for hiding. It will be

Note:
The current folder is chosen through the Shooting menu *(see pages 90–94)*.

tagged with a 🔲 icon. If you change your mind, highlight a tagged image and press **OK** again to remove the tag.

4) Repeat steps 1–3 to select further images. To exit without hiding any images, press **MENU**.

5) Press **OK**.

› Display mode

This is an important menu, since it enables you to choose the information about each image that will be displayed on playback.

› Copy image(s)

This menu item allows images recorded on one memory card to be copied to the other card, assuming both card slots are in use and there is space on the destination card. **Select source** determines the card from which images will be copied, the other card automatically becoming the destination. **Select image(s)** allows individual images or entire folders to be selected for copying. **Select destination folder** determines the folder on the destination card to be used (you can also create a new folder).

> ### Tip
>
> *Although it's worth backing up precious images, this is a slow way to do it. If you find yourself using this facility frequently, consider enabling automatic backup of all images as they are taken (see **Role played by card in Slot 2** in the Shooting menu).*

› Image review

If Image review is **ON**, images are automatically displayed on the monitor after shooting. If **OFF**, they are only displayed by pressing ▶.

› After delete

This menu determines what happens after an image is deleted (in normal playback, not via the Delete menu). **Show next** displays the next image in the order of shooting. **Show previous** displays the previous image in the order of shooting. **Continue as before** displays the next image as determined by the order in which you were viewing images before deleting: if you were scrolling back through the sequence, the previous image will be displayed, and vice versa.

› Rotate tall

This menu determines whether portrait format ("tall") images are displayed the "right way up" during playback. If set to **OFF** (the default), these images will not be rotated, and you will need to turn the camera through 90° to view them correctly. If set to **ON**, the images will be correctly oriented, but because the monitor screen is rectangular, they will appear smaller.

› Slide show

This menu enables you to display images as a slide show, either on the camera's screen or when it is connected to a TV. All images in the folder or folders selected for playback (under the Playback folder menu) will be displayed in chronological order.

1) In the Playback menu, select **Slide show**.

2) Select **Frame interval**. Choose between 2, 3, 5, or 10 seconds. Press **OK**.

3) Select **Start** and press **OK**.

4) When the show ends, a dialog screen is displayed. Select **Restart** and press **OK** to play again. Select Frame interval and press **OK** to return to the **Frame interval** dialog. Select **Exit** and press **OK** to exit.

5) If you press **OK** during the slide show, the sequence pauses and the same dialog screen is displayed. The only difference is that if you select **Restart** and press **OK**, the show will resume where it left off.

› Print set (DPOF)

This allows you to select image(s) to be printed when the camera is connected to, or the memory card is inserted into, a printer that complies with the DPOF (Digital Print Order Format) standard. For more on printing, *see pages 235-6*.

1) In the Playback menu, highlight **Print set (DPOF)** and press ▶.

2) In the next screen, choose **Select/set**. Images in the active playback folder or folders are displayed as thumbnails.

3) Use the Multi-selector to scroll through the displayed images, pressing

and holding ^Q to view a highlighted image full-screen.

4) Hold ⊖⊞ and press ▲ to select the image to be printed as a single copy. It will be tagged with a **PRINT** icon and the number 01. To print more than one copy, keep holding ⊖⊞ and press ▲ as many times as necessary; the number displayed increases accordingly. If you change your mind, highlight a tagged image and press **OK** again to remove the tag.

5) Repeat steps 1–3 to select further images. When all desired images have been selected, press **OK**.

6) From the confirmation screen, select **Data imprint** if you want shutter speed and aperture to be shown on all pictures printed. Select **Imprint date** if you want the date of the photo to be shown. When you're ready to confirm the order, select **DONE** and press **OK**.

> **Note:**
> Only JPEG images can be selected for printing by this method. If there are no JPEG images on the memory card, this menu item is unavailable.

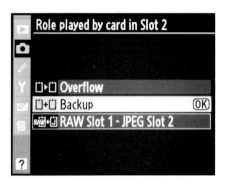

Role played by card in Slot 2

□▸□ Overflow
□+□ Backup OK
RAW Slot 1 - JPEG Slot 2

The Shooting menu contains numerous options, many also accessible through button and dial, and previously discussed; they will only be mentioned briefly here.

› Reset shooting menu

This is a quick way to restore Shooting menu settings to their original default settings. Use with caution, since it can wipe out settings that you have carefully created.

1) In the Shooting menu, select **Reset shooting menu** and press **OK**.

2) Select **YES** and press **OK**. Or select **NO** to make no changes.

› Active folder

By default, the D7000 stores images in a single folder (named 100D7000). If several memory cards are used, they will all end

up containing folders of the same name. This can be a problem if you are backing up directly from the camera to an external device rather than importing images through a computer. You might also want to create specific folders for different shoots or different types of image. For instance, a folder could be linked to a User settings shooting mode. On extended trips away from base, when you may be storing thousands of images on high-capacity memory cards, creating an ordered series of folders will be helpful.

You can't name these folders freely: only the first three digits can be changed, and only numbers can be used.

› Creating a new folder number

1) In the Shooting menu, select **Select folder by number** and press **OK** or ▶.

2) Press ◀ or ▶ to highlight a digit, ▲ or ▼ to change it. If the indicated number is not already in use, a new folder will be created.

3) Press **OK** to create the new folder and return to the Shooting menu. It automatically becomes the active folder.

› Changing the active folder

1) In the Shooting menu, select **Select folder from list** and press **OK** or ▶.

2) Select **Select folder** and press **OK** or ▶. To exit without making a change, press ◀ or **MENU**.

› File naming

By default, if a file uses sRGB color space, its name begins with DSC_; if it uses Adobe RGB color space, the name begins with _DSC. This is followed by a four-digit number and a three-letter extension (.JPG for JPEG files; .NEF for RAW files). You can edit the initial three-letter string, and I use it to indicate which camera was used: images taken on the D7000 are named D7K_4567.JPG, and so on.

› Editing the file naming string

1) In the Shooting menu, select **File naming** and press **OK** or ▶.

2) In the new screen, select **File naming** and press **OK** or ▶.

3) Edit the three-digit string, using the Multi-selector to navigate the "keyboard." To apply the highlighted character, press **OK**. To make corrections, move the cursor by holding

🔍📧 and pressing ◀ or ▶; press 🗑 to delete a character from the string.

4) Press **OK** to accept the new name, **MENU** to exit without applying the change.

› Role played by card in Slot 2

When memory cards are inserted in both slots, Slot 2 can be used in three different ways:

Overflow (the default setting) means that images will only be recorded to the secondary card when the primary card is full.

Backup ensures that each image is written to both cards simultaneously.

RAW Slot 1–JPEG Slot 2 is a little more complicated. If Image quality is set to **NEF (RAW)+JPEG**, the NEF version of each shot is recorded to the primary card and the JPEG version to the secondary. At other Image quality settings, this option replicates Backup.

› Image quality

Use to choose between NEF (RAW) and JPEG options *(see page 64–65)*.

› Image size

Use to select image size *(see page 66)*. If RAW is selected for Image quality, this item is grayed out and cannot be accessed.

› JPEG compression

Use to choose how JPEG images are compressed. **Size priority** compresses all images to a set size (for each of the quality options Fine, Normal, and Basic). **Optimal quality** allows image sizes to vary, accounting for better file quality.

› NEF (RAW) recording

This menu offers options that govern how NEF (RAW) files are recorded *(see also pages 64–65)*.

Type gives two options for NEF (RAW) file compression: **Lossless compressed** and **Compressed**. With the former, files are compressed by 20–40% with no detectable effect on image quality. With the latter, they are compressed by 40–55% with a very small effect on image quality.

NEF (RAW) bit depth allows you to select between 12-bit or 14-bit depth.

› White balance

This menu allows you to set the white balance *(see pages 66–69)*.

› Set Picture Control & Manage Picture Control

These menus govern the use of Nikon Picture Controls *(see pages 83–84)*.

› Auto distortion control

If **ON**, this automatically corrects for distortion, which may arise with certain lenses. Use only with Type G and D lenses *(see Chapter 7)*, excluding fisheye and PC lenses; it only affects JPEG images.

› Color space

This menu allows you to choose either sRGB or Adobe RGB color space *(see page 71)*.

› Active D-Lighting

This menu governs the use of Active D-Lighting *(see page 82)*.

› Long exp. NR

Photos taken at long shutter speeds can be subject to increased noise, but the D7000 has the option of extra image processing to counteract this. If Long exposure noise reduction is **ON**, it acts when exposure times of 8 sec. or more are employed. During processing, **Job nr** flashes in the viewfinder and Control Panel displays. The time taken is roughly equal to the shutter speed in use, and no further pictures can be taken until processing is complete. This causes significant delays in shooting, so many users prefer to use post-processing to reduce image noise. For this reason, Long exp. NR is **OFF** by default.

› High ISO NR

Photos taken at high ISO settings can also be subject to increased noise. Normally, High ISO NR comes into play at ISO settings of 800 and above, the default setting of **Normal** applying a middling amount of NR. This can be changed to **Low** or **High**. High ISO NR can also be set to **OFF**, but even then a modest amount of NR is applied to images taken at ISO 1600 or above.

› ISO sensitivity settings

See pages 70–71 for more information.

› Multiple exposure

Images can easily be combined on a computer, so it might seem that the D7000 has little need of a multiple-exposure facility. However, Nikon's manual states *"multiple exposures ... produce colors noticeably superior to those in software-generated photographic overlays."* It's debatable whether this would apply if you shot RAW images for post-processing before combining on the computer, but the feature does offer a way of combining images for immediate use, e.g., as JPEG files for printing.

Creating a multiple exposure

1) In the Shooting menu, select **Multiple exposure** and press ▶.

2) Select **Number of shots** and use ▲ ▼ to choose a number between 2 and 9, then press **OK**.

3) Select **Auto gain** and choose **ON** or **OFF** *(see Note)*, then press **OK**.

4) Select **DONE** and press **OK**.

5) Frame the photo and shoot normally. If the release mode is CL (Continuous Low-speed) or CH (Continuous High-speed), the designated number of images will be exposed in a single burst. In Single frame release mode, one image in the sequence will be exposed each time the shutter-release button is pressed. Normally the maximum interval between shots is 30 sec. This can be extended by setting a longer monitor-off delay in Custom setting c4.

Note:
Auto gain (**ON** by default) adjusts the exposure, so if you are shooting a sequence of three shots, each is exposed at ⅓ the exposure value required for a normal exposure. You might turn Auto gain **OFF** where a moving subject is well lit, but the background is dark, so that the subject is well exposed and the background isn't overlightened. Multiple exposure can also be combined with the camera's interval timer facility to take the exposures at set intervals.

2

› Movie settings

This menu sets key options for movie shooting *(see Chapter 6)*.

› Interval timer shooting

The D7000 has the facility to take a number of shots at predetermined intervals. If Multiple exposure is activated first, they will be combined into a single image; otherwise they will be recorded separately.

1) In the Shooting menu, highlight **Interval timer shooting** and press ▶ or **OK**.

2) Choose a start time. If **Now** is selected, shooting begins 3 sec. after you complete the other settings, and you can skip step 3. If **Start time** is selected, press ▶ to continue to the next step.

3) Use ◀ and ▶ to select hours or minutes. Use ▲ and ▼ to change these values to the desired time in the next 24 hours. Press ▶ to continue to the next step.

4) Choose the interval between shots. Use ◀ and ▶ to select hours, minutes,

Note:
If planning a large number of shots and/or long intervals, ensure that the battery is fully charged or the camera is connected to an AC adapter, and that there is sufficient space on the memory card. If the card becomes full during an Interval timer sequence, shooting stops until the card is replaced.

or seconds. Use ▲ and ▼ to change these values as desired. Press ▶ to continue.

5) Select the number of intervals (up to 999) and the number of shots to be taken at each interval (up to 9). The total number of shots that this amounts to is also displayed. Press ▶ to complete the setup and reach the primary Interval timer shooting screen.

6) Highlight **Start> On** and press **OK**.

› Remote control mode

This determines how the camera responds to the optional ML-L3 remote control unit when the Release mode dial is set to ▐.

Setting		Description
▐🕑	Delayed remote	Shutter fires about 2 sec. after remote is tripped.
▐	Quick response remote	Shutter fires immediately when remote is tripped.
	Remote mirror-up	Press remote once to raise the mirror; press it again to take the picture.

» THE CUSTOM SETTING MENU

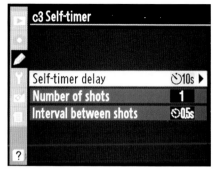

Note:
The custom setting identifier code (e.g., a4) is shown in the appropriate color for that group. If the setting has been changed from default values, an asterisk appears over the initial letter of the code.

The Custom Setting menu allows almost every aspect of the camera's operation to be fine-tuned to suit individual preferences. The menu is split into six main groups, identified by key letters and colors:

a: Autofocus (red)
b: Metering/Exposure (yellow)
c: Timers/AE Lock (green)
d: Shooting/display (light blue)
e: Bracketing/flash (dark blue)
f: Controls (lilac).

In addition, there is a **Reset custom settings** option, which restores all current custom settings to standard default values.

› Choosing Custom setting

1) Press **MENU**. If another menu appears first, press ◄ to highlight the icons in the left-hand column and scroll up or down to the Custom setting menu icon. Press ▶ to enter the Custom setting menu.

2) Use the Multi-selector to scroll up or down to the desired settings group. Press ▶ to display the group.

3) Use the Multi-selector to scroll up or down to the desired settings. Press ▶ to display options for that setting.

4) Highlight the desired option and press **OK** to select it.

a: Autofocus

Custom setting	a1	AF-C priority selection
Options		Release priority (default) Focus priority
Notes		Applies when the camera is in AF-C release mode *(see page 59)*.

Custom setting	a2	AF-S priority selection
Options		Focus priority (default) Release priority
Notes		Applies when the camera is in AF-S release mode *(see page 59)*.

Custom setting	a3	Focus tracking with lock-on
Options		5 (Long) 4 3 (Normal) (default) 2 1 (Short) Off
Notes		Governs how fast the camera reacts to sudden large changes in the distance to the subject. When Off, the camera reacts instantly to such changes, but can be fooled when other objects pass through the frame; longer delays reduce sensitivity to such intrusions.

Custom setting	a4	AF Point illumination
Options		Auto (default) On Off
Notes		Governs whether the active focus point is illuminated in red in the viewfinder.

Custom setting	a5	Focus point wrap-around
Options		Wrap No wrap (default)
Notes		Governs whether the active focus point wraps to the opposite edge of the available area.

Custom setting	a6	Number of focus points
Options		AF39 (default) AF11
Notes		Governs the number of focus points available in Single-area AF mode.

Custom setting	a7	Built-in AF-assist illuminator
Options		On (default) Off
Notes		Governs whether the AF-assist illuminator operates when lighting is poor *(see page 63)*.

Custom setting	a8	Live view/movie AF
Autofocus mode		AF-S AF-F
AF-area mode		Face-priority AF Wide area AF Normal area AF Subject tracking AF
Notes		*(see pages 73–77).*

Custom setting	b1	ISO sensitivity step value
Options		⅓ step (default) ½ step
Notes		Governs the increment used when changing ISO sensitivity value.

Custom setting	b2	EV steps for exposure cntrl
Options		⅓ step (default) ½ step
Notes		Governs the increment used by the camera for setting shutter speed and aperture, and also for bracketing.

Custom setting	b3	Easy exposure compensation
Options		On (Auto reset) On Off (default)
Notes		Governs how exposure compensation operates in **P**, **S**, and **A** modes. When Off, the exposure compensation button must be pressed and the Main command dial rotated. When On, exposure compensation can be applied simply by rotating the Sub-command dial (**P** & **S** modes) or Main command dial (**A** mode). Auto reset means the setting is not retained when the camera or meter turns off.

Custom setting	b4	Center-weighted area
Options		6mm 8mm (default) 10mm 13mm Average
Notes		Governs the size of the primary area when center-weighted metering is in use *(see page 54)*. Requires a CPU lens. Average means the camera meters evenly from the full screen area.

Custom setting	b5	Fine tune optimal exposure
Options		Yes No (default)
Notes		Allows for a sort of permanent exposure compensation, with separate settings for each of the three main metering methods. Usually the normal exposure compensation procedure is preferable, but this option could be useful for specific needs. You may, for example, prefer portraits to have a consistently lighter feel and could fine-tune the center-weighted setting for this purpose.

c: Timers/AE Lock

Custom setting	c1	Shutter-release button AE-L
Options		Yes No (default)
Notes		Governs whether exposure is locked by half-pressure on the shutter-release button. If Off, exposure can only be locked using the **AE-L/AF-L** button *(see page 63).*

Custom setting	c2	Auto meter-off delay
Options		4 sec. 6 sec. (default) 16 sec. 30 sec. 1 min. 5 min. 10 min. 30 min. No limit
Notes		Governs how long the exposure meter (and related displays in the viewfinder and Control Panel) remain active if no further operations are carried out. A shorter delay is good for battery economy. "No limit" applies when the D7000 is connected to an AC adapter.

2

Custom setting c3 Self-timer delay

Self-timer delay	2 sec.
	5 sec.
	10 sec. (default)
	20 sec.
Notes	Governs the delay in self-timer release mode. You can also select Number of shots (1–9) and Interval between shots (0.5, 1, 2, or 3 sec.) to create sequences from one press of the release button when in self-timer mode.

Custom setting c4 Monitor off delay

Options	Can be set individually for:	4 sec.
	Playback	10 sec.
	Menus	20 sec.
	Information display	1 min.
	Image review	5 min.
	Live view	10 min.
Notes	Governs how long the LCD monitor screen remains illuminated if no further operations are carried out. A shorter delay is good for battery economy. A 10-min. delay applies when the D7000 is connected to an AC adapter.	

Custom setting c5 Remote on Duration

Options	1 min. (default)
	5 min.
	10 min.
	15 min.
Notes	When using the optional ML-L3 remote control, this governs how long the camera will remain on standby for a signal from the remote before becoming inactive.

d: Shooting/display

Custom setting	d1	Beep
Volume		3
		2
		1
		Off (default)
Pitch		High (default)
		Low
Notes		Governs the volume and pitch of the optional beep that sounds when the self-timer operates, and to signify that focus has been acquired when shooting in single-servo AF mode.

Custom setting	d2	Viewfinder grid display
Options		Off (default)
		On
Notes		Displays grid lines in the viewfinder for assistance with precise framing.

Custom setting	d3	ISO display and adjustment
Options		Show ISO sensitivity
		Show ISO/Easy ISO
		Show frame count (default)
Notes		If Show **ISO sensitivity** is selected, the figure at bottom right of LCD screen and viewfinder displays shows the selected ISO. If **Show frame count** is selected, the figure shows the number of exposures remaining. For an explanation of Easy ISO, *see page 71.*

Custom setting	d4	Viewfinder warning display
Options		On (default)
		Off
Notes		Choose whether warnings are displayed in the viewfinder when the battery is approaching exhaustion, a monochrome Picture Control is in effect, or there is no memory card in the camera.

2

Custom setting	d5	Screen tips
Options		On (default) Off
Notes		Governs the availability of on-screen tips when items are selected in the shooting info display.

Custom setting	d6	CL mode shooting speed
Options		5 fps 4 fps 3 fps (default) 2 fps 1 fps Off
Notes		Governs the frame rate when using CL Continuous Low-speed release mode.

Custom setting	d7	Max continuous release
Options		Set with Multi-selector (range 1–100)
Notes		Governs the maximum number of shots that can be taken in a single burst when using either of the continuous release modes.

Custom setting	d8	File number sequence
Options		On (default) Off Reset
Notes		Controls the way file numbers are set. If On, when a new memory card is inserted, the card is formatted, or a new folder is created, numbering continues from the previous highest number used. If Off, file numbering is reset to 0001 in any of these conditions. Reset means that 1 is added to the largest number used in the current folder.

Custom setting	d9	Information display
Options	Auto (default)	
	Manual	Dark on light
		Light on dark

Notes	Governs the way shooting information is displayed on the monitor: display can be switched from light-on-dark to dark-on-light to suit lighting conditions; the camera does so automatically by default.

Custom setting	d10 LCD illumination
Options	On
	Off (default)

Notes	Governs illumination of the Control Panel. If On, the Control Panel will be illuminated when the exposure meter is active. If Off, the Control Panel is only illuminated when the power switch is moved to the ☀ position.

Custom setting	d11 Exposure delay mode
Options	On
	Off (default)

Notes	Can be used to create a shutter delay of approximately 1 sec. when the shutter-release button is pressed. A possible alternative to the self-timer or mirror lockup to reduce vibration when shooting on a tripod.

Custom setting	d12 Flash warning
Options	On
	Off (default)

Notes	In **P**, **S**, **A**, or **M** modes, determines whether the flash-ready symbol will blink in the viewfinder to indicate that flash may be required. (In other modes, flash either activates automatically or remains off.)

2

Custom setting	d13 MB-D11 battery type
Options	LR6 (AA alkaline) HR6 (AA Ni-MH) FR6 (AA lithium)
Notes	When the optional MB-D11 battery pack is attached and AA cells are inserted, set this to match the type of cells.

Custom setting	d14 Battery order
Options	Use MB-D11 batteries first (default) Use camera battery first
Notes	Governs order in which batteries are called on when the optional MB-D11 battery pack is attached.

e: Bracketing/flash

Custom setting	e1	Flash sync speed
Options		1/320 sec. (Auto FP) 1/250 sec. (Auto FP) 1/250 sec. (default) 1/200 sec. 1/160 sec. 1/125 sec. 1/100 sec. 1/80 sec. 1/60 sec.
Notes		Governs the flash sync speed *(see pages 164–5)*. The (auto FP) settings only apply when certain auxiliary Nikon flash units are attached, in which case flash sync is possible at any speed. If other flash units are attached, sync speed.

Custom setting	e2	Flash shutter speed

Options	From 1/60 sec. (default) to 30 sec. in increments equal to 1 Ev

Notes	Governs the slowest shutter speed that the camera can set when using **P** or **A** exposure modes. When using **M** or **S** exposure modes, any speed down to 30 sec. can be set.

Custom setting	e3	Flash cntrl for built-in flash

Options	TTL Manual (options from Full down to 1/128 power) Repeating flash (options for power, no. of flashes, and frequency) Commander mode

Notes	Governs how the built-in flash is regulated. TTL regulates flash output automatically. Manual allows it to be set manually. Repeating flash fires multiple flashes, giving a strobe-like effect. Commander mode uses the built-in flash as a trigger for remote flash units.

Custom setting	e4	Modeling flash

Options	On (default) Off

Notes	Applies when the built-in flash is active or a certain optional flash unit is attached. If On, a modeling flash is emitted when the depth of field preview button is depressed, giving some indication of the flash effect.

Custom setting	e5	Auto bracketing set

Options	AE & flash (default) AE only Flash only WB bracketing ADL bracketing

Notes	Determines which settings are bracketed when auto bracketing is activated. If flash is not active, AE & flash has the same effect as AE only.

2

Custom setting	e6	Bracketing order
Options		MTR> under> over (Default) Under> MTR> over
Notes		Determines the order in which auto bracketed exposures are taken: by default, the first exposure is taken at the metered exposure, while the alternative places it, perhaps more logically, in the middle of the sequence.

f: Controls

Custom setting	f1	☀ switch
Options		LCD Backlight (default) ☀ and information display
Notes		At the default setting, moving the power switch to the ☀ position illuminates the LCD control panel for about 6 sec. If **☀ and information display** is selected, operating this switch also activates the Information display on the rear screen.

Custom setting	f2	OK button (shooting mode)
Options (shooting mode)		Select center focus point (default) Highlight active focus point Not used
Notes		Governs which functions are activated when **OK** is pressed in shooting mode.

Custom setting f3 Assign Fn. button

Options		
Preview	Activates depth of field preview.	
FV lock (default)	Locks flash value (built-in and compatible flashguns only).	
AE/AF lock		
AE lock only		
AE lock (Reset on release)		
AE lock (Hold)	Exposure locks when Fn button is pressed and remains locked until button is pressed again.	
AF lock only		
Flash off		
Bracketing burst	Activates a bracketing burst at last used settings.	
Active D-Lighting	Use Fn button and Main command dial to select Active D-Lighting settings.	
+NEF (RAW)	When Image quality is JPEG, records a NEF copy of the next shot taken.	
Matrix metering		
Center-weighted metering		
Spot metering		
Framing grid	Use Fn button and Main command dial to show/hide framing grid in viewfinder.	
Viewfinder virtual horizon		
Access top item in My Menu		
1 step spd/aperture	If Fn button is pressed while command dials are rotated, changes to aperture/shutter speed are made in 1-Ev steps	
Choose non-CPU lens number	Use Fn button and either command dial to select among lenses specified using Non-CPU lens data.	
Playback	Fn button duplicates function of ▶ button.	
Start movie recording	Press Fn button in Live View to start movie recording.	

Notes A wide range of functions can be assigned to the Fn button, both on its own and in conjunction with the command dials. Some of these duplicate functions normally assigned to other buttons (e.g., Preview, normally assigned to the depth of field preview button).

2

Custom setting f4 Assign Preview button

The same wide range of functions can be assigned to the Preview button as to the Fn button. The only difference is that the default setting is Preview.

Custom setting f5 Assign AE-L/AF-L button

Options	AE/AF lock (default)
	AE lock only
	AF lock only
	AE lock (Hold)
	AF-ON
	FV lock

Custom setting f6 Customize command dials

Options	Reverse rotation
	Change main/sub
	Aperture setting
	Menus and playback
Notes	Normally, Main command dial sets shutter speed and Sub-command dial sets aperture: Change main/sub reverses these roles. Aperture setting governs whether the aperture ring (on lenses that have one) can be used to set apertures, or only the Sub-command dial. Menus and playback allows the command dials, as well as the Multi-selector, to be used to navigate images during playback.

Custom setting f7 Release button to use dial

Options	Yes
	No (default)
Notes	Normally, buttons such as **QUAL** , ⊡, and ⊞ must be kept pressed while the appropriate command dial is rotated to make changes. If this option is activated, changes can continue to be made after the button is released

Custom setting	f8	Slot empty release lock
Options		Release locked Enable release (default)
Notes		If **Enable release** is selected, the shutter can be released even if no memory card is present. Images are held in the camera's buffer and can be displayed on the monitor (demo mode), but are not recorded.

Custom setting	f9	Reverse indicators
Options		+ 0 - (default) - 0 +
Notes		Governs how the exposure displays in the viewfinder and Control Panel are shown, i.e., with overexposure to left or right.

Custom setting	f10	Assign MB-D11 AE-L/AF-L button
Options		AE/AF lock (default) AE lock only AF lock only AE lock (Hold) AF-ON FV lock Same as Fn button
Notes		A range of functions can be assigned to the **AE-L/AF-L** button on the optional MB-D11 battery pack. These need not duplicate the function assigned to the **AE-L/AF-L** button on the camera, but the options available are the same, with one addition: Same as Fn button, which gives the MB-D11 **AE-L/AF-L** button the same function as that selected for the Fn button (in Custom setting f3).

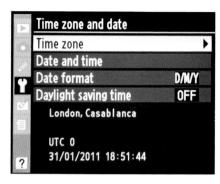

The Setup menu controls a variety of important functions, although you will need to access many of them only occasionally.

> **Format memory card**

The one item in this menu that many users will employ regularly, although the alternative two-button method of formatting may be more convenient.

1) In the Setup menu, select Format memory card and press **OK**.

2) Select Slot 1 or 2 and press **OK**.

3) Select Yes and press **OK**.

> **Save user settings/Reset user settings**

For details, see pages 52–53.

> **LCD brightness**

Alters the brightness of the LCD to suit ambient lighting conditions.

> **Clean image sensor/Lock mirror up for cleaning**

For details, see pages 246–7.

> **Video mode**

This is not directly related to the camera's movie mode. You can connect the camera to a TV or VCR to view images; this menu sets the camera to NTSC or PAL standards to match that device. NTSC is used in North America and Japan, PAL in most of the rest of the world.

> **HDMI**

You can also connect the camera to an HDMI (High Definition Multimedia Interface) TV with a special cable. This menu matches the camera's output to the HDMI device. The Device control submenu applies when connected to an HDMI-CEC television and allows the TV remote to be used to navigate through images.

> **Flicker reduction**

Some light sources can produce visible flicker in the Live View screen image and

in movie recording. To minimize this, Flicker reduction can be used to match the frequency of the local AC power supply— 60Hz is common in North America, while 50Hz is normal in the European Union, including the UK.

› Time zone and date

Sets date, time, and time zone, and specifies the date display format (Y/M/D, M/D/Y, or D/M/Y). First select the time zone in which you normally operate, then set the time correctly. If you travel to a different time zone, change the time zone setting; the time will be corrected automatically.

› Language

Sets the language used in the camera menus. The options include most major European languages, Arabic, Indonesian, Chinese, Japanese, Korean, and Thai.

› Image comment

This allows comments to be appended to images. Comments appear in the third page of the photo info display, and can be viewed in Nikon View NX2 and Nikon Capture NX2. To attach a comment, select **Input comment** and press ▶. Use the Multi-selector to input text. When you are finished, press ⊕. Select **Attach comment**, then select **DONE** and press

OK. The comment will be attached to all new shots until turned off again.

› Auto image rotation

If set to **ON** (default), information about the orientation of the camera is recorded with every photo taken, ensuring that images appear right way up on playback, and when viewed with Nikon software and most third-party imaging applications.

› Image Dust off ref photo

Nikon Capture NX2 removes dust spots on images automatically by reference to a photo that maps dust on the sensor. If there are stubborn dust spots that resist normal sensor cleaning, this can save a lot of work on the computer. The option **Clean sensor and then start** should not be used if the pictures from which spots are to be removed have already been taken.

1) To take a dust off reference photo, fit a lens of at least 50mm focal length. With a zoom lens, use the longest setting. Locate a bright, featureless white object such as a sheet of paper, large enough to fill the frame.

2) In the Setup menu, select **Dust off ref photo** and press **OK**. Select **Start** or **Clean sensor and then start** and press **OK**.

3) When the camera is ready to shoot the reference photo, **rEF** appears in the viewfinder and Control Panel.

4) Frame the white object at a distance of about 4in (10cm). Press the shutter-release button halfway; focus will automatically be set at infinity (or set Manual focus to infinity). Depress the button fully. If the reference object is too bright or dark, a warning will be displayed: change exposure settings or choose another reference object and reshoot.

› Battery info

This menu displays information about battery status, including percentage of charge remaining and how many shots have been taken since the battery was last charged. The information may change if an optional battery pack is fitted.

› Wireless transmitter

Normally grayed-out and inaccessible, this menu is only used if the camera is connected to a wireless transmitter *(see page 229)*.

› Copyright Information

Copyright is an important protection against the theft or misappropriation of your work. This menu allows copyright information to be embedded into file data,

using the standard method of text input. There are fields for **Artist** (i.e., photographer) and **Copyright holder**, although they are usually one and the same, since in many countries copyright automatically belongs to the person creating the image. There is an exception for photographers shooting in the course of their employment (not freelances under contract), when copyright belongs to the employer. To attach this information to all subsequent photos, select **Attach copyright information**, then scroll to **DONE** and press **OK**.

Employ this facility with caution if more than one person may use the camera.

› Save/load settings

This item allows you to save many camera settings to a memory card in Slot 1. Unlike **Save user settings**, the list includes various Playback and Setup menu options, but does not include shooting settings like exposure mode or ISO. If a card containing this settings file is inserted later, the saved settings can be restored. This is useful if two or more photographers share the camera, but require different settings, or when the camera is sent away for servicing. It can also be used to transfer settings to another D7000, but not to other models. The settings file is named NCSETUP7, and the procedure will fail if the file name is changed. The table opposite gives the settings that can be saved.

Menu	
Playback	Display mode
	Image review
	After delete
	Rotate tall
Shooting menu	File naming
	Role played by card in Slot 2
	Image quality
	Image size
	JPEG compression
	NEF (RAW) recording
	White balance
	Set Picture Control
	Auto distortion control
	Color space
	Active D-Lighting
	Long exp. NR
	High ISO NR
	ISO sensitivity settings
	Movie settings
	Remote control mode
Custom settings	All custom settings (except Reset custom settings)
Setup menu	Clean image sensor (auto settings)
	Video mode
	HDMI
	Flicker reduction
	Time zone and date display format (does not actually reset the time and date)
	Language
	Image comment
	Auto image rotation
	Copyright information
	GPS
	Non-CPU lens data
My menu/Recent settings	All My menu items
	All recent settings
	Choose tab

› GPS

Used to set up a connection between the D7000 and a compatible GPS device *(see page 243)*.

› Virtual horizon

Displays a horizon indicator on the monitor to assist in leveling the camera.

› Non-CPU lens data

Many older Nikon lenses, often ruggedly built and optically superb, can be fitted to the D7000. When lenses lack a built-in CPU, little information is available to the camera and shooting options are drastically reduced, but important functions can be restored by using this menu to specify the focal length and maximum aperture of a given lens. If several non-CPU lenses are available, this data can be specified for each of them and each can be assigned a number, which saves having to input the details manually every time. Data can be stored for up to nine such lenses.

› AF fine tune

With this menu, allowance can be made for slight variations in autofocus performance between different lenses (back-focus or front-focus). Note that this applies to CPU lenses only, but the camera can store details for up to 12 lenses. Subsequently, it will recognize these lenses automatically. This feature should be used with care, and only when you are certain that back-focus or front-focus exists. It is **OFF** by default.

› Eye-Fi upload

This menu option will only be visible if an Eye-Fi card is inserted *(see page 239)*. It allows you to **Enable** (default) or **Disable** automatic upload of photos over a WiFi network.

› Firmware version

Displays the firmware version currently installed in the camera. Updates are issued periodically and can be downloaded from the Nikon web site.

» THE RETOUCH MENU

The Retouch Menu is used to make a variety of corrections and enhancements to images, including cropping and color balance. This does not affect the original image, but creates a copy to which the changes are applied. Additional retouch options can be applied to the copy, with some limitations: for example, you can't normally apply any given effect more than once. Copies are always created in JPEG format, but the size and quality depends on the format of the original.

Format of original photo	Quality and size of copy
NEF (RAW)	JPEG (Fine, Large)
JPEG	JPEG (Quality and size match original)

› Creating a retouched image

There are two ways to access the retouch options and create a copy. They follow the same basic steps, but in a different sequence.

From the Image playback screen
1) Display the image you wish to retouch.

2) Press **OK**. The Retouch menu appears, overlaying the image.

3) Select the desired retouch option and press ▶. If subsidiary options appear, make a further selection and press ▶ again. A preview of the retouched image appears.

4) Depending on the type of retouching to be done (see later), further options may be available.

5) Press **OK** to create a retouched copy. The access lamp blinks as the copy is created. Press ◀ to return to the options screen, or ▶ to exit without creating the copy.

From the Retouch menu
1) In the Retouch menu, select the desired retouch option and press ▶. If subsidiary options appear, make a further selection and press ▶ again. A screen of image thumbnails appears.

2

2) Select the required image using the Multi-selector. Press **OK**. A preview of the retouched image appears.

3) Depending on the type of retouching to be done (see later), further options may be available.

4) Press **OK** to create a retouched copy. The access lamp blinks as the copy is created. Press ◀ to return to the options screen, or ▶ to exit without creating the copy.

› D-Lighting

This should not be confused with Active D-Lighting, which is applied before shooting; D-Lighting is applied later. In essence, it lightens the shadow areas of the image. The D-Lighting screen shows a side-by-side comparison of the original image and the retouched copy; to zoom in on the copy, press 🔍 Use ▲ and ▼ to select the strength of the effect: **High**, **Medium**, or **Low**.

› Red-eye correction

This tackles the problem of "red-eye" caused by the camera's built-in flash. The camera analyzes the photo for evidence of red-eye. If it detects this, a preview image appears; you can use the zoom controls and Multi-selector to view it more closely.

› Trim

This option allows you to crop an image to eliminate unwanted areas or to fit a

Aspect ratio	Possible sizes for trimmed copy							
3:2	4480 x 2984	3840 x 2560	3200 x 2128	2560 x 1704	1920 x 1280	1280 x 856	960 x 640	640 x 424
4:3	3840 x 2880	3200 x 2400	2560 x 1920	1920 x 1440	1280 x 960	960 x 720	640 x 480	
5:4	3600 x 2880	2992 x 2400	2400 x 1920	1808 x 1440	1200 x 960	896 x 720	608 x 480	
1:1	2880 x 2880	2400 x 2400	1920 x 1920	1440 x 1440	960 x 960	720 x 720	480 x 480	
16:9	4480 x 2520	3840 x 2160	3200 x 1800	2560 x 1440	1920 x 1080	1280 x 720	960 x 536	640 x 360

specific print size. When this option is selected, a preview screen appears, with the crop area shown by a yellow rectangle. Change the aspect ratio of the crop by rotating the Main command dial, choosing from 3:2 (same as the original image), 4:3, 5:4, 1:1 (square), and 16:9. Adjust the size of the cropped area using ⊖▩ and ⊕. Adjust its position with the Multi-selector.

› Monochrome

MONOTONES ⌃
Comparison of Cyanotype *(left)* and Sepia *(right)*.

This Retouch menu option creates a monochrome copy. You can choose from straight **Black-and-white**, **Sepia** (a brown

toned effect with an antique feel), and **Cyanotype** (a blue toned effect). If you select Sepia or Cyanotype, a preview screen appears, allowing you to make the toning effect stronger or weaker with ◄ and ▲.

› Filter effects

This option mimics several common photographic filters. **Skylight** reduces the blue cast that can affect photos taken on clear days with a lot of blue sky. Applied to other images, its effect is very subtle, even undetectable. **Warm filter** has a stronger warming effect, akin to an 81B or 81C filter. **Red intensifier**, **green intensifier**, and **blue intensifier** are all self-explanatory, but **Cross screen** is not. This creates a "starburst" effect around light sources and other bright points (like sparkling highlights on water). There are multiple options within Cross Screen, as shown in the table below.

Filter option heading	Options available
Number of points	Create 4-, 6-, or 8-pointed star
Filter amount	Choose brightness of light sources that are affected
Filter angle	Choose angle of the star points
Length of points	Choose length of the star points
Confirm	See a preview of the effect; press ⊕ to see it full-screen
Save	Create a copy incorporating the effect

› Color balance

This creates a copy with adjusted color balance. When this option is selected, a preview screen appears, allowing the Multi-selector to be used to move around a color grid. The effect is shown in both the preview and adjacent histograms; you can zoom in on the preview to examine the effect close-up.

› Image overlay

Similar to double exposure, but applied after shooting, this combines two existing photos to create a new JPEG image. Image overlay can only be applied to originals in NEF (RAW) format, but Nikon claims that the results are better than combining the images in applications like Photoshop because it makes direct use of the raw data from the camera's sensor.

1) To create an overlaid image, select **Image overlay** in the Retouch menu and press **OK**. The next screen has sections

> **Note:**
> Although Image overlay works from RAW images, the size and quality of the new image are not set automatically to Fine, Large. Before employing Image overlay, make sure the Image Quality and Image Size options are as required.

labeled **Image 1**, **Image 2**, and **Preview**. Initially, **Image 1** is highlighted. Press **OK**.

2) The camera displays thumbnails of RAW images on the memory card. Select the first image required for the overlay and press **OK**. Press ▶ to move to Image 2 and select the second image.

3) Use the Gain control below Image 1 and Image 2 to determine the "weight" each image will have in the final overlay. Use ▲ and ▼ to adjust gain from a default value of X1.0.

4) Use ◀ and ▶ to move between Image 1 and Image 2. Press **OK** to change the selected image.

5) Press ▶ to highlight **Preview**. Press **OK** to preview the overlay. If satisfied, press **OK** again to save the overlay. Return to the previous stage by pressing ⊕▣, or skip the preview stage altogether by highlighting **Save** and pressing **OK**.

› NEF (RAW) Processing

This creates JPEG copies from images originally shot as RAW files. While no substitute for full RAW processing on computer it allows the creation of quick copies for immediate sharing or printing. Options available for the processing of RAW images are displayed in a column to the right of the preview image *(see table, above right)* and allow considerable

Option	Description
Image quality	Choose Fine, Normal, or Basic.
Image size	Choose Large, Medium, or Small.
White balance	Choose a white balance setting.
Exposure comp.	Adjust exposure (brightness) levels from +3 to -3.
Set Picture Control	Choose any of the range of Nikon Picture Controls to be applied to the image.
High ISO NR	Choose level of noise reduction where appropriate.
Color space	Choose color space.
D-Lighting	Choose D-Lighting level—High, Normal, Low, or Off.

control over output. When satisfied with the previewed image, select **EXE** and press **OK** to create the JPEG copy. Pressing **MENU** exits without creating a copy.

› Resize

This option creates a small copy of the selected picture(s), suitable for immediate use with various external devices. When two memory cards are present, you can choose a destination for the copy. Five possible sizes are available:

Resize can be accessed from the Retouch Menu or from Image playback, but there are slight differences in the procedure. From the Retouch Menu, choose a picture size first and then select the picture(s) to be copied at that size. From Image Playback, select a picture first and then choose the copy size; this way, you can only copy one picture at a time.

Option	Size (pixels)	Possible uses
2.5M	1920 x 1280	Display on HD TV and larger computer monitor
1.1M	1280 x 856	Display on typical computer monitor or iPad
0.6M	960 x 640	Display on standard (non-HD) television
0.3M	640 x 424	Display on mobile devices like iPhone
0.1M	320 x 216	Display on standard cell phone

› Quick retouch

Provides basic one-step retouching for a quick fix, boosting saturation and contrast. D-Lighting is applied automatically to retain shadow detail. Use ▲ and ▼ to increase or reduce the strength of the effect, then press **OK** to create the retouched copy.

› Straighten

It's best to get horizons level at the time of shooting, but that doesn't always happen. This option allows correction by up to 5° in steps of 0.25°. Use ▶ to rotate clockwise, ◀ to rotate counterclockwise. Inevitably, this crops the image slightly. Press **OK** to create the retouched copy, or ▶ to exit without creating a copy.

› Distortion control

Some lenses create noticeable curvature of straight lines *(see page 145)*. This menu allows you to correct the effect in-camera. Inevitably, it crops the image slightly. **Auto** allows automatic compensation for the known characteristics of Type G and D Nikkor lenses; it can't be used on images taken with other lenses. **Manual** can be applied whatever lens was used: use ▶ to reduce barrel distortion, ◀ to reduce pincushion distortion. The Multi-selector can also be used for fine-tuning after **Auto** control is applied.

› Fisheye

This applies exaggerated barrel distortion to give a fisheye lens effect. Use ▶ to strengthen the effect, ◀ to reduce it.

› Color outline

This detects edges in the photograph and uses them to create a "line-drawing" effect.

› Color sketch

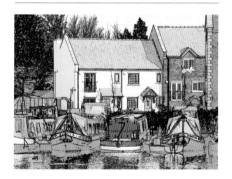

COLOR SKETCH ⌄
Create a "drawing" with Color sketch (for original image, *see page 67*).

This retouch effect turns a photo into an image that resembles a colored pencil drawing. Vividness and Outlines controls are used to adjust the strength of the effect.

› Perspective control

Corrects the convergence of vertical lines in photos taken looking up, for example, at tall buildings. Grid lines aid in assessing the effect, and the strength of the effect is controlled with the Multi-selector. Inevitably, the process crops the original image, so it's vital to leave space around the subject.

› Miniature effect

This mimics the technique of shooting images with extremely small and localized depth of field, making real landscapes or city views look like miniature models. It usually works best with photos taken from a high viewpoint, which typically have clearer separation of foreground and background. A yellow rectangle shows the area that will remain in sharp focus, which can be repositioned using the Multi-selector. Press ⊕ to preview the results, and **OK** to save a retouched copy.

› Edit movie

This option has a rather inflated title: it allows you to trim the start and/or end of a movie clip, and that's it. It's a very long way from proper editing.

1) Select a movie clip in full-frame playback (do not play the movie).

2 Press **OK**, select **Edit Movie**, and press ▶.

3) Select Choose start point or Choose end point, and press **OK**.

4) Press **OK** to start playing the movie. Press ▼ to pause, ▶◀ to advance or rewind, ▲ to set the start/end point.

5) Repeat if necessary to trim the other end of the clip.

6) Select **Yes** and press **OK** to save the trimmed clip as a copy. (The original is retained.)

› Side-by-side comparison

This option is only available in full-frame playback, when a retouched copy, or its source image, is selected. It displays the copy alongside the original source image. Highlight either image with ◀ or ▶, pressing ⊕ to view it full frame. Press ▶ to return to normal playback, or **OK** to return to the playback screen with the highlighted image selected.

My menu is a convenient way to speed up access to menu items and settings that you use frequently. Items from any other menu can be added to My menu to create a handy shortlist of up to 20 items.

Alternatively, you can activate the Recent settings menu, which stores the 20 most recent settings made using the other menus.

› Adding items to My menu

1) In My menu, highlight **Add items** and press ▶. A list of the other available menus appears.

2) Select the appropriate menu and press ▶.

3) Select the desired menu item and press **OK**.

4) The My menu screen reappears with

the newly added item at the top. Use ▼ to move it lower down the list if desired. Press **OK** to confirm the new order of the list.

› Removing items from My menu

1) In My menu, highlight **Remove items** and press ▶.

2) Highlight any listed item and press ▶ to select it for deletion. A check mark appears beside the item.

3) If more than one item is to be deleted, use ▲ ▼ to select additional items in the same way.

4) Highlight **DONE** and press **OK**. A confirmation dialog appears. To confirm the deletion(s), press **OK** again. To exit without deleting anything, press **MENU**.

> **Tip**
>
> *To delete an item highlighted in My menu, press* 🗑. *A confirmation dialog appears. To confirm the deletion, press* 🗑 *again.*

› Rearranging items in My menu

1) In My menu, highlight **Rank items** and press ▶.

2) Highlight any item and press **OK**.

3) Use ▲ or ▼ to move the item up or down: a yellow line shows its new position. Press **OK** to confirm the new position of the item.

4) Repeat steps 2 and 3 to move additional items. When finished, press **MENU** to exit.

> **Note:**
> Recent Settings only stores items from the menus. It does not record changes made using buttons and dials. For instance, if you change Image quality using the Shooting menu, this will be recorded, but if you use ❊ and the Main command dial, this will not appear in Recent settings.

› Recent settings

Note that items are not recorded automatically in Recent settings: first you must activate the option as described.

1) In My menu, select **Choose tab** and press ▶.

2 Select **Recent settings** and press **OK**.

The name of the menu changes to Recent settings. When activated, Recent settings records any changes to settings made using the other menus. Select any item from the list and press ▶ to access the range of options for that setting. To revert to My menu, use the **Choose tab** procedure again.

› Removing items from Recent settings

It is possible to delete items from the list, which may be useful, for example, if you've recently made extensive use of the Retouch menu. By deleting the Retouch options from the Recent settings list, you will move shooting settings—which are usually more useful—back to the top of the list.

1) Highlight any item in the list and press 🗑 to select it for deletion. A confirmation dialog appears.

2) To complete the deletion(s), press 🗑 again. To exit without deleting anything, press **MENU**.

> **Note:**
> If you start with a full Recent settings menu (20 items), deleting items simply makes the list shorter; the camera does not recall older items.

» DEPTH OF FIELD *127–129*

» RECORDING MOTION *130–132*

» COMPOSITION *133*

» PRINCIPLES OF FRAMING *134–136*

» LIGHTING *137*

» CONTRAST AND DYNAMIC RANGE *138–139*

» DIRECTION OF LIGHT *140–141*

» COLOR *142–143*

» IMAGE PROPERTIES *144–149*

» BEYOND THE SPONTANEOUS *150*

» UNUSUAL LIGHT SOURCES *151*

» AVAILABLE LIGHT *152*

» AFTER DARK *153*

» FIGURE IN THE LANDSCAPE *154*

» PUSHING THE LIMITS *155*

Chapter 3
IN THE FIELD

3 IN THE FIELD

Cameras like the D7000 are so capable that getting focusing and exposure right is rarely a major worry. However, there's a big difference between photos that "come out" and those that turn out exactly the way you want them. Possessing a great camera like the D7000 does not guarantee stunning shots every time. Photography still offers ample scope for individual expression, vision, and skill.

Although in-depth technical knowledge may no longer be essential to obtain correctly exposed, in-focus images, understanding essential photographic principles will help you make the most of a powerful tool like the D7000.

However, technical mastery is wasted without vision. With any camera, knowing what you want to express with any photo is vital. The clearer your ideas on what you want the photo to show and how you want it to look, the better. If you know why you're taking the shot and what you want it to show (and, equally important, what you want to leave out), then the how part should flow much more naturally.

Of course, the how part is the main concern of this book. Vision is a personal thing, but it's more easily realized if you understand how light works, and how lenses and digital images behave.

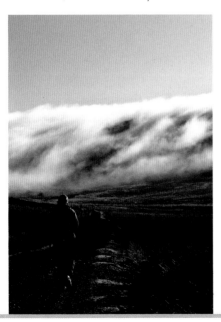

CAPTURE THE MOMENT **《**
Exposure, framing, and light all play their part, but there's still no substitute for being in the right place at the right time. This view of Black Clough, the Forest of Bowland in Lancashire, UK, was a combination of numerous elements.

» DEPTH OF FIELD

No camera will always see what the eye sees. Nothing illustrates this better than depth of field. In simple terms, depth of field means what's in focus and what isn't. A more precise definition is that depth of field is the zone—extending both before and behind the point of focus—in which objects appear to be sharp.

The eye scans the world dynamically: whatever we look at, near or far, appears in focus (assuming you have good eyesight, with suitable glasses or contact lenses). This gives us a sense that everything is in focus, which photographs frequently fail to match.

In landscape photography, for example, it is traditional to emulate this all-in-focus view of the world by maximizing depth of

POINTS OF FOCUS ⌃
Three otherwise identical shots, focused on the nearest sign, taken at f/2.8, f/8, and f/22, showing the effect on depth of field.

3

field. However, we can take a different approach—creative intent or simple necessity may prompt us to take photos with much narrower depth of field.

Three main factors determine depth of field: the focal length of the lens, the aperture, and the distance to the subject. Because focal length and subject distance are often determined by other factors, aperture is key. The simple rule is small aperture = big depth of field, and vice versa. Remember that aperture numbers are really fractions, so f/16 is small and f/4 is large.

Long lenses (telephotos) produce less depth of field than wide-angles. To increase depth of field, then, you would naturally think of fitting a wide-angle lens. However, real shooting situations are more complex. For example, suppose your main subject is a tree. To ensure that every branch and twig is sharp, you need good depth of field, so you might fit a wide-angle lens, but then you would have to move in closer to keep the tree the same size in the frame—and moving closer reduces depth of field, losing at least some of the benefits of changing the lens. Moving closer also changes perspective and the apparent shape of the tree.

For many shots, changing the lens may not be an option anyway. When photographing a broad landscape, for instance, you may be limited to a single viewpoint.

Depth of field preview

When you look through the D7000's viewfinder, the lens is set at its widest aperture; if a smaller aperture is selected, it will stop down at the moment the picture is actually taken. This means that the viewfinder image frequently has less depth of field than the final picture. The D7000 has a depth of field preview button *(see page 12)*; pressing this stops the lens down to the selected aperture, giving a sense of the depth of field in the final image. Unfortunately, this also darkens the viewfinder image, but it's usually still possible to assess the sharpness of clear edges (e.g., trees against the sky). If time allows, check images on the monitor after shooting, perhaps using the zoom function for a better look.

Hyperfocal distance

When you really need an image to be sharp from front to back, remember that depth of field extends both in front of and behind the point of exact focus. If you focus at infinity, there's nothing beyond that, so in effect you are wasting half your depth of field. In fact, depth of field extends farther behind the point of focus than in front of it. To exploit this, you'll frequently see advice to "focus one third of the way into the picture," although this doesn't really make sense: what's one third of the distance from here to infinity?

What this advice is hinting at is focusing

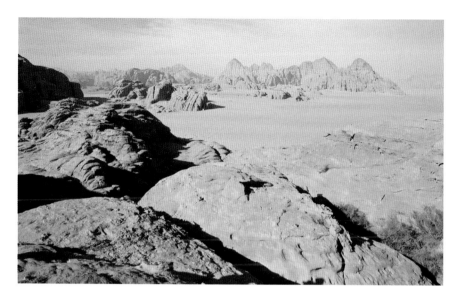

at the hyperfocal distance, the point—for any given aperture—at which depth of field extends to infinity. A rough way of finding the hyperfocal point for any combination of lens and aperture begins by focusing on infinity. Use the depth of field preview and find the nearest objects that appear sharp: they are at the hyperfocal point. Refocus at this distance for maximum depth of field.

Apparent sharpness

The definition of depth of field referred to objects appearing to be sharp. Things may appear perfectly sharp in a small print or on a web image, yet look distinctly fuzzy when the image is enlarged. This shows that depth of field is relative, not absolute. It's easy to forget this, and become

WADI RUM ⌃
I wanted every part of the scene to be sharp, and focusing at the hyperfocal distance helped make it so.

obsessed with using the smallest apertures and determining the hyperfocal distance. Often this is overkill, unless you are planning to make big prints or submit your images for magazine reproduction. The depth of field preview is usually an adequate guide for images that will be printed small or only viewed on-screen. For various reasons, images shot with the D7000, or any DX-format camera, will have greater depth of field than comparable images shot with a 35mm camera. This gain is only partly offset by the extra enlargement needed in printing.

3 » RECORDING MOTION

Motion is another area where the camera doesn't see what the eye sees. After all, we see movement, but the camera produces still images. There are very effective ways of conveying movement in a still photograph, however, often revealing drama and grace that may be missed by the naked eye or in a movie.

Freezing the action

A fast shutter speed freezes the action very effectively, but means we need other clues, such as body language and angle, to give a sense of speed. Dynamic posture and straining muscles shout "movement," even

in a figure frozen by a fast shutter speed. Pin-sharp definition of muscles or facial expression can enhance the feeling of dynamism. But what is a fast shutter speed? Do you need to use the D7000's maximum 1/8000 sec. every time?

The answer to the second question is definitely "No," but the first is harder to determine. The exact shutter speed needed to capture a sharp, frozen image depends on various factors: not just the speed of the subject, but its size and distance. What matters is the scale of movement in relation to the image frame. It can be easier to obtain a sharp image of a train traveling at 180mph (300km/h) than of a cyclist doing 18mph (30km/h), because you need to be so much closer to the latter. The direction of movement is another factor: subjects traveling across the frame need faster shutter speeds than those moving toward or away from the camera.

There's no "right" shutter speed, but you can play safe by setting the fastest shutter speed that's feasible under prevailing light conditions, as the D7000's Sports mode does. When you want more control, Shutter Priority is the obvious choice.

PIN SHARP ACTION �When〉
Everything in this shot, taken at the Tour Series Race, Blackpool, UK, is pin-sharp, but there's plenty of dynamism in the angle and body language.

PANNING THE ACTION ⌃
An ideal situation for a panning shot: regular movement across the field of view. The high viewpoint adds a different emphasis.

Check images on the monitor if you have time, and if a faster shutter speed appears necessary, be prepared to increase the ISO setting *(see page 71)*. If you regularly shoot a particular activity, you'll soon discover what works for those particular needs.

Panning

When subjects move across the field of view, panning is an excellent way to convey a sense of movement. By following the subject with the camera, it is recorded crisply while the background becomes blurred. The effect varies, so experimentation is advisable, preferably well before a critical shoot. Relatively slow shutter speeds are usually employed: anything from 1/8 to 1/125 sec. can work, although you can go beyond this range. Sports mode is not suitable; Shutter Priority or Manual are the only logical choices.

Panning is usually easiest with a standard or short telephoto lens, but the choice may be out of your hands if the shooting distance

is fixed (e.g., behind barriers at sports events). To maintain a smooth panning movement during the exposure, follow through after pressing the shutter-release button.

Blur

Another way to imply movement is with blur. This may be unavoidable if you can't set a sufficiently fast shutter speed, or it may be a creative choice, like the silky effect achieved by shooting waterfalls at exposures measured in whole seconds or even minutes. Again, finding the right shutter

3

speed for a specific motion is a matter of experiment. To ensure that only the moving elements are blurred, secure the camera on a tripod or other solid support. For a more impressionistic effect, try handholding. Again, Shutter Priority is the obvious choice.

Camera shake

Sometimes when shooting action, you'll move the camera intentionally; panning is the commonest example. Unintentional movement is another story. Camera shake can produce anything from a slight loss of sharpness to a hopeless mess. Careful handling or the use of a camera support *(see pages 230–1)* will help alleviate it, and Nikon also makes several Vibration Reduction (VR) lenses *(see Chapter 7)*.

DISCREET FLASH ☆
A discreet amount of fill-in flash sharpens the figure, while the background remains blurred.

FREEZING THE WATER ☆
A slow shutter speed smooths the movement of the water at Launchy Gill, Lake District, UK.

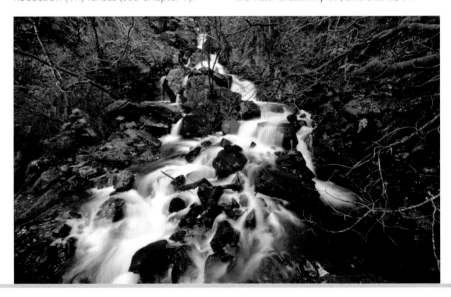

» COMPOSITION

Composition is an innocuous word for something that causes endless frustration and confusion. In its widest sense, it is the reason why some photos can be perfectly exposed and focused, yet have no emotional or aesthetic impact, while others may be technically flawed, yet heartstopping.

Every time you take a picture, you make decisions (consciously or unconsciously) about where to shoot from, where to aim the camera, how wide a view you want, what to include, and what to leave out. These are the essence of composition. I try to avoid using the term "composition"—

"framing" is a much better word that relates far more closely to what photographers actually do. Jettisoning the word "composition" also liberates us from its associated baggage, particularly "rules" of composition, like the Rule of Thirds. As the great Ansel Adams said, "There are no rules for good photographs, there are only good photographs."

EVENING LIGHT ON WHITBARROW ❯❯
SCAR CUMBRIA, UK
Framing is about seeing a picture as a complete entity. Many, perhaps most, images can't be reduced to a single "subject."

3 » PRINCIPLES OF FRAMING

Two basic principles underpin effective framing: knowing where the edges are, and seeing what the camera sees.

The edges of the frame define the picture, and the picture is everything within them. Our eyes and brains are very good at selecting specific parts of a scene, but the camera doesn't make the same distinction. It will happily record the parts we're interested in and the parts we didn't notice, frequently producing pictures that seem cluttered or confusing. Hence the importance of seeing what the camera sees, not just what we want or expect to see.

Looking through a camera viewfinder, even a good one like the D7000's, is rather like looking through a window, so it is interesting to experiment with Live View mode. Now, instead of looking through a viewfinder, you're looking at a screen. If the viewfinder is like a window, the screen is like a picture. And of course, it's a picture we want. Viewing the screen might make it easier to see the whole picture— the parts that interest you and those that don't.

However, using Live View all the time isn't recommended: it makes handling

DOMINANT CLOUDSCAPE ⌄
There's no "correct" position for the horizon. Here I placed it low in the frame to give space for this striking cloudscape near Helsington, Cumbria, UK

more difficult, drains batteries fast, and can be hard to see in bright sunlight. The viewfinder is far superior for most shooting, but the Live View "picture" approach is a worthwhile exercise.

When you revert to the viewfinder, make a conscious effort to see the scene as a picture: look at the whole image, take note of the edges and what's included, and consciously seek out distracting and irrelevant elements. Incidentally, unlike many lesser SLRs, the D7000's viewfinder gives 100% coverage, showing you the entire image.

Framing the landscape

Landscape photography poses special challenges for framing, because—unlike portraits, for example—there's rarely a single "subject." Landscape is boundless. The first challenge is simply choosing the part you want to photograph. Be selective; look for the "essence" of a place; try to capture its appeal. Remember the old saying: "Can't see the wood for the trees." "Views" are fine, but landscape is an all-round sensory experience. Many photos of views end up looking small, or flat, or otherwise disappointing. Very often there's a simple reason: no foreground. A foreground shows texture and detail, evoking sounds and smells, and the rest of the sensory totality. It can bring life and crispness where the distant scene is hazy or flatly lit. Above all, including a

TAKING A BROAD VIEW ⌃⌃
A wide-angle lens allowed me to get close to the tree while still seeing a broad sweep of landscape beyond, at Helsington Barrows.

foreground connects the viewer to the place, distinguishing your shot from the detached views that anyone might get from a bus or train window.

A foreground can also help to convey depth and distance, and strengthen a sense of scale. If you want a photo of a mountain that conveys a sense of its awesome size, filling the picture with it may not be the best way. For many people, a shot of a peak in isolation is hard to "read." Including a relatively familiar object, like a tree, helps make sense of the unfamiliar. Human figures are also ideal for this, because we all know how large we are. Making the figure really tiny in the frame is often very effective, as long as it's still recognizably human.

To obtain strong foregrounds in your pictures, the first principle is to get close. The second is to get closer. Don't be afraid to sit, kneel, crouch, crawl, or climb.

3

Wide-angle lenses are excellent for encompassing both the foreground and the distant vista. The D7000 has a 1.5x magnification factor, so a typical wide-angle zoom, with a minimum focal length of 18mm, gives the same coverage as a 27mm lens on a 35mm SLR or a "full-frame" digital SLR like the Nikon D3s. Photographers intent on making the most of foregrounds, or large vistas, will hanker after something wider, like the 12–24mm f/4G ED-IF AF-S DX Nikkor *(see page 213)*. Not every landscape photo need be on the grand scale. Small details can also convey the essence of a place. If the light is not magical, if distant prospects look flat or hazy, details and textures and the miniature landscapes of a rock pool or forest clearing can bring a picture back to life. Variations in scale, focus, and so on also help enliven sequences of pictures. No matter how good they may be individually, eventually an unrelieved sequence of big landscape images will become oppressive.

WELL-LIT COMPOSITION ⌄

As usual in landscape photography, there was no single "point of interest" in this view of Bowland Knotts, Forest of Bowland in Lancashire, UK. I played with the framing while waiting for the right light to develop.

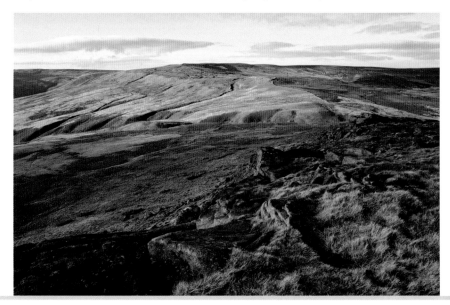

» LIGHTING

What makes a good photograph? For that matter, what makes any photograph? The answer is light. It's easy to take light for granted, to assume that the camera will take care of it. Up to a point this is true: cameras like the D7000 are very good at dealing with varying amounts of light. However, there's much more to light than its quantity, and it really is worth tuning in to all the ways that it varies, such as color and direction.

Light sources
Natural light essentially means direct or indirect sunlight. Bear in mind that even moonlight is reflected sunlight. The sun itself varies little, but by the time the light reaches the camera it can be modified in many ways by the atmosphere and by reflection.

As a direct light source, the sun is very small, giving strongly directional light and hard-edged shadows, yet on an overcast day, the same light can be soft, even, and spread across the entire sky. Studio photographers use massive softboxes to replicate this effect; the closest most other photographers can get, and only on a small scale, is usually with bounce flash (see page 168).

There are many other artificial light sources, the color of which can vary enormously—making the D7000's white

BOLD CONTRAST ⌃
Strong oblique lighting creates high contrast and powerful modeling on this ancient door at the Latvian Ethnographic Open-air Museum in Rīga, Latvia.

balance controls a blessing—but other qualities, such as direction and contrast, can usually be understood by comparison with the familiar effects of sunlight and flash.

Contrast, dynamic range, and tonal range are all terms that refer to the spread of tones between the brightest and darkest areas of a scene or subject. It's easy to ignore this, since our eyes are very adaptable, and generally are able to see detail in bright areas and deep shade to a degree that even the best camera cannot always match.

In high-contrast conditions, it's very common for either the brightest highlights, like white clouds or snow, to end up completely blank and white, or for the deepest shadows to become solid black. Known as "clipping," this effect can occur in both highlights and shadows simultaneously. High-contrast conditions typically occur when the sun shines from a clear sky. The clearer the sky, the higher the contrast; it's most extreme in deserts and at high altitude.

In overcast conditions, the contrast is much lower. This is rarely ideal for wide landscapes, but can be excellent for portraits and details. Photographers who specialize in shooting wild flowers often carry diffusers to create such soft light.

High-contrast options

The D7000 offers several options for tackling high contrast, notably Active D-Lighting *(see page 82)* and D-Lighting *(see page 116)*. Shooting RAW also gives you a chance to recover highlight and/or shadow detail in post-processing. Sometimes, however, it's simply impossible to capture the entire brightness range of a scene in a single

DYNAMIC POSE ⌄
High dynamic range poses a challenge for any photographer, but it occurs in many of the shots we want to take, such as this image of a statue in Vigelandsparken, Oslo, Norway.

Tips

If the highlights display shows clipping, some detail may be recoverable when shooting RAW. However, it is worth bracketing exposures for insurance.

High Dynamic Range (HDR) software facilitates the merging of images that cover a wide dynamic range. Adobe Photoshop (CS3 onward) has an HDR capability.

exposure. Checking the histogram display and the highlights display *(see page 81)* will help identify such instances. One solution may be to reframe the shot to exclude large areas at the extremes of the brightness range. Small patches of solid black or white will go unnoticed in most pictures, whereas large featureless blobs will be only too conspicuous.

Reflectors

For close subjects, such as portraits, you can compensate for high contrast by adding fill-in light to the shadows with the built-in flash or an accessory flashgun, or you may prefer to use a reflector, which has the advantage that the effect is easily previewed. Dedicated photographic reflectors are available, but I often use a map, which I'm usually carrying anyway. Light-colored rocks, white walls, or snow can also act as effective reflectors. Occasionally, even a large white cloud can be used as a mega-reflector.

Digital imaging also offers another solution that is unavailable with film. This involves making multiple exposures—typically one for the bright areas, one that's right for the mid-tones, and another for the shadows—which can be combined on the computer later. The D7000's Exposure bracketing facility can automate this, although a solid tripod is essential to keep the images aligned. This method may not be suitable when there's movement in the scene.

3 » DIRECTION OF LIGHT

With direct sunlight or a single flashgun, the direction of the light source is obvious, and the same subject, seen from different angles, can appear totally different. At the other extreme, under an overcast sky, light comes from a wide area, so its quality varies much less with the viewing angle. Completely even lighting is quite rare; there's usually at least a vague sense of direction to it. Even so, the effects of the direction of light are much easier to appreciate with a distinct main source like direct sunlight. We refer to frontal lighting, oblique lighting, and back-lighting.

Frontal lighting

Frontal lighting hits the subject head-on; it's what you get with on-camera flash or with the sun behind you. While this might sound positive, the lack of shadows makes everything look flat. This can work well for subjects that derive impact from pure color, shape, or pattern. True frontal lighting doesn't lead to extremes of contrast, so making a correct exposure is usually easy.

Oblique lighting

Oblique lighting is usually more complex and interesting. Shadows emphasize form and texture, outlining hills and valleys. At acute angles, the light accentuates fine details, from crystals in rock to individual blades of grass. This is one reason why landscape photographers love the beginning and end of the day, when the sun is low in the sky. In hilly terrain, however, even a high sun may cast useful shadows. In some places, such as deep gorges, direct light only penetrates when the sun is high. The key is the angle at which light strikes the subject. Oblique lighting is terrific for landscapes and many other subjects, but often is accompanied by high contrast, making exposure more difficult.

Backlighting

Backlighting can produce striking and beautiful results in almost any sphere of photography—nature, portrait, landscape—but it needs to be handled with care. By definition, a backlit subject will be in shadow and can easily appear as a silhouette. Sometimes this is what you want: bare trees can look fantastic against a colorful sky. If so, meter for the bright areas to maximize color saturation there, perhaps using exposure lock, or try Silhouette mode.

If you don't want a silhouette effect, a reflector or fill-in flash can help, but don't overdo it, since you risk negating the backlit effect. Backlighting combined with a reflector is a simple way to obtain great portraits. Translucent materials such as foliage and fabric can glow beautifully when backlit, and they don't readily turn into silhouettes.

BOLD FORM ⌃
Frontal lighting can work well for landscapes with strong colors and shapes, such as this view of an island on Lake Bled, Slovenia.

LIGHTING DIRECTION ⌃
These three shots of the same subject, taken seconds apart, show frontal, oblique, and backlighting respectively. The different results with opaque and translucent areas are obvious.

RICH DEPTH ⌃
In this example, precisely angled light gives depth to what easily could have appeared as a two-dimensional subject.

3 » COLOR

A prism in a sunbeam reveals all the colors of the rainbow. The term "white" light is a misnomer, and natural light varies enormously in color. Most of the time, our eyes adjust automatically, so that we continue to see green leaves as green, oranges as orange, and so on. Only at its most extreme, as in the intense red of the setting sun, are the changing colors of light really obvious.

It's all due to the way the sun's light is filtered by the atmosphere. When the sun is high in a clear sky, the light is least affected; when the sun is low, the light's

Tip

The D7000's Sunset mode is intended for shooting the evening sky itself, rather than scenes and subjects illuminated by a red sun. It won't hurt to try it out, but be prepared to use Aperture Priority and a Direct sunlight setting instead.

MORNING SUNLIGHT ⌄
The warm light of the rising sun, in this view near Garstang, Lancashire, UK, contrasts with the blue sky and cool tones in the shadows.

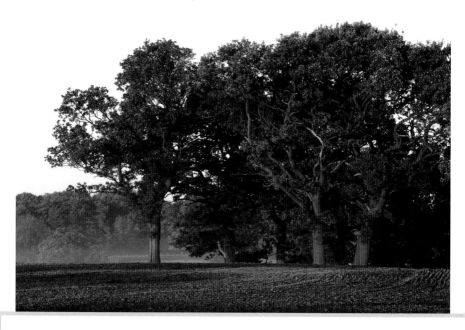

path through the atmosphere is much longer and it is shifted toward yellow and ultimately red, while the "lost" or scattered light turns the sky blue.

The warmer light of a low sun is another reason why landscape photographers traditionally favor mornings and evenings. It's not just that that we find warm colors more pleasing; if that were all, the effect could be easily replicated with a Photoshop adjustment. In the real world, sunlit surfaces pick up a warm hue, while shadows receive light from the sky, tinting them blue. This difference in color between sunlit and shadow areas increases as the direct light becomes redder, adding vibrancy to morning and evening shots. Filters can't duplicate this effect.

When shifting colors are part of the attraction in a photo, you don't want to "correct" them back to "normal," so white balance settings should be chosen with great care. In the user-control modes, selecting Direct sunlight will often work perfectly.

Artificial light

Similar principles apply with artificial light. Sometimes you'll want to correct its color, sometimes it's better left alone. Portraits shot under fluorescent lamps (even some "daylight" types) can take on a ghastly

> ### Tip
>
> *Shooting RAW gives you far more scope for adjusting the white balance later. Another option, when shooting JPEGs, is white balance bracketing.*

greenish hue, which you will surely want to correct. Auto White Balance often improves matters, but isn't always perfect under artificial light.

On the other hand, if you're shooting floodlit buildings, the variations in color may be part of the appeal. The results you'll get with Auto White Balance are less predictable here and may not match either what you see or what you want. Night Landscape mode is an obvious choice in this instance, but you should be prepared to take control.

Cameras and lenses handle light and images differently from the human eye, and sometimes produce results that don't match what you see, expect, or want. Some of these properties are related to the way lenses work, and are common to both film and digital cameras, while other issues are uniquely digital.

Flare

Lens flare results from stray light bouncing around within the lens. It's most prevalent when shooting toward the sun, whether the sun itself is in or out of frame. It may produce a string of colored blobs, aligned as if radiating from the sun, or a more general veiling of light.

Advanced lens coatings, like those on Nikkor lenses, greatly reduce the incidence of flare. Keeping lenses and filters scrupulously clean is also vital. Beyond that, if the sun is actually in the frame, some flare may be inescapable, although it may diminish when the lens is stopped down. Otherwise, look for ways to reframe the shot or mask the sun, behind a tree for instance.

If the sun isn't actually in the frame, try to shield the lens from its direct rays. A good lens hood is essential, but further shading may be needed, especially with a zoom lens. You can provide this with a piece of card, a map, or even your hand. This is easiest with the camera on a tripod; otherwise it requires one-handed shooting or someone to help. Check the viewfinder and/or monitor playback carefully to see if the flare has gone—and make sure the shading object hasn't crept into shot.

ELIMINATING FLARE »
The flare in the first shot *(top)* is horrendous, but was easily eliminated by shading the lens, as shown in the second shot.

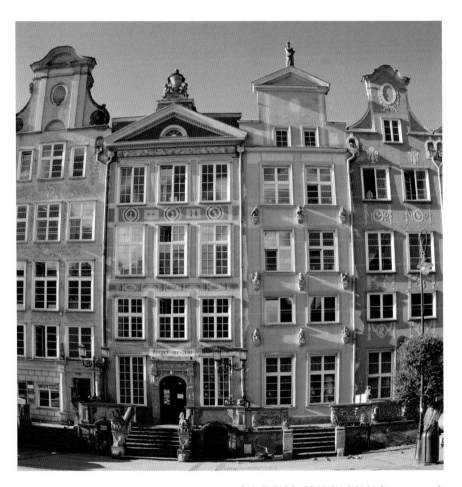

Distortion

Distortion makes objects that are actually straight appear curved in the image. It's a result of lens design, but as this continually improves, it's less and less of an issue; the worst offenders are likely to be old and/or

DŁUGI TARG, GDANSK, POLAND ⌃
Distortion was added to this photograph in post-processing. If any lens gave this much distortion, you'd either throw it away or call it a semi-fisheye.

cheap zoom lenses, distortion often being worst at the extremes of the zoom range.

When straight lines bow outward, it's called barrel distortion; when they bend inward, it's pincushion distortion. Both problems can be forestalled using Auto Distortion Control (Shooting menu), or subsequently corrected using Distortion Control in the Retouch menu, or in later processing with software such as Nikon Capture NX2 or Adobe Photoshop. All these methods crop the image, however, so it's better to avoid the issue in the first place by using good lenses.

Distortion may go unnoticed when shooting natural subjects with no straight lines, but can become apparent when a level horizon appears in a landscape or seascape, especially when it is near top or bottom of the frame.

Aberration

Aberration is a lens property that appears when light rays from the subject aren't all focused together. Chromatic aberration occurs when light of different colors is focused in slightly different places on the sensor; it can be seen as colored fringing when images are examined closely. The D7000 has built-in correction for chromatic aberration during processing, but this applies only to JPEG images. Aberration can also be corrected in post-processing, which is the only option with RAW images.

Ideally, use lenses that minimize aberration in the first place. Although it's a lens property, chromatic aberration can be exaggerated by the way light strikes a digital sensor. It's best to use lenses that are specifically designed for digital cameras, such as Nikon's DX series.

Vignetting

Vignetting is a darkening toward the corners of the image. It's most conspicuous in even-toned areas like clear skies. Almost all lenses have a slight tendency to vignetting at maximum aperture, but usually it disappears on

WATERFRONT, GDANSK, POLAND ⏶
A fairly low ISO rating required a long exposure. There is some noise, most easily seen in the dark sky, but overall it is not obtrusive.

stopping down. Like most faults, it can be tackled in post-processing, but prevention is better than cure.

Vignetting can also be caused, or exaggerated, by unsuitable lens hoods or filter holders, or by stacking multiple filters on the lens—rarely a good idea.

DARK CORNERS ⏴⏴
A strong vignette effect was added in post-processing to this photograph of crocuses in front of Carlisle Cathedral, Cumbria, UK.

Noise

Image noise is created by random variations in the amount of light recorded by each pixel. It appears as speckles of varying brightness or color. Noise is most apparent in areas that should have an even tone, especially in the darker areas of the image. Unfortunately, it becomes more prevalent as the individual photosites on the sensor become smaller, which results from cramming more megapixels onto the same size sensor. However, this has driven major improvements in the software that compensates for image noise. Although the D7000 has more than 16 million photosites on its 23.6 x 15.8mm sensor, its noise reduction abilities are excellent.

3

Noise reduction is often applied to JPEG images during in-camera processing, but you may prefer to apply it to RAW files during post-processing.

To minimize noise, shoot at the lowest ISO rating possible and expose carefully: underexposure increases the risk of visible noise. A tripod can be a big help.

Clipping

Clipping occurs when highlights or shadows are rendered without detail—i.e., shadows are solid black and/or highlights are blank white. Clipping can be detected as a "spike" at either extreme of the histogram display, and in full-frame playback you can set the D7000 to show highlight clipping by flashing affected areas of the image.

The D7000 is much less prone to clipping than older cameras, but is not immune. There is some scope to recover clipped areas if you shoot RAW, while Active D-Lighting can help with JPEG images.

Artifacts and aliasing

Normally when viewing a digital image, it's not apparent that it is made up of individual pixels, but sometimes small clumps of pixels can become apparent as "artifacts," or visual faults, of various kinds. They are usually more evident in low-resolution images, simply because of the smaller number of pixels.

Aliasing is most evident on diagonal or curved lines, giving them a jagged or

stepped appearance. Moire or maze artifacts can occur when there's interference between areas of fine pattern in the subject and the grid pattern of the sensor itself. This often takes the form of aurora-like swirls or fringes of color. To compensate for such issues, digital cameras employ a low-pass filter directly in front of the sensor itself. This actually works by blurring the image slightly. Although very effective in removing artifacts, it means that images must be resharpened either in-camera or in post-processing.

Another form of artifact is the JPEG artifact, which looks a lot like aliasing, but is created when JPEG images are compressed, either in-camera or on a computer. Avoid it by limiting JPEG compression: use the Fine setting for images that may be printed or viewed at large sizes.

Sharpening images

As mentioned, the low-pass filter makes some sharpening necessary to make images look acceptable. Too much sharpening can produce artifacts, however, including white fringes or halos along defined edges.

JPEG images are sharpened during in-camera processing, and sharpening settings are accessed through the Set Picture Control item in the Shooting menu. Any changes to the sharpening level only affect images taken using that particular Picture Control. It's always wise to be

HIGHLIGHT DETAILS **«**
At first glance, this exposure appears fine, but a second look reveals highlights on the statue, Fontana Neptuna, Gdansk, Poland, where all detail has been clipped or burned out. Shooting in RAW or using Active D-Lighting may have overcome this.

conservative with in-camera sharpening levels. You can always add more, but it's virtually impossible to remove it.

With RAW images, sharpening takes place on the computer, either during initial RAW conversion or later. Sharpening at the RAW conversion stage is reversible, because the original file is saved untouched.

Tip

Repeatedly opening and resaving JPEG images on a computer can multiply the effect of JPEG artifacts. If repeated edits are anticipated, save the image as a TIFF first.

This may look like a spontaneous shot, and it was easy to see the opportunity, but execution wasn't that simple. First I had to be sure that the exposure was right to catch good color in the flag while retaining detail in the shadowy foreground.

I used Manual mode and took a few test shots, then framed the shot carefully and kept shooting until I caught the flag in just the right position. With a mix of anticipation and luck, the whole process only took a few minutes.

Settings
> Focal length: 16mm
> Mode: Manual
> Sensitivity: ISO 320
> Shutter speed: 1/1000 sec.
> Aperture: f/11
> Support: tripod

INNER HARBOR, GLASSON DOCK, LANCASHIRE, UK

» UNUSUAL LIGHT SOURCES

Since I don't regularly photograph industrial subjects, I had to feel my way with this shot of a welder. Shooting RAW was the first step, allowing me to sort out the color balance later. Masking the welding torch behind the clamp eliminated flare and made contrast more manageable. A few test shots fine-tuned the exposure, while a flashgun placed off-camera to the right helped fill in the shadows. I didn't notice the lovely little starburst through a hole in the clamp until I viewed the images on my Mac.

Settings
> Focal length: 135mm
> Sensitivity: ISO 1000
> Shutter speed: 1/250 sec.
> Aperture: f/11

PENDLE ENGINEERING, LANCASHIRE, UK

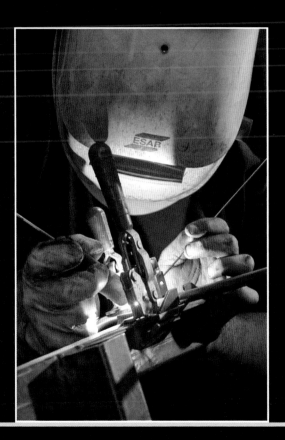

For this shot of singer Paul Heaton, I didn't do anything clever except to make sure that he sat facing the window. Since it was foggy outside, the window light was beautifully soft and even. Because he was also being interviewed at the time, I knew that using flash would have been distracting, and in any case nothing but a massive studio softbox could have matched this free available light.

SINGER, CAT AND FIDDLE PUB, DERBYSHIRE, UK

» AFTER DARK

Blackpool's famous Illuminations are a popular photographic subject, but I wanted to do something slightly different, so I headed down to the beach. The tide was going out, leaving plenty of pools and areas of highly reflective wet sand. A few test shots got the exposure right; the final thing to remember was to shoot when the ferris wheel was in full motion to record complete circular tracks of light.

Settings
> Focal length: 32mm
> Sensitivity: ISO 500
> Shutter speed: 4 sec.
> Aperture: f/11
> Support: tripod

ILLUMINATIONS, BLACKPOOL, LANCASHIRE, UK

instinct made me walk a little way upstream to where they would be backlit. I couldn't stand just anywhere because of trees, and I didn't want the sun directly in shot because I was concerned about flare. A quick test shot to check exposure and I was ready to go.

Settings
> Focal length: 32mm
> Sensitivity: ISO 200
> Shutter speed: 1/125 sec.
> Aperture: f/9
> Support: tripod

ESKSDALE, LAKE DISTRICT, UK

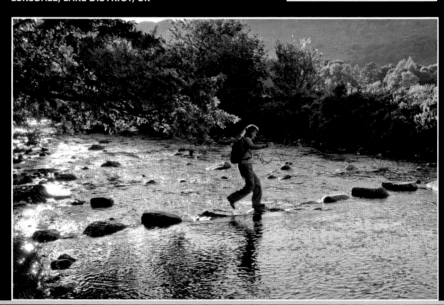

» PUSHING THE LIMITS

I was on a long bike ride and my main job was writing, not photography, so I wasn't carrying much gear. But when I looked into this ancient chapel, I knew I had to try to capture something of its quiet charm. The only light came from a few small windows, and I knew that the built-in flash would give a horrible result, so I pushed up the ISO rating and gave thanks for VR lens technology.

Settings
> Focal length: 18mm
> Sensitivity: ISO 1600
> Shutter speed: 1/25 sec.
> Aperture: f/5.6
> Support: tripod

ST. ALDHELM'S HEAD, ISLE OF PURBECK, DORSET, UK

» FLASH CHARACTERISTICS 158–161

» FLASH EXPOSURE 162

» FLASH RANGE 163

» FLASH SYNCHRONIZATION & FLASH MODES 164–165

» FLASH COMPENSATION 166–167

» OPTIONAL SPEEDLIGHTS 168–176

» FLASH ACCESSORIES 177

Chapter 4
FLASH

4 FLASH

The D7000 has great flash capabilities, whether using its built-in flash or more powerful accessory units. Even so, flash photography causes frequent confusion and frustration. The full benefits are only seen if basic principles are grasped.

» FLASH CHARACTERISTICS

A fundamental point is that all flashguns are small light sources. This is especially true of built-in units like that of the D7000 and most other DSLRs.

The small size of a flashgun gives its light a hard, one-dimensional quality. It's somewhat similar to direct sunlight, but even the strongest sunlight is slightly softened by scattering and reflection. There are various ways to soften and redirect the light.

The weakness of flash is an even more fundamental property. Essentially, all flashguns have a limited range. If the subject is too far away, the flash simply can't deliver

Guide Numbers

In the past, determining flash exposures and working range required calculation based on the Guide Number (GN) of each unit, which relates subject distance to the f-stop (aperture setting) in use. GNs are specified in feet and/or meters, and usually for an ISO rating of 100. When comparing different units, be sure that the GNs for both are given in the same terms. Nikon quotes the GN for the D7000's built-in flash as 12 (meters) or 39 (feet).

It's not necessary to memorize the formula for the calculation, since the D7000 has very advanced flash metering that usually will ensure correct illumination. The GN does help, however, when it comes to comparing the power and range of different flashguns. For instance, it indicates that Nikon's SB-900 offers at least three times the power of the built-in unit, allowing shooting at three times the distance, at a lower ISO, or with a smaller aperture.

enough light. The result is that flash—especially built-in flash—is not the answer to every low-light shot. Understanding its limitations helps us determine when not to use flash, as well as when and how we can use it most effectively.

Fill-in flash

A key application for flash is for fill-in light, giving a lift to dark shadows like those cast by direct sunlight. This is why professionals regularly use flash in bright sunlight, when most people wouldn't think to use it.

Fill-in flash doesn't need to illuminate the shadows fully, only to lighten them a little. This means that the flash can be used at a smaller aperture, or a greater distance, than when it's the main light source (averaging around two stops smaller, or four times the distance).

As part of its Creative Lighting System (CLS), Nikon has developed i-TTL balanced fill-flash to help achieve natural looking results when using fill-in flash.

FLASH RANGE ⌃
The limited range of the built-in flash is obvious here, lighting only the nearer railings.

i-TTL balanced fill-flash for DSLR

i-TTL balanced fill-flash automatically comes into play when matrix or center-weighted metering is selected and a CPU lens is attached, or lens data has been specified: in other words, most of the time. The flash (built-in or compatible flashgun)

FILL-IN FLASH ⌄
The background exposure is the same for both shots, retaining detail in the sky, but in the shot without flash (left) the foreground is unpleasantly dark.

emits a series of virtually invisible pre-flashes immediately before exposure. Light reflected from these is detected by the metering sensor and analyzed together with the ambient light. If type a D or G lens is used, distance information is also incorporated.

Standard i-TTL flash for DSLR

If spot metering is selected, this mode is activated instead (it can also be selected directly on some accessory flashguns). Flash output is controlled to provide correct illumination of the subject, but background illumination is not taken

into consideration. This mode is more appropriate when flash is the main light source, rather than providing fill light.

> Operating the built-in flash

The built-in flash of the D7000 is small, low-powered, and fixed in position close to the lens axis. Low power limits working range, while its size and position produce a rather harsh frontal light which is—to say the least—unflattering for portraits, although it can be better than nothing. The built-in flash really comes into its own when used for fill-in light; it can also be used to trigger remote flashguns. The following assumes you are using **P**, **S**, **A**, or **M** modes; in Full Auto and Scene modes, the flash activates either automatically or not at all.

1) Select a metering method: matrix or center-weighted metering is appropriate for fill-in flash. Spot metering is suitable when flash is the main or only light.

SAMBO'S GRAVE, SUNDERLAND POINT, LANCASHIRE, UK
i-TTL balanced fill-flash for DSLR gives a very natural result; it's not overly obvious that flash has been used at all, but without it the collection of offerings would be poorly lit.

2) Press ⚡. The flash pops up and begins charging. When it is charged, the ready indicator ⚡ is displayed in the viewfinder.

3) Choose a flash mode by pressing ⚡ and rotating the Main command dial until the appropriate icon appears in the Control Panel. *(See pages 164-5 for details of the different flash modes.)*

4) Depress the shutter-release button halfway to meter and focus. Fully depress the button to take the photo.

5) When finished, stow the flash by pressing it down gently until it clicks back into place.

Tip

The built-in flash is recommended for use with CPU lenses between 16mm and 300mm focal length. Some lenses may block part of the flash output at close range; removing the lens hood often helps.

BUILT-IN SHADOW �

The built-in flash throws a very obvious shadow of the lens/lens hood, particularly noticeable on close-up subjects.

 » FLASH EXPOSURE

The combinations of shutter speed and
aperture that are available when using flash
depend on the exposure mode selected.
The following table applies when the built-
in flash is used; with optional
SB-900/800/700/600 units, it is possible to
use faster shutter speeds.

Exposure mode	Shutter speed	Aperture
P	Set automatically by the camera. The normal range is between 1/250 and 1/60 sec., but in certain flash modes all settings between 1/250 and 30 sec. are available.	Set automatically by the camera.
S	Selected by user. All settings between 1/250 and 30 sec. are available.	Set automatically by the camera.
A	Set automatically by the camera. The normal range is between 1/250 and 1/60 sec., but in certain flash modes all settings between 1/250 and 30 sec. are available.	Selected by user.
M	Selected by user. All settings between 1/250 and 30 sec. are available. If user sets a faster shutter speed, the D7000 will fire at 1/250 sec. when the flash is active.	Selected by user.

» FLASH RANGE

The range of any flash depends on its power, and on the ISO sensitivity setting and the aperture selected. If the flash does not reach as far as you want, you can increase its effective range, within limits, by using a higher ISO rating and/or a wider aperture—but be sure to check first that flash compensation (see page 166) is not in effect.

The table below shows the approximate range of the built-in flash for selected distances, apertures, and ISO settings. These figures are based on Nikon's published figures, verified by practical tests. It's not necessary to memorize all of the figures, but it is helpful to have a general sense of the range limitations that apply when using flash. In any given situation, a few quick test shots will soon establish a workable shooting range.

	ISO equivalent setting						Range	
	100	200	400	800	1600	3200	meters	feet
		1.4	2	2.8	4	5.6	1.0–12	3′ 3″–39′
	1.4	2	2.8	4	5.6	8	0.7–8.5	2′ 4″–28′
	2	2.8	4	5.6	8	11	0.6–6.1	2′–20′
	2.8	4	5.6	8	11	16	0.6–4.2	2′–13′ 9″
Aperture	4	5.6	8	11	16	22	0.6–3.0	2′–9′ 10″
	5.6	8	11	16	22	32	0.6–2.1	2′–6′ 11″
	8	11	16	22	32		0.6–1.5	2′–4′ 11″
	11	16	22	32			0.6–1.1	2′–3′ 7″

4 » FLASH SYNCHRONIZATION & FLASH MODES

As the name implies, flash is virtually instantaneous and lasts just a few milliseconds. If the flash is to cover the whole image frame, it must be fired when the shutter is fully open, but at faster shutter speeds SLRs like the D7000 do not expose the whole frame at once. In fact, with the D7000, the fastest shutter speed that normally can be used with flash is 1/250 sec. This is known as the sync (for synchronization) speed.

The D7000 has a number of flash modes, the differences between them largely being related to synchronization and shutter speed.

› Operating the built-in flash

This is the default flash mode when using **P**, **S**, **A**, and **M** exposure modes; it is ideal for fast response. In standard flash operation, the flash fires as soon as the shutter is fully open, i.e., as soon as possible after the shutter-release button is pressed. In P and A exposure modes, the camera will set a shutter speed in the range 1/60–1/250 sec.

› Red-eye reduction

On-camera flash, especially a built-in unit, is very prone to "red-eye," where light reflects off the subject's retina. In animals, you may see other colors.

Note:
For some reason, Nikon calls this basic flash mode "Fill-flash" on the D7000. This is correct when using matrix or center-weighted metering, but not when spot metering is active.

Red-eye reduction works by shining a light (the AF-assist illuminator) at the subject just before the exposure, causing their pupils to contract. This delay makes it inappropriate with moving subjects, and kills spontaneity. Most of the time, it's far better to remove red-eye using the Red-eye correction facility in the Retouch menu *(see page 116)* or on the computer. Better still, use a separate flash, away from the lens axis, or no flash at all, perhaps shooting at a high ISO rating.

› Slow sync

This mode allows longer shutter speeds (up to 30 sec.) to be used in **P** and **A** exposure modes, so that backgrounds can be captured even in low ambient light. Movement of the subject and/or camera can result in a partly blurred image combined with a sharp image where the subject is lit by the flash. This may be unwanted, but often is used for specific

Slow sync combines a flash image with a motion-blurred image from the ambient light. Front-curtain sync *(top)* makes the light trails run ahead of the flash image; rear-curtain sync *(below)* lets them trail behind it.

creative effect. This mode is unavailable when shooting in **S** and **M** exposure modes, where longer shutter speeds are available anyway.

› Red-eye reduction with slow sync

This combines the two modes previously described, allowing backgrounds to register, which may give a more natural look to portraits than Red-eye reduction mode on its own. It is available in **P** and **A** exposure modes, plus Night Portrait.

› Rear-curtain sync

Rear-curtain sync triggers the flash at the last possible instant. This makes sense when photographing moving subjects, because any image of the subject created by the ambient light then appears behind the subject, which looks more natural than having it appear to extend ahead of the direction of movement. Rear-curtain sync can be used in any exposure mode; in **P** and **A** modes, it also allows slow shutter speeds (below 1/60 sec.) to be used, and is referred to as slow rear-curtain sync.

Shooting with rear-curtain sync can be difficult at longer exposure times, since you need to predict where the subject will be at the end of the exposure, rather than immediately after pressing the shutter-release button. It is often best suited to working with cooperative subjects so that the timing can be fine-tuned after reviewing the images on the monitor.

4 » FLASH COMPENSATION

Although the D7000's flash metering is extremely sophisticated, you may still want to adjust flash output, perhaps for creative effect. Reviewing images on the monitor makes it easy to assess the effect of the flash level, allowing compensation to be applied with confidence to further shots.

To use flash compensation, hold down ⚡ and rotate the Sub-command dial. Flash compensation can be set from -3 to +1 Ev in ⅓-Ev steps. Positive compensation brightens areas lit by the flash while leaving other parts of the image unaffected. Negative compensation darkens flash-lit areas, again leaving other areas unaffected. After use, reset the flash compensation level to zero.

POINTING THE WAY »
The sky was very bright, but without flash the sign was just a silhouette. The background exposure remains the same for these three shots, taken with flash compensation set to +1, 0, and -1 respectively.

Tip

If the flash is already at the limit of its range, positive compensation won't make it any brighter. To brighten the flash image, use a wider aperture or move closer to the subject.

Note:
Flash compensation and FV Lock work similarly when a compatible Speedlight is attached.

0

+1

-1

› FV lock

FV lock is analogous to exposure lock, allowing flash output to be locked and the image to be reframed. It's most useful when you want to use flash with an off-center subject, especially one outside the area covered by the focusing sensors (and spot metering). Using FV lock with the D7000 is somewhat involved, since it requires assigning the Fn button to the FV lock function. It's often more convenient to employ flash compensation, fine-tuning the compensation level after image review.

1) To assign the Fn button to the FV lock function, navigate to Custom setting f3 **Assign Fn button**. Select **FV lock** and press **OK**.

2) Activate the flash.

3) Position the subject in the center of the frame; depress the shutter-release button halfway to activate focus and metering.

4) Check that the flash-ready indicator ⚡ is shown in the viewfinder. Press the Fn button. A pre-flash is fired to set the flash level, after which FV lock icons appear in the viewfinder and Control Panel.

5) Recompose the image and press the shutter-release button fully. With further shots, the flash level remains locked.

6) To release FV lock, press the Fn button once again.

› Flash exposure bracketing

Flash exposure bracketing is yet another way to achieve exactly the required level of flash illumination. It works just like exposure bracketing *(see pages 57–58)*; indeed it's possible to bracket both flash and the main exposure simultaneously.

Flash bracketing requires Custom setting e5 **Auto bracketing set** to be set to **Flash only** (to bracket flash values only) or **AE & flash** (to vary the main exposure as well).

1) While pressing **BKT**, rotate the Main command dial to select the number of shots (2 or 3) for the bracketing burst.

2) While pressing **BKT**, rotate the Sub-command dial to select the flash output increment between shots. Possible values run from 0.3 Ev to 2 Ev.

3) Frame, focus, and shoot normally. The camera will vary the flash output (and exposure if **AE & flash** was selected) with each frame until the sequence is completed. A progress indicator appears in the Control Panel.

4) To return to normal shooting, press the Fn button and rotate the Main command dial until **OF** appears in the Control Panel.

 » OPTIONAL SPEEDLIGHTS

If you're serious about portrait or close-up photography in particular, you'll soon find the built-in flash inadequate. Accessory flashguns, which Nikon calls Speedlights, extend the power and flexibility of flash with the D7000.

For really outstanding results, Nikon's Creative Lighting System is hard to beat, and to take full advantage requires a Speedlight. The current range offers six sophisticated models, aimed mainly at professional and advanced users, and priced accordingly.

Independent makers such as Sigma offer alternatives, many of them compatible with Nikon's i-TTL flash control, but rarely cheap. Many possibilities can be explored with much cheaper units. For instance, any flashgun that has a test button, allowing it to be fired manually, can be used for the "painting with light" technique outlined here.

› **Mounting an external Speedlight**

1) Check that both camera and Speedlight are switched off, and that the pop-up flash is down. Slide the Speedlight into the camera's hotshoe. If resistance is felt, check whether the mounting lock on the Speedlight is extended.

2) Rotate the lock lever at the base of the Speedlight to secure it.

3) Switch on the camera and Speedlight.

› **Bounce flash and off-camera flash**

The fixed position of the built-in flash throws shadows on close subjects and gives portraits a "police mugshot" look. A separate Speedlight mounted in the hotshoe improves things slightly, but you can make a much bigger difference by either bouncing the flash light off a ceiling, wall, or reflector, or taking the Speedlight off the camera.

Bounce flash
Bouncing the flash off a suitable surface spreads the light, softening hard-edged shadows, and changes its direction, producing better modeling on the subject. Nikon's SB-900, SB-800, SB-700, and SB-600 Speedlights have heads that can be tilted and swiveled through a wide range, allowing light to be bounced off walls, ceilings, and other surfaces. The SB-400 has a basic tilt capability, allowing light to be bounced off the ceiling or a reflector.

Tips

Most surfaces will absorb some light, and in any case the light has to travel farther to reach the subject; i-TTL metering will automatically adjust for this, but the working range is reduced. However, Nikon's Speedlights have more power than the built-in unit.

Colored surfaces will change the color of the bounced light. This may be an advantage for creative effect, but for neutral results choose a white surface.

Off-camera flash

Taking the flash off the camera gives complete control over the direction of its light. The flash can be fired wirelessly or by using a remote cord; Nikon's dedicated cords *(see page 229)* preserve control of the i-TTL flash.

The first shot *(above right)* was taken using the built-in flash; despite some hard shadows, this very three-dimensional object looks rather flat. The second shot *(center right)* was taken with off-camera flash from the right, giving more interesting light and adding depth. The third image *(bottom right)* was taken with bounce flash to give a softer, more even light while retaining most of the three-dimensional quality.

CAMERA AND BOUNCE FLASH ⌃

› Wireless flash

Many Speedlights and studio flash units can be fired wirelessly using a "slave" attachment, but this gives no control over flash output. Using Nikon's SB-900, SB-800, SB-700, SB-600, and SB-R200 Speedlights allows full flash control, integrated by the camera's powerful metering system. The D7000's built-in flash can act as the "commander" unit, controlling multiple Speedlights in one or two separate groups.

To enable Commander mode, and tune the output of one or more remote Speedlights, use Custom setting e3 **Flash cntrl for built-in flash**. To allow the camera to regulate flash output, set **Mode** to **TTL** for each unit or group. **Comp** settings are exactly like Flash Compensation *(see page 166).*

› High speed flash sync

Nikon's SB-900, SB-800, SB-700, SB-600, and SB-R200 Speedlights offer Auto FP High Speed sync. This enables the flash output to be phased or pulsed, allowing flash to be used at all shutter speeds. Combining flash with fast shutter speeds is useful, for instance, when ambient light levels are high or you wish to employ a wide aperture.

Enable Auto FP High Speed sync using Custom setting e1. If a suitable Speedlight is attached, flash can then be used at any shutter speed from 30 sec. to 1/8000 sec. Note, however, that the effective power (and therefore working range) of the Speedlight will reduce as the shutter speed becomes faster. See the Speedlight manual for more details, and take test shots, reviewing them on the monitor if possible.

› Painting with light

This intriguing technique can be employed with any flashgun, even the cheapest, provided it can be triggered manually. By firing repeated flashes at a static subject from various directions, you can build up the coverage of light without losing the sparkle that directional light gives. It's a matter of trial and error, but that's part of the fun. The basic steps are as follows:

1) Set up so that neither camera nor subject can move during the exposure.

2) Use Manual mode and set a long shutter speed, such as 20 or 30 sec., or even B. Set a small aperture, such as f/16. Focus on the subject, then turn the focus

> **Tip**
>
> *Enabling Auto FP High Speed sync also allows a slightly faster shutter speed (1/320 sec.) to be used with the built-in flash.*

selector to M so that the camera doesn't try to refocus.

3) Turn out the lights. It helps to have enough background light to see what you are doing, but no more.

4) Trip the shutter and then fire the flash at the subject from different directions, without aiming it directly into the lens.

5) After the exposure, review the results and start again. For example, if the result is too bright, use fewer flashes, a lower ISO, or a smaller aperture; or fire from farther away. If the flash has a variable power setting, try turning it down.

MULTIPLE BURSTS OF FLASH ⟩⟩
This shot was made with six bursts of flash, three each from left and right. Some were from slightly in front and some from slightly behind, emphasizing the translucency of the outer leaves.

› Speedlight SB-900

The SB-900 is the flagship of Nikon's Speedlight range, designed to fully complement the advanced capabilities of the latest SLRs such as the D7000. It offers multiple illumination patterns, an impressive 12–135mm zoom range, and automatic detection of sensor format (FX or DX). Coverage can be widened with the built-in diffuser.

The guide number is quoted as 34 (ISO 100/meters), but the effective GN varies according to the zoom setting; however, the SB-900 offers at least three times the

power of the built-in flash, and its reach is even greater at longer focal lengths. The SB-900 can also be employed as a commander, giving integrated flash control with multiple Speedlights.

Guide number (GN)
34 (meters)—ISO 100, set at 35mm zoom

Flash coverage (lens focal length range)
Equivalent of 12–135mm with D7000 (10mm with built-in adapter or separate diffusion dome)

Tilt/swivel
Yes

Recycling time
2.3 sec. with Ni-MH batteries; 4.5 sec. with Lithium batteries

Approximate number of flashes per set of batteries
190 with Ni-MH batteries; 230 with Lithium batteries

Dimensions (w x h x d)
78 x 146 x 118.5mm

Weight (without batteries)
415g

Included accessories
Diffusion Dome SW-13H, Speedlight Stand AS-21, Color Filter Set SJ-900, Color Filter Holder SZ-2, Soft Case SS-900

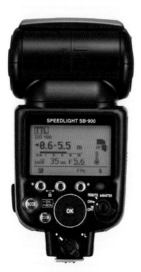

› Speedlight SB-800

Although overtaken by the SB-900, the SB-800 remains a highly capable unit offering ample power plus all the capabilities of Nikon's Creative Lighting System. It can also be employed as the commander in a wireless flash setup.

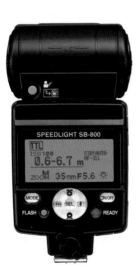

Guide number (GN)
38 (meters)—ISO 100, set at 35mm zoom

**Flash coverage
(lens focal length range)**
24–105mm with full-frame cameras, equivalent to 16–70mm on D7000 (14mm—10mm equivalent—with built-in adapter or supplied diffusion dome)

Tilt/swivel
Yes

Recycling time
2.7 sec. with supplied SD-800 attached; 6 sec. with standard AA batteries

Approximate number of flashes per set of batteries
150 at full power

Dimensions (w x h x d)
70.6 x 127.4 x 91.7mm

Weight (without batteries)
350g

Included accessories
Quick Recycle Battery Pack SD-800 (for one AA size battery), Diffusion Dome SW-10H, Speedlight Stand AS-19, Colored Filter Set SJ-800 (FL-G1 and TN-A1), Soft Case SS-800.

The SB-700 is the latest addition to Nikon's Creative Lighting System. It has several innovative features, including intuitive operation and a choice of illumination patterns.

Guide number (GN)
28 (meters)—ISO 100, set at 35mm zoom

Flash coverage (lens focal length range)
Equivalent to 16–80mm on Nikon D7000

Tilt/swivel
Yes

Recycling time
2.5 sec.

Approximate number of flashes per set of batteries
200

Dimensions (w x h x d)
71 x 126 x 104.5mm

Weight (without batteries)
360g (without batteries)

Included accessories
Speedlight Stand AS-22, Nikon Diffusion Dome SW-14H, Incandescent Filter SZ-3TN, Fluorescent Filter SZ-3FL, Soft Case SS-700.

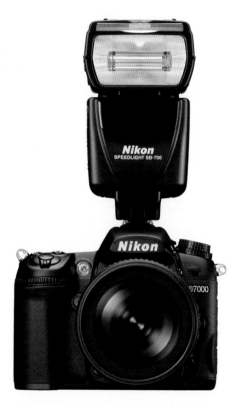

› Speedlight SB-600

Although less powerful or versatile than the numerically higher units, the SB-600 is still a highly advanced flashgun and is fully integrated with Nikon's Creative Lighting System (although it cannot be used as a commander). It works very well as a standalone unit, and has an extensive tilt and swivel ability for bounce flash.

Guide number (GN)
30 (meters)—ISO 100, set at 35mm zoom

**Flash coverage
(lens focal length range)**
24–85mm with full-frame cameras, equivalent to 16–56mm on D7000

Tilt/swivel
Yes

Recycling time
3.5 sec.

Approximate number of flashes per set of batteries
200

Dimensions (w x h x d)
68 x 123.5 x 90mm

Weight (without batteries)
300g (without batteries)

Included accessories
Speedlight Stand AS-19, Soft Case SS-600.

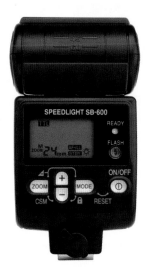

› Speedlight SB-400

A compact, lightweight, and simple flash.

Guide number (GN)
21 (meters)—ISO 100, set at 35mm zoom

Flash coverage
(lens focal length range)
Equivalent to 16–80mm on Nikon D7000

Tilt/swivel
Tilt only

Dimensions (w x h x d)
66 x 56.5 x 80mm

Weight (without batteries)
127g (without batteries)

Included accessories
SS-400 soft case

› Speedlight SB-200

Designed to work as part of a close-up lighting system; can't be used as a standalone or attached to the camera's hotshoe. It can be triggered using the D7000's built-in flash as a commander, or an SU-800 commander, or SB-900/SB-800 Speedlight.

› Wireless Speedlight Commander SU-800

The Wireless Speedlight Commander SU-800 allows complete control over a complex setup of up to three groups of Speedlights.

› Speedlight Commander Kit R1C1 and Speedlight Remote Kit R1

Dedicated kits for close-up photography
(see page 185).

FLASH ACCESSORIES

Nikon has an extensive range of flash accessories, such as diffusers, reflectors, and remote leads, allowing yet more flexibility and control over lighting effects.

Battery Pack SD-800
Quick recycling battery pack supplied with the SB-800. Takes an extra AA battery to speed recycling time to 2.7 sec.

Battery Pack SD-8A
External power source for a higher flash capacity, compatible with the SB-800 and some earlier Speedlights.

Speedlight Stand AS-19
Allows compatible Speedlights to stand on a flat surface or be mounted on a tripod.

Color Filter Set SJ-1
Color filter system for the SB-800/SB-600 with eight different colors.

TTL Sync Cord SC-28
Extending to 5ft (1.5 meters), this cord allows a compatible Speedlight to be positioned well away from the camera.

TTL Sync Cord SC-29
Adds an AF-assist illuminator to the SC-28 (this only works with the SB-800).

› Flash diffusers

Flash diffusers are a simple, economical way to spread and soften the hard light from flashguns. They may slide over the flash head, like Nikon's SW-10H diffusion dome (included with the SB-800), or be attached by other means such as rubber bands or Velcro. The Jessops Universal Flash Diffuser is an ultra-cheap option.

Inevitably, diffusers reduce the light reaching the subject; the D7000's metering system will allow for this, but remember that the effective range will be reduced.

› Flash brackets

The ability to mount the flash off camera, and therefore to change the angle at which the light hits the subject, is invaluable in controlling the quality of light. Nikon's Speedlights can be mounted on a tripod or stand on any flat surface using the AS-19 stand, but for a more portable solution, many photographers prefer a light flexible bracket that attaches to the camera and supports the flashgun. Novoflex produces a range of such products.

» CLOSE-UP *180–182*

» CLOSE-UP ATTACHMENT LENSES *183–184*

» MACRO FLASH *185–186*

» MACRO LENSES *187*

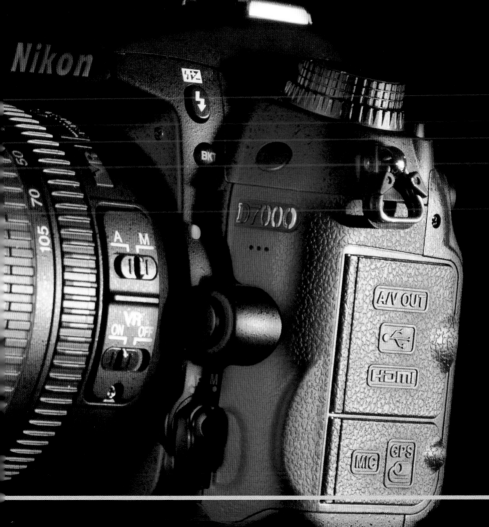

Chapter 5
CLOSE-UP

5 CLOSE-UP

Most photography is about capturing what you can see with the naked eye. Close-up photography goes beyond this into a whole new world, or at least a new way of seeing the world.

For close-up photography, the 35mm SLR and digital successors like the D7000 reign supreme. Reflex viewing is practically essential in close-up work—supplemented by Live View on occasions. Also, the D7000 is part of the legendary Nikon system of lenses and accessories, which offers many additional options for close-up photography.

A key issue in close-up and macro photography is depth of field. As you move closer to the subject, depth of field becomes narrower. This has several consequences. First, it's often necessary to stop down to small apertures, which can make long exposures essential. Second, the slightest movement of either subject or camera can ruin the focus. For both reasons, a tripod or other solid support is often required. It may also be necessary to prevent the subject from moving.

Because depth of field is so slim, focusing becomes critical. Merely focusing on "the subject" is no longer adequate, and it is necessary to decide which part of the subject—an insect's eye, the stamen of a flower—should be the point of sharp focus. With its 39 AF points, the D7000 can

Tip

To ensure that you're as close to the subject as you can possibly get, use manual focus and set the lens to its minimum focusing distance. Don't touch the focus control again; instead move either camera or subject until the image is sharp. This may seem slow, but it does guarantee that you're as close as the lens will allow.

FINE ALE, FINE DETAIL «
Close-up subjects are everywhere, such as this simple glass of beer, and close-up photography really opens our eyes to them.

focus accurately within much of the frame, but this is also where Live View mode comes into its own. By selecting 〔□〕 WIDE Wide-area AF or 〔·〕 NORM Normal area AF *(see pages 75–76)*, the focus point can be set anywhere in the frame. If you prefer to use manual focus, Live View, with its zoom facility, also makes this ultra-precise.

Macro photography

There's no exact definition of "close-up," but the term "macro" really should be used more precisely. Traditionally, macro photography means photography of objects at lifesize or larger, implying that a true macro lens should allow a reproduction ratio of at least 1:1. Many zoom lenses are sold as having "macro" capability when their reproduction ratio is around 1:4 or 1:2 at best. This still allows a great deal of fascinating close-up photography, but it isn't true macro.

Reproduction ratio

The reproduction ratio (or image magnification) is the ratio between the actual size of the subject and the size of its image on the D7000's imaging sensor,

which measures 23.6 x 15.8mm. An object of the same dimensions captured at 1:1 would exactly fill the image frame. For example, an SD memory card is a little larger than this, so at 1:1 the image of the card will completely fill the frame, and then some. When the image is printed, or displayed on a computer screen, it may appear many times larger, but that's another story.

A 1:4 reproduction ratio means that the smallest subject that would give you a

BICYCLE CHAIN »
The first shot *(above right)* shows the closest view achieved with a "normal" 18–105mm zoom lens (approximately 1:4). The second *(bottom right)*, taken with a 50mm macro lens at the closest possible distance, gives approximately life size (1:1) reproduction.

5

Tip

When using the built-in flash on close-up subjects, a longer working distance also reduces the likelihood that the lens/lens hood will cast a shadow on the subject.

Working distance

Working distance is the distance required to obtain the desired reproduction ratio with any given lens. It is directly related to the focal length of the lens: with a 200mm macro lens, the working distance for 1:1 reproduction is double that of a 100mm lens. This can be a big help when photographing living subjects.

frame-filling shot would be one that's four times as long/wide as the sensor. With DX-format cameras like the D7000, this is approximately 4 x 2½in (94 x 63mm)—slightly larger than a credit card.

LICHEN ⌄
The minimal depth of field obtained in extreme close-up shooting is exemplified in this shot, at close to 1:1 reproduction ratio.

» CLOSE-UP ATTACHMENT LENSES

Close-up attachment lenses are simple magnifying lenses that screw into the filter thread of the lens. They are light, easy to carry and attach, and relatively inexpensive. They are also easy to use, since they are fully compatible with the camera's exposure and focusing systems. For best results, it's best to use them with prime (fixed focal length) lenses.

Nikon produces six close-up attachment lenses *(see table below)*.

› Extension tubes

Extension tubes, also known as extension rings, are another simple, relatively inexpensive way of extending the close-focusing capabilities of an existing lens. An extension tube is just that: a tube that fits between the lens and the camera. This decreases the minimum focusing distance and thereby increases the magnification factor. Again they are light, compact, and easy to carry and attach. Unlike close-up attachment lenses, they contain no glass

elements and should not compromise the optical quality of the lens. They can also be used with almost any lens.

The Nikon system includes four extension tubes, PK-11A, PK-12, PK-13, and PN-11, which extend the lens by 8mm, 14mm, 27.5mm, and 52.5mm respectively. The PN-11 incorporates a tripod mount. These extension tubes do not support many of the camera's functions. There's no autofocus (although arguably this is less of a drawback in macro photography than in most other areas), no auto-exposure modes, and no matrix metering. But if you're prepared to use the D7000 in the old-fashioned way, they offer a great low-cost route into true macro photography.

Note:
Compatible extension tubes are also produced by other manufacturers, notably Kenko. These may support exposure metering, but still do not permit autofocus.

Product number	Attaches to filter thread	Recommended for use with
0, 1	52mm	Standard lenses
3T, 4T	52mm	Short telephoto lenses
5T, 6T	62mm	Telephoto lenses

5

› Bellows

Like extension tubes, bellows increase the distance between the lens and the camera body. However, they are not restricted to a few set lengths. Again, there's no extra glass to impair optical quality. Bellows are expensive, heavy, and cumbersome, though, and take time to set up. They are usually employed in controlled shooting situations, such as a studio.

Nikon's PB-6 bellows offers extensions from 48mm to 208mm, giving a maximum reproduction ratio of about 11:1. Focusing and exposure are manual only.

› Reversing rings

Also known as reverse adapters or inversion rings, these allow lenses to be mounted in reverse; the adapter screws into the filter thread. This allows much closer focusing than when the lens is used normally. Ideally, they should be used with a prime lens, such as an old manual-focus 50mm f/1.8: Nikon's BR-2A inversion ring fits a 52mm filter thread.

> *Note:*
> Because extension tubes and bellows increase the effective physical length of the lens, they also increase the effective focal length. However, the physical size of the aperture does not change. The result is that the lens is "slower"; that is, a lens with a maximum aperture of f/2.8 begins to behave like an f/4 or f/5.6. This makes the viewfinder image dimmer than normal and affects the exposure required, although the camera's metering will compensate. Reversing rings do not have this effect.

» MACRO FLASH

Controlled lighting is often required for serious macro work, and this usually means flash. However, regular Speedlights are less than ideal. They are not designed for such close-range work and, if mounted on the hotshoe, the short working distance means that the lens may throw a shadow onto the subject. The built-in flash is even less suitable for real close-up work; Nikon's manual gives a minimum range of 2ft (0.6m).

Specialized macro flash units usually take the form of a ring-flash or twin flash. Because of the close operating distances, they do not need high power, and can be relatively light and compact.

A ring-flash unit fits around the lens itself, giving an even spread of light even on ultra-close subjects. Nikon's SB-29s has been discontinued, but may still be found at some dealers. Alternatives come from Sigma and Marumi.

Nikon now concentrates on a twin-flash approach with its Speedlight Commander Kit R1C1 and Speedlight Remote Kit R1. Both rely on two Speedlight SB-R200 flashguns, which mount each side of the lens. The R1C1 uses a Wireless Speedlight Commander SU-800 unit, which fits into

Speedlight Commander Kit R1C1

JOINTED RUSH *(Juncus articulatus)*　　**»**
The natural light was very flat; to enliven the shot, I used a Nikon SB-600 flash off to the left, triggered wirelessly by the built-in flash of the D7000.

5

the camera's hotshoe, while the R1 employs either a separate SB-800 flash or the D7000's own built-in flash as the commander. These kits are expensive, but they give flexible and controllable light for macro subjects.

› Improvisation

Dedicated macro flash units are expensive, and may be unjustifiable for occasional macro work. You can do a lot with even the most basic flashgun, plus a remote cord. With the cheapest flashguns, you'll lose the D7000's advanced flash control, but it only takes a few test shots to establish settings that you can use repeatedly. An essential is a small reflector, perhaps just a piece of white card; position it as close as possible to the subject for maximum benefit.

This arrangement can even be more

Tip

One reason why flash is often favored in close-up work is to overcome the problem of subject movement. When such movement is caused by a breeze, it can be reduced with a "light tent," which also throws a diffused, even light on the subject. Examples are available from Lastolite, that also produce the collapsible ePhotomaker, but it's possible to make your own; the fabric needs to let plenty of light through and be neutral in color.

flexible than twin-flash or ring-flash, allowing the light to be directed wherever you choose. With static subjects, "painting with light" *(see page 170)* is also an option.

CHARD LEAVES ⌄
This lighting setup is very simple, with one flashgun fired from the left. A white reflector was placed close to the leaf to bounce light back into the shadows.

ORCHID FLOWERS *(Phalaenopsis)* ⌄
The lighting here is a little more complex, with one flashgun directly behind the flower and a second off to the right. A long exposure allows ambient light to register and fill in some shadows.

» MACRO LENSES

True macro lenses achieve reproduction ratios of 1:1 or better and are optically optimized for close-up work, although normally they are suitable for general photography, too. This is certainly true of Nikon's widely admired Micro Nikkor lenses, of which currently there are four.

The 60mm f/2.8G ED AF-S Micro Nikkor is an improvement on the previous 60mm f/2.8D AF Micro Nikkor because of the use of ED (Extra-low Dispersion) glass for superior optical quality, a Silent Wave Motor (SWM) for ultra-quiet autofocus, and a non-rotating front element, which makes life easier when using front-mounted macro flash.

The 105mm f/2.8G AF-S VR Micro Nikkor also features internal focusing, ED glass, and a Silent Wave Motor. It is the world's first macro lens with VR (Vibration Reduction). Since the slightest camera shake is magnified at high reproduction ratios, VR can be a boon, allowing the use of shutter speeds as much as four stops slower than otherwise possible. However, it cannot compensate for subject movement.

The 200mm f/4D ED-IF AF Micro Nikkor is a favorite among wildlife photographers,

Nikkor 105mm macro lens

since its longer working distance means there is less chance of frightening the subject away. Finally, Nikon has produced its first Micro Nikkor lens for the DX format: the 85mm f/3.5G ED VR AF-S DX Micro NIKKOR. This achieves 1:1 reproduction, and features VRII, internal focusing, ED glass, and Silent Wave Motor.

BUTTERFLY HOUSE »
Longer lenses are very useful for some subjects, especially those that can fly away. Depth of field is minimal, but one wing is almost parallel to the camera, which helps

» MOVIE MODE *190–191*

» SHOOTING MOVIES *192–193*

» MAKING MOVIES *194–199*

» EDITING MOVIES *200–201*

Chapter 6
MOVIES

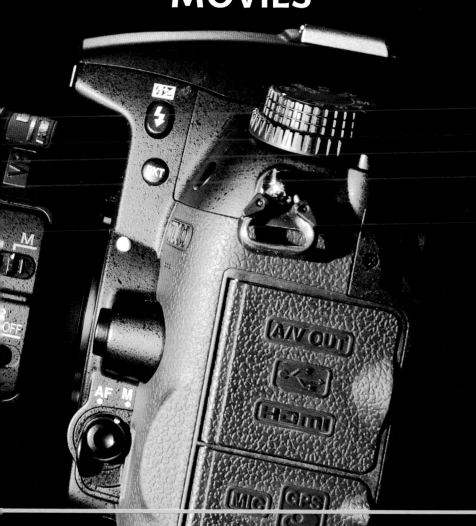

6 MOVIES

The ability to record moving images is now widespread among DSLRs, but it was as recently as August 2008 that the Nikon D90 became the first DSLR to offer this feature. Movie mode is really an extension of Live View, which creates some idiosyncrasies and limitations in the way it works. These need to be understood to get the best results. Familiarity with Live View shooting is a big asset when you start shooting movies.

Movie quality

The D7000 is the first Nikon DSLR to shoot movies in Full HD (High Definition) quality, with a frame size of 1920 x 1080 pixels. This means that movies shot on the D7000 can be played through an HD TV and will look excellent on most computer screens. The D7000 produces movies in a standard Motion-JPEG format (the file extension is .AVI) which is acceptable to such media players such as QuickTime, RealPlayer, and Windows Media Player.

Today many compact cameras and camcorders also deliver HD resolution, but because the D7000 has a larger sensor, its image quality can be superior in many respects. However, a dedicated camcorder will have ergonomic advantages.

The D7000 also allows you to select frame sizes of 1280 x 720 and 640 x 424 pixels. The smaller size is fine for YouTube or playing on the majority of mobile devices, and the lower settings allow you to record more video on the same memory card. A 4GB card will hold a little over 20 min. of footage at the highest quality setting, almost two hours at the lowest.

Advantages

Although dedicated movie makers will probably stick with cameras designed specifically for shooting video, the D7000 does have some advantages over these. The biggest plus is its ability to use the entire array of Nikon-fit lenses, giving a range that is difficult to match with any

**BEACON CLIMBING CENTER, GWYNEDD, «
WALES, UK**
The D7000 allows wide-angle shooting. Here a 12mm lens was used; I was actually almost close enough to reach out and touch the climber.

WINDSURFER, YYTERI, FINLAND ☆
It's much easier to obtain really shallow depth of field than with most video cameras. Focus was on the surfer, and the distant coastline is quite soft.

BANDSTAND, TIVOLI, COPENHAGEN, DENMARK ☆
The D7000 also scores when it comes to low-light shooting.

conventional video camera, especially for wide-angle shooting.

Another plus is that the D7000's larger sensor and ability to use lenses with wide maximum apertures make it possible to achieve a shallower depth of field than with most camcorders and compact cameras.

The D7000's large sensor and ability to shoot at ISO settings of 6400 and above also mean that results in low light should be better than most of the alternatives. In addition, the full range of exposure settings, Nikon Picture Controls, and many other options can be used, giving a high level of creative control.

Limitations

The movie mode of the D7000 is a big advance on the D90, but some limitations

remain. The viewing system makes handheld shooting awkward, and Live View AF isn't slick enough for fast-moving subjects. Sound quality is at best mediocre unless you attach a separate microphone.

The D7000 records video from the sensor by a "rolling" scan, rather than capturing the whole frame at one go. This produces an odd effect when dealing with fast movement, whether it's a rapid pan of the camera or movement of the subject itself: objects can appear distorted, with rectangular shapes turning to parallelograms and so on. If you rock the camera violently from side to side, you can even achieve a wobbly effect that has come to be called "jello-cam." Some movie editing software will compensate for this.

6 » SHOOTING MOVIES

Autofocus

For shooting movies, the D7000 offers the same focusing options as Live View, including manual focus. While the quality of the Live View display does make manual focusing fairly easy, at least in good light, it is difficult to operate the controls really smoothly, especially when handholding the camera.

Exposure

Exposure control depends on the exposure mode selected. In Auto and Scene modes, exposure control is fully automatic, although exposure level can be locked using the **AE-L/AF-L** button. This is useful, for instance, to prevent the main subject from appearing to darken as it moves against a brighter background.

If **P**, **S**, **A**, or **M** mode is selected, exposure levels can be adjusted by ±3 Ev using the ▣ button. In addition, in **A** mode, aperture can be manually adjusted during shooting. Normally, the camera will set the shutter speed automatically and adjust the ISO sensitivity if necessary to keep shutter speed within suitable limits. However, in mode **M**, provided the Manual movie settings option is On, both shutter speed and aperture can be adjusted manually. Also, ISO sensitivity is not adjusted automatically.

While all these adjustment options are welcome, actually making them while shooting is awkward. It's difficult to avoid joggling the camera unless it's on a very solid tripod, and the built-in microphone can pick up the sounds of the operations. Another consequence can be abrupt changes in brightness level in the resulting footage. Getting these things right takes practice.

Sound

The D7000 has a built-in microphone, giving modest-quality mono output. It is very sensitive to wind noise and liable to pick up any sounds you make while operating the camera (focusing, zooming, even breathing). Sensitivity can be adjusted in the Movie settings section of the Shooting menu, and there is always the option of adding a soundtrack later. However, this is difficult if your film includes people speaking. If you want to include dialog or "talking heads," keep subjects close to the camera and ensure that background noise is minimized.

Fortunately, the D7000 allows you to attach an external microphone, which also permits stereo sound to be recorded. External microphones connect to a standard 3.5mm mini-jack socket under the cover on the left side of the camera. This automatically overrides the internal microphone.

› Preparing to shoot

Before starting to shoot, select key settings in the **Movie settings** section of the Shooting menu. This has four sub-menus:

Quality sets the image size, frame rate, and quality for movie recording. The size options are: 640 x 424 pixels (default), 1920 x 1080 pixels, and 1280 x 720 pixels. The frame rate options vary according to the size chosen and whether NTSC or PAL is selected for video mode.

Microphone determines the sensitivity of the microphone (built-in or external). The options are: Auto, High, Medium, Low, and Off.

Destination determines which card slot is used for recording the movie. It makes sense to use one card for stills and one for movies.

Manual movie settings, allows manual adjustments to be made to shutter speed and ISO setting.

› Shooting

1) Choose exposure mode, AF mode, and AF-area mode as for Live View shooting.

2) Activate Live View by flicking the **Lv** switch.

3) Check framing and initial exposure level. If using **A** or **M** exposure mode, set the aperture. Set initial focus by depressing the shutter-release button halfway.

4) Press the center of the Live View switch to start recording. A red **REC** flashes at the top of the monitor screen and an indicator shows the maximum remaining shooting time.

5) To stop recording, press the center of the Live View switch again.

6) Exit Live View by flicking the **Lv** switch.

6 » MAKING MOVIES

A golden rule when shooting movies is to think ahead. If you shoot a still frame and it isn't quite right, you can review it, change position or settings, and be ready to shoot again within a second or two. To shoot and review even a short movie clip eats up much more time, and often you don't get a second chance anyway. Therefore, it's doubly important to make sure shooting position, framing, and camera settings are right before you start. A good habit to adopt is to check the general look of the shot by taking a still frame before you start the movie clip.

A still frame can only tell you so much, however, and does not allow for movement of the subject, the camera, or both. For example, the D7000 has limited ability to follow focus on a moving subject when movie shooting. This can be an issue if the subject is moving toward or away from the camera, or you plan to pan across a scene that contains several objects at different distances. Sometimes you can rely on depth of field to cope with this, more so when shooting with wide-angle lenses than long telephotos. Rapid subject movement can be a real problem.

Thus it is relatively easy to shoot action when the subject is at a constant distance (e.g., panning shots on the inside of a curve); otherwise, depth of field is your friend, so you should use a small aperture, with a high ISO setting if necessary.

Shooting movies is plainly more complex than shooting stills. It makes sense to start with simple shots; don't try zooming, panning, and changing focus simultaneously, but alter one thing at a time. Many moving subjects can be filmed with the camera in a fixed position; good examples include waterfalls, fountains, birds coming and going at a feeder, and musicians playing. Equally, you can become familiar with camera movement while shooting static subjects: try panning across a wide landscape or zooming in from a broad cityscape to a detail of a single building.

› Handheld or tripod shooting

It's impossible to overemphasize the importance of a tripod for shooting good movies. Shooting handheld is a good way to reveal just how wobbly you really are—especially since you can't use the viewfinder. Of course, even professional movie directors sometimes use handheld cameras to create a specific feel, but there's a big difference between controlled wobble for deliberate effect and unwanted, uncontrolled, and unending shakiness. Using a tripod or other suitable camera support is the best and easiest way to give

Tip

A standard tripod with a pan-and-tilt head is a good start. Ball-and-socket heads are fine for static shots and zooms, but less suitable for panning. If you're serious about movies, consider investing in a dedicated video tripod. This will have a head specifically designed for smooth movement. The best are fluid-damped for ultra-smooth results. Often your existing tripod legs will be fine and you may only need to change the head.

PANNING SPEED ⌃
Too rapid a pan can make objects appear severely distorted.

movie clips a polished, professional look.

If you choose to handhold, or need to shoot a clip when no tripod is available, it really pays to approach the task carefully. Adopt a comfortable stance where you won't be jostled; look for something solid on which you can rest your elbows. Sometimes you can get better results by sitting with elbows braced on your knees. Whatever you do, think "steady."

› Panning

The panning shot is a mainstay of movie making. Often essential for following a moving subject, it can also be used to great effect with static subjects. For instance, a panning shot enables you

to capture a vast panorama in a way that's impossible in a single still frame.

Handheld panning is very difficult to get right; it might look acceptable when following a moving subject, but a wobbly pan across a grand landscape will definitely irritate most viewers. This really does call for a tripod.

TRÀIGH MHÒR, BARRA, OUTER HEBRIDES, UK ⌃
Panning with the plane is an obvious shot, but the tripod must be leveled correctly in advance, or it could appear to be landing on a steep slope.

The tripod needs to be properly leveled. Otherwise you may start panning with the camera aimed at the horizon, but finish with it showing nothing but ground or sky. Many tripods have a built-in spirit level; failing this, visually check that the tripod's central column looks vertical from all sides. Carry out a "dry-run" before shooting. If you're panning to follow a moving subject, you also need to think about its expected path. Some subjects move predictably—trains being obvious examples. At the other extreme, trying to follow a player in a football game can be very challenging: even seasoned pros don't always get that right.

It's best to start with static subjects such as landscapes. Of course, even landscapes aren't always static, and the combination of a panning shot with waves breaking on the shore or grass blowing in the breeze can produce beautiful results. If there's a stream or river in the shot, try panning both with the current and against it.

Keep panning movements slow and

> ### Tip
>
> *Many tripod heads have projecting arms that are used to lock and unlock the movements; one of these controls the pan adjustment, and holding this lightly at its end will help you obtain a smooth panning movement. Extra length gives even finer control, so if you do a lot of panning shots it could be worth adding an extension. This could be as simple as a length of wooden rod secured with strong rubber bands.*

steady. Panning too rapidly can make it difficult to "read" the shot and even make the viewer feel seasick. With the D7000, it can also make objects appear distorted. Smooth panning is easiest with a video tripod, but is perfectly possible with a standard model: leave the pan adjustment slack, but make sure the other adjustments are tight. It's probably better to hold the tripod head rather than the camera. It can be easier if you don't try to look at the screen, which is unnecessary if you've framed the shot properly in advance. Instead use the front

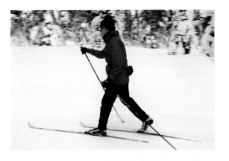

CROSS-COUNTRY SKIER, YLLÄS, **»**
FINLAND
A classic panning shot, but still difficult to follow neatly when handholding.

SURVEYING THE SCENE ⌃
The camera can "explore" a scene such as this—Scarborough, North Yorkshire, UK—either by panning across it or by zooming in on specific aspects of the subject.

of the lens as a reference to track steadily across the scene.

With a moving subject, the speed and direction of panning is dictated by the need to keep the subject in frame. Here you may need to watch the screen to keep the subject in approximately the same place in the frame. Fast-moving subjects can be very hard to track accurately.

› Zooming

The zoom is another fundamental movie technique. Moving from a wide view to a tighter one is called zooming in, and the converse is zooming out. A little forethought makes all the difference to using the zoom effectively; consider which zoom direction you want (in or out), and consider the framing of the shot both at the start and at the end. If you're zooming in to a specific subject, double-check that it's central to the frame before starting.

The D7000 and its range of lenses are not designed specifically for shooting movies, which becomes apparent when it comes to zooming. Firstly, none of them has such a wide zoom range as a video

camera lens, although "superzooms" (e.g., Tamron's 18–270mm) can be handy for movie shooting. They may lack ultimate quality for still images, but video (even Full HD) has much lower definition. Even so, sometimes you may have to cut from one shot to another instead of linking them in a continuous zoom.

Secondly, whether the lens has a zoom ring or a "trombone" action, it's difficult to achieve a totally smooth, even-paced zoom action. Practice does help, as does mounting the camera firmly on a solid tripod. Trying to zoom while handholding is a recipe for jerkiness. If you have a selection of lenses, experiment to see which has the smoothest zoom action.

A really quick zoom, known a "whip zoom," is hard to execute with most lenses on the D7000, but you can try. It can always be edited out later, replacing the zoom with a quick cut from wide shot to close—run the camera for a few seconds of static shots before and after the zoom.

When zooming, remember that depth of field decreases at the telephoto end of the range. Your subject may appear perfectly sharp in a wide-angle view, but end up looking quite fuzzy when you zoom in; if the camera refocuses, the sudden shift in focus is a distraction in itself. To avoid this, set focus at the telephoto end of the zoom, whether you're starting here and zooming out, or zooming in to end up here.

› Focusing

The D7000's large sensor and ability to use long telephoto lenses make it possible to achieve very shallow depth of field, which is virtually unattainable with compact cameras and camcorders. This can give some very striking effects, and is one of the strongest features of the D7000's Movie mode.

The D7000 will automatically maintain focus while movie recording is in progress, provided Full-time servo AF (AF-F) is selected first, although it may lag behind rapid camera movements. If Single-servo AF (AF-S) is selected, the camera will only refocus when you depress the shutter-release button halfway, which is often very obvious in the final movie clip. However, maintaining half-pressure on the button is one way of locking focus. Using a fixed focus for each shot is often perfectly viable, especially when depth of field is good. This reduces operations that can make the shot wobbly and avoids distracting shifts of focus in midshot.

Manual focusing is also possible, but can be another recipe for wobbly pictures. Yet again, this indicates the need for a tripod, especially with longer lenses, where focusing is more critical and wobbles are magnified. Some lenses may have a smoother manual focus action; the physical design of older lenses often makes them more suitable, with large and well-

placed focus rings. Older lenses commonly have a distance scale marked on the lens barrel, which can offer a viable alternative to using the Live View display to focus. Additionally, refocusing manually avoids undesirable focus shifts during shooting.

Study the credits for major movies and TV shows, and you'll often see someone called a "focus puller." This is an assistant to the camera operator, whose sole task is to adjust the focus, normally between predetermined points, such as shifting from one character's face to another. This leaves the camera operator free to concentrate on framing, panning, and zooming. Frequently, the focus puller uses the distance scale on the lens barrel, relying on previously measured distances. While this may seem a long way from shooting simple movie clips on the D7000, it does suggest that it could be worth trying a bit of teamwork, especially if you want to pan or zoom at the same time as adjusting focus.

> ## Importing movies to the computer

The basic procedure for importing movies is much the same as for stills. Nikon Transfer will recognize and import them, but it's likely you will want to store movies in a different folder to still images. Some dedicated photographic software will not import movie files, and often the best way to import them is through your movie editing software *(see overleaf)*; this ensures that all your movie clips are stored in the same place and that the software can immediately locate them for editing.

To keep things in order when downloading, it may help to use one memory card slot as primary destination for stills and the other for movies (Shooting Menu> Movie settings> Destination).

Warning!

Older lenses lacking a CPU can only be used on the D7000 in Aperture-priority or Manual mode. Use the **Non-CPU lens data** item in the Setup menu to optimize the functionality of such lenses.

6 » EDITING MOVIES

iMOVIE «

The iMovie editing program comes will all new Apple Macs.

WINDOWS MOVIE MAKER ⌄

Windows Movie Maker software is bundled with most Windows PCs.

Like all movie cameras, the D7000 doesn't shoot movies, it shoots movie clips. A single clip straight from the camera may serve some purposes—if you capture a bank raid in progress, it could even earn you a reward!—but to turn a collection of clips into a movie worth watching means editing.

The name of the game here is Non-Linear Editing (NLE). This means that clips in the final movie don't have to appear in the same order in which they were shot. You might shoot a stunning tropical sunset on the first night of your vacation, but use it as the closing shot in your movie.

In fact, with modern software, editing digital camera movies is almost easier to do than it is to describe. The D7000's .AVI movies are a standard format that can be edited in most available programs. Even better, if you own a recent computer, you probably already have suitable software.

For Mac users, the obvious choice is Apple's iMovie, part of the iLife suite, which is included with all new Macs. The Windows equivalent is Windows Movie Maker, which came preinstalled with Windows Vista; for Windows 7, it must be downloaded from windowslive.com.

Both programs offer Non-Linear Editing, which is nondestructive. This means that editing does not affect your original clips; the new movie is produced by copying the desired sections. During editing, you work with preview versions of these clips, and the software keeps "notes" on the edit; a

new movie file is only created when you select Export Movie (in iMovie) or Save (in Windows Movie Maker).

iMovie has a largely visual interface, while Windows Movie Maker relies more on text-based menus. In both cases, the movie clips you work with are displayed in one pane of the screen and you simply drag the one you want to the Project pane (iMovie) or Timeline (Windows Movie Maker). You can rearrange clips at any time just by drag-and-drop, and you can trim any clip to a desired length (iMovie's procedure for this is definitely more intuitive). A Viewer pane allows you to preview your movie as a work in progress at any time.

You can also adjust the look of any clip or segment of the movie. There are basic controls for brightness, color, and so on, just as with any photo-editing program. A range of special effects can also be added: e.g., give your movie an "aged" look, as if it had been shot on film many years ago.

Another basic feature of both programs is the transition. This means that instead of simply cutting instantaneously from one shot to the next, you can apply effects such as dissolves, wipes, and fades. They're fun to play with and can add visual polish to the finished movie, but it's better to work with just a few transitions rather than using every possible trick in the course of a five-minute movie. Generally, transitions should enhance the shots on either side and help the narrative flow of the movie.

› Adding to your movie

iMovie and Windows Movie Maker allow you to add other media to your movie, like still photos and sound. With a quality camera like the D7000, adding stills is easy, but you can use photos from other sources, too. You can insert them individually at appropriate points or create slideshows within the main movie. Again, various effects and transitions can be applied to give a more dynamic feel as you move from one photo to the next. It's equally easy to add a new soundtrack, like a voiceover or music, to part or all of the movie. Last, but not least, you can add titles and captions.

› Storyboarding

Editing can transform a jumbled assortment of clips into a coherent movie, but it can also lead to frustration when you realize that a wider shot of X, or a close-up of Y would have been better. This is where planning comes in, and why big movie productions start with a screenplay and a storyboard before a single scene is shot. A storyboard looks like a giant comic strip, with sketches of every shot and scene envisaged in the final movie. Things can still change in the final edit, but storyboarding should give the director and editor all the material they need to work with. You may not want to go that far, but a bit of forward planning can still add to the final movie.

» NIKON LENS TECHNOLOGY *205–206*

» FOCAL LENGTH *206–208*

» PERSPECTIVE *209*

» STANDARD LENSES *210*

» WIDE-ANGLE LENSES *211*

» TELEPHOTO LENSES *212*

» ZOOM LENSES *213*

» MACRO LENSES *213*

» PERSPECTIVE CONTROL LENSES *214*

» TELECONVERTERS *215*

» NIKKOR LENS CHART *217–221*

Chapter 7
LENSES

7 LENSES

There are many reasons for choosing an SLR like the D7000 over a compact. One of the most important is the ability to use a vast range of lenses, including Nikon's own legendary system as well as lenses from other makers.

Nikon's F-mount lens mount is—in its basic form—50 years old. Continuity of design means that most Nikkor lenses will work on the D7000, although sometimes with major limitations. The best lenses for the camera, however, are among the more recent range, not least because many older lenses lack a CPU, making a number of automatic functions unavailable.

Warning!

Do not use older pre-AI lenses, since they can damage the camera. They can be recognized by their meter-coupling prong *(see below)*. Certain other specific (and uncommon) lenses should also be avoided and are listed in the maker's manual.

Another reason for preferring lenses designed specifically for digital cameras concerns the way light reaches the minute individual photodiodes, or "photosites," on the camera's sensor. Because these are slightly recessed, there can be some cutoff if light hits them at an angle. This is less critical with 35mm film, for which older Nikkor lenses were designed. Nikon's DX-series and other newer lenses are specifically designed to ensure that light hits the sensor as nearly perpendicular as possible, maintaining illumination and image quality right across the frame.

Many older lenses can still be used, however, and will often give very good results, although a critical examination may detect some loss of brightness toward the edges of the frame, and perhaps a hint of chromatic aberration (color fringing). Wide-angle lenses are most susceptible, telephotos less so. Much depends on the size of print or reproduction you require; to some extent, these shortcomings can be corrected in post-processing, especially if you shoot RAW files. DX lenses are specifically designed for digital cameras and appear first in the table of Nikkor lenses on *pages 216–21*.

» NIKON LENS TECHNOLOGY

Nikon's lens range has long been renowned for technical and optical excellence, and many lenses incorporate special features or innovations. Since these are referred to extensively in the lens tables, brief explanations of the main terms and abbreviations are given in the table below.

Abbreviation	Term	Explanation
AF	Autofocus	Lens focuses automatically. Most current Nikkor lenses are AF, but a substantial manual-focus range remains.
ASP	Aspherical Lens Elements	Precisely configured lens elements that reduce the incidence of certain aberrations. Especially useful for reducing distortion with wide-angle lenses.
CRC	Close-range Correction	Advanced lens design that improves picture quality at close focusing distances.
D	Distance information	D-type and G-type lenses communicate information to the camera about the distance at which they are focusing, supporting functions like 3D Matrix Metering.
DC	Defocus-Image Control	Found in a few lenses aimed mostly at portrait photographers; allows control of aberrations and thereby appearance of out-of-focus areas in the image.
DX	DX lens	Lenses designed for DX-format digital cameras.
G	G-type lens	Modern Nikkor lenses with no aperture ring; aperture must be set by the camera.
ED	Extra-low Dispersion	ED glass minimizes chromatic aberration (tendency for light of different colors to be focused at different points).
IF	Internal Focusing	Only internal elements of the lens move during focusing: the front element does not extend or rotate.
M/A	Manual/Auto	Many Nikkor AF lenses offer M/A mode, allowing seamless transition from automatic to manual focusing.
N	Nano Crystal Coat	Said to virtually eliminate internal reflections within lenses, minimizing flare.

Abbreviation	Term	Explanation
RF	Rear Focusing	Lens design where only the rearmost elements move during focusing: makes AF operation faster.
SIC	Super Integrated Coating	Nikon developed lens coating that minimizes flare and "ghosting."
SWM	Silent Wave Motor	Special in-lens motors that deliver very fast and very quiet autofocus operation.
VR	Vibration Reduction	System that compensates for camera shake. VR is said to allow handheld shooting up to three stops slower than would otherwise be possible (i.e., 1/15 instead of 1/125 sec.). New lenses feature VRII, said to gain an extra stop over VR (1/8 instead of 1/125 sec.).

» FOCAL LENGTH

Most photographers are familiar with the term "focal length," but it is often misapplied. The focal length of any lens is a basic optical characteristic, which is not changed by fitting the lens to a different camera. A 20mm lens is a 20mm lens, no matter what. Unfortunately, the lenses on most digital compact cameras are described not by their actual focal length, but by their "35mm equivalent," i.e., the focal length that would give the same angle of view on a 35mm or full-frame (FX) camera.

Of course, zoom lenses do have variable focal length (that's what zoom means), but an 18–55mm zoom is an 18–55 whether it's fitted on a DX-format camera like the D7000 or an FX camera like the

D3s. However, because the D7000 has a smaller sensor than the D3s, the actual image shows a smaller angle of view.

Crop factor

The D7000's smaller sensor, relative to the 35mm/FX standard, creates a crop factor, also referred to as focal length magnification factor, of 1.5. If you fit a 200mm lens to a D7000, the field of view is equivalent to what you'd get with a 300mm lens on a 35mm or FX camera. For

BAINES CRAG, LANCASHIRE, UK »
The series of images shown opposite were taken on a Nikon D7000, from a fixed position, with lenses from 12mm to 300mm.

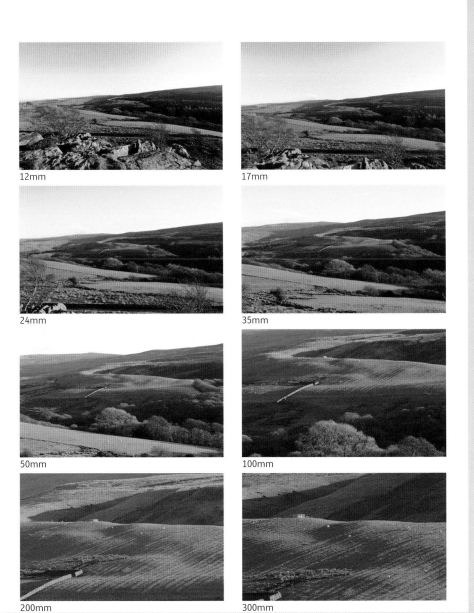

12mm

17mm

24mm

35mm

50mm

100mm

200mm

300mm

sports and wildlife, this can be an advantage, allowing long-range shooting with relatively light and inexpensive lenses. On the other hand, the crop factor means that wide-angle lenses effectively become less wide, which is not good news for landscape shooters. One consequence has been the development of new ultra-wide lenses, like the 14mm f/2.8D ED AF Nikkor.

Field of view

The field of view, or angle of view, is the area covered by the image frame. While the focal length of a lens remains the same on any camera, the angle of view seen in the image changes with the sensor format. The angle of view is usually measured diagonally *(see table pages 216–21).*

THE SIQ, PETRA, JORDAN ≪
An ultra-wide lens helps dramatize the sculptural rock-formations of this narrow defile.

» PERSPECTIVE

Perspective concerns the visual relationship between objects at different distances. The apparent fading of distant objects due to haze or scattering of light is known as "atmospheric perspective," while "optical perspective" refers to changes in the apparent size of objects at different distances.

It's commonly asserted that different lenses give different perspective. This is untrue: perspective is determined solely by distance. However, different lenses do lend themselves to different working distances and therefore are often associated with different perspective.

A powerful emphasis on the foreground may be loosely called "wide-angle perspective" because a wide-angle lens allows you to move closer to foreground objects. Similarly, the apparent compression of perspective in telephoto shots is a result of the greater working distance associated with the long lens. In the series of shots below, the gateway remains the same apparent size even though it's viewed from different distances, but both its apparent shape and its relationship to the background are altered.

KISSING GATE 〈〈 〉
Perspective: 200mm lens, approximate distance 20m *(left)*; 50mm lens, approximate distance 5m *(bottom left)*; 12mm lens, approximate distance <1m *(below)*.

7 » STANDARD LENSES

In traditional 35mm photography, a 50mm lens was called standard, since its field of view was held to approximate that of the human eye. Because of the crop factor of the D7000, the equivalent lens would be around 35mm. Standard lenses are typically light and simple, and have wide maximum apertures. Zoom lenses whose range includes the 35mm focal length are often referred to as "standard zooms."

Nikkor 50mm lens »

GRAND HOTEL, «
SCARBOROUGH, NORTH
YORKSHIRE, UK
The standard lens can be used for a wide variety of subjects.

» WIDE-ANGLE LENSES

A wide-angle lens is really any lens wider than a standard lens; for the D7000, this means any lens shorter than 35mm. Wide-angle lenses are valuable for working close to subjects or bringing foregrounds into greater prominence. They suit photographing expansive scenic views and working in cramped spaces where you can't step back to get more in.

Because of the D7000's crop factor, a lens like a 17mm, once regarded as "super-wide," gives a less extreme angle of view. This has prompted the development of a new breed of lens, like Nikon's 12–24mm f/4G ED-IF AF-S DX.

Nikkor 14mm f/2.8D ED AF lens ☆

**ST. ALDHELM'S HEAD, ISLE OF PURBECK, ☆
DORSET, UK**
Wide-angle lenses don't just add width, but also enhance depth.

7 » TELEPHOTO LENSES

Nikkor 300mm f/4D ED-IF AF-S lens ⌃

Telephoto, or long lenses, give a narrow angle of view. Mostly, they are employed where working distances need to be longer, as in wildlife and sports photography, but have many other uses, such as singling out small and/or distant elements in a landscape. Moderate telephoto lenses are favored for portrait photography, because the greater working distance gives a natural-looking result and is more comfortable for nervous subjects. The traditional "portrait" range is 85–135mm, equivalent to 60–90mm with the D7000.

The laws of optics, plus greater working distance, mean that telephoto lenses produce limited depth of field. This is often beneficial in portraiture, wildlife, and sport, since it concentrates attention on the subject by throwing backgrounds out of focus. It can be less welcome in landscape shooting.

The size and weight of longer lenses make them harder to handhold comfortably, while their narrow angle of view also magnifies any movement; high shutter speeds and/or the use of a tripod or other camera support are therefore the order of the day. Nikon's Vibration Reduction technology mitigates the effects of camera shake.

**WALLABY, BOWLAND WILD BOAR PARK, «
LANCASHIRE, UK**
The long working distances associated with telephoto lenses create compressed or foreshortened perspectives.

> ### Tip
>
> *Switch VR OFF when using the camera on a tripod.*

» ZOOM LENSES

The term "zoom" applies to lenses with variable focal length, like the AF-S DX Nikkor 18–105mm f/3.5–5.6G ED VR. A zoom lens can replace a bag full of prime lenses and cover the gaps in between: great for weight, convenience, and economy. Flexible focal length also allows very precise framing of images. While they were once considered inferior in terms of optical quality, there is now little to choose between a good zoom and a good prime lens. Cheaper zooms, and those with a very wide range (e.g., 18–200mm or 28–300mm) may still be optically compromised, and usually have a relatively small ("slow") maximum aperture.

Nikkor 12-24mm f/4G **«**
ED-IF AF-S DX zoom lens

VIGELANDSPARKEN, OSLO, NORWAY **«**
Zoom lenses are a real advantage when precise framing is required.

» MACRO LENSES

For special close-up work, there is little to beat a true macro lens *(see page 220)*.

SPINDLE BERRIES **«**
Ultra-close-up work, such as these *Euonymus europaeus* berries, is best tackled with a true macro lens.

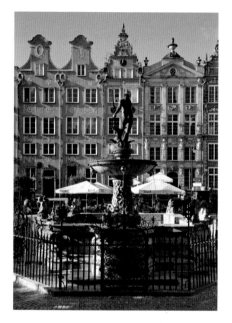

Perspective control, or tilt-and-shift, lenses give unique flexibility in viewing and controlling the image. Their most obvious, but by no means only, value is in photographing architecture, where with a "normal" lens it often becomes necessary to tilt the camera upward, resulting in converging verticals (buildings appear to lean back or even to one side). The shift function of the PC lens allows the camera back to be kept vertical, which in turn means that vertical lines in the subject remain vertical in the image.

The current Nikon range features three PC lenses, with focal lengths of 24mm, 45mm, and 85mm. They retain many automatic functions, but require manual focusing.

CONVERGING VERTICALS �textbf《
The same view using a tilt-and-shift lens *(above)* and a normal lens *(left)* clearly show the problem of converging verticals.

Nikkor 24mm f/3.5D ED PC-E lens 〓

» TELECONVERTERS

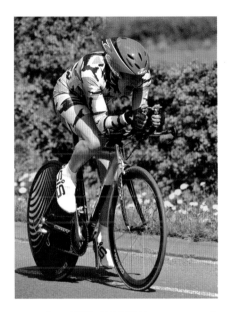

TIME TRIAL NEAR GARSTANG, LANCASHIRE, UK �> ↕
A teleconverter may save you the cost and weight of a separate long lens, but a tripod is often required.

Teleconverters are supplementary optics that fit between the main lens and the camera body, magnifying the focal length of the main lens. Nikon's three examples, the TC-14E II, TC-17E II, and TC-20E III, give magnification of 1.4x, 1.7x, and 2x respectively. The advantages are obvious, extending the available focal length range relatively cheaply and with minimal

additional weight (the TC-14E II, for example, weighs just 7oz/200g).

A teleconverter can slightly degrade image quality, however, and also cause a loss of light. Fitting a 2x converter to a 300mm f/4 lens turns it into a 600mm f/8. One consequence is that the camera's autofocus may become sluggish or may not work at all.

Warning!

Nikon states that some lenses, including the AF-S DX Nikkor 18–105mm f/3.5–5.6G ED VR often supplied as a kit lens with the D7000, are incompatible with teleconverters. Check before using any lens with a teleconverter.

› Lens hoods

A lens hood serves two functions: it shields the lens against knocks, rain, etc., and helps to exclude stray light that does not contribute to the image, but may degrade it by causing flare. Most Nikkor lenses come with a dedicated lens hood.

7 » NIKKOR LENS CHART

This table lists currently available Nikkor autofocus lenses, starting with the DX-series, which is specifically designed for DX-format cameras like the D7000.

	Optical features/notes
DX Lenses	
10.5mm f/2.8G DX Fisheye	CRC
10-24mm f/3.5-4.5G ED AF-S DX	ED, IF, SWM
12-24mm f/4G ED-IF AF-S DX	SWM
16-85mm f/3.5-5.6G ED VR AF-S DX	VRII, SWM
17-55mm f/2.8G ED-IF AF-S DX	ED, SWM
18-55mm f/3.5-5.6G AF-S VR DX	VR, SWM
18-55 f/3.5-5.6GII AF-S DX	ED, SWM
18-70mm f3.5-4.5G ED-IF AF-S DX	ED, SWM
18-105mm F/3.5-5.6G ED VR AF-S DX	ED, IF, VRII, NC, SWM
18-135mm f/3.5-5.6 ED-IF AF-S DX	ED, SWM
18-200mm f/3.5-5.6G ED AF-S VRII DX	ED, SWM, VRII
35mm f/1.8G AF-S	SWM
55-200mm f/4-5.6 AF-S VR DX	ED, SWM, VR
55-200mm f/4-5.6G ED AF-S DX	ED, SWM
55-300mm f/4.5-5.6G ED VR	ED, SWM
85mm f/3.5G ED VR AF-S DX Micro Nikkor	ED, IF, SWM, VRII
AF Prime lenses	
14mm f/2.8D ED AF	ED, RF
16mm f/2.8D AF Fisheye	CRC
20mm f/2.8D AF	CRC
24mm f/1.4G ED	ED, NC
24mm f/2.8D AF	
28mm f/2.8D AF	
35mm f/2D AF	

Angle of view with D7000 (°)	Min. focus distance (m)	Filter size (mm)	Dimensions dia. x length (mm)	Weight (g)
180	0.14	Rear	63 x 62.5	300
109–61	0.24	77	82.5 x 87	460
99–61	0.3	77	82.5 x 90	485
83–18.5	0.38	67	72 x 85	485
79–28.5	0.36	77	85.5 x 11.5	755
76–28.5	0.28	52	73 x 79.5	265
76–28.5	0.28	52	70.5 x 74	205
76–22.5	0.38	67	73 x 75.5	420
76–15.3	0.45	67	76 x 89	420
76–12	0.45	67	73.5 x 86.5	385
76–8	0.5	72	77 x 96.5	560
44	0.3	52	70 x 52.5	210
28.5–8	1.1	52	73 x 99.5	335
28.5–8	0.95	52	68 x 79	255
28.5–5.2	1.4	58	76.5 x 123	530
18.5	0.28	52	73 x 98.5	355
90	0.2	Rear	87 x 86.5	670
120	0.25	Rear	63 x 57	290
70	0.25	62	69 x 42.5	270
61	0.25	77	83 x 88.5	620
61	0.3	52	64.5 x 46	270
53	0.25	52	65 x 44.5	205
44	0.25	52	64.5 x 43.5	205

Optical features/notes

35mm f/1.4G AF-S	NC, SWM
50mm f/1.8D AF	
50mm f/1.4D AF	
50mm f/1.4G AF-S	IF, SWM
85mm f/1.4G AF	SWM, NC
85mm f/1.8D AF	RF
105mm f/2D AF DC	DC
135mm f/2D AF DC	DC
180mm f/2.8D ED-IF AF	ED, IF
200mm f/2G ED-IF AF-S VRII	ED, VRII, SWM
300mm f/2.8G ED VR II AF-S	ED, VRII, NC, SWM
300mm f/4D ED-IF AF-S	ED, IF
300mm f/2.8 ED-IF AF-S VR	ED, SWM, NC
400mm f/2.8G ED VR AF-S	ED, IF, VRII, NC
400mm f/2.8D ED-IF AF-S II	ED, SWM
500mm f/4G ED VR AF-S	IF, ED, VRII, NC
500mm f/4D ED-IF AF-S II	ED, IF
600mm f/4G ED VR AF-S	ED, IF, VRII, NC
600mm f/4D ED-IF AF-S II	ED, SWM

AF Zoom lenses

14–24mm f/2.8G ED AF-S	IF, ED, SWM, NC
16–35mm f/4G ED VR	NC, ED, VR
17–35mm f/2.8D ED-IF AF-S	IF, ED, SWM
18–35mm f/3.5–4.5D ED	ED
24–70mm f/2.8G ED AF-S	ED, SWM, NC

Angle of view with D7000 (°)	Min. focus distance (m)	Filter size (mm)	Dimensions dia. x length (mm)	Weight (g)
44	0.3	67	83 x 89.5	600
31.3	0.45	52	63 x 39	160
31.3	0.45	52	64.5 x 42.5	230
31.3	0.45	58	73.5 x 54	280
18.5	0.85	77	86.5 x 84	595
18.5	0.85	62	71.5 x 58.5	380
15.2	0.9	72	79 x 111	640
12	1.1	72	79 x 120	815
9.1	1.5	72	78.5 x 144	760
8.2	1.9	52	124 x 203	2930
5.2	2.2	52	124 x 267.5	2900
5.2	1.45	77	90 x 222.5	1440
5.2	2.2	52	124 x 268	2850
4	2.9	52	159.5 x 368	4620
4	3.8	52	160 x 352	4800
3.1	4	52	139.5 x 391	3880
3.1	5	52	140 x 394	3800
2.4	5	52	166 x 445	5060
2.4	6	52	166 x 455	5900
90–61	0.28	None	98 x 131.5	970
79–44	0.28	77	82.5 x 106	745
76–44	0.33	77	82.7 x 82.5	370
61–22.50	0.38	77	83 x 133	900

7

Optical features/notes

24–85mm f/2.8–4D IF AF	
24–120mm f/4G ED-IF AF-S VR	ED, SWM, NC, VRII
28–70mm f/2.8 ED-IF AF-S	ED, SWM
28–300mm f/3.5–5.6G ED VR	ED, SWM
70–200mm f/2.8G ED-IF AF-S VRII	ED, SWM, VRII
70–300mm f/4.5–5.6G AF-S VR	ED, IF, SWM, VRII
80–400mm f/4.5–5.6D ED VR AF	ED, VR
200–400mm f/4G ED-IF AF-S VRII	ED, NC, VRII, SWM

Macro lenses

60mm f/2.8G ED AF-S Micro	ED, SWM, NC
60mm f/2.8D AF Micro	CRC
105mm f/2.8G AF-S VR Micro	ED, IF, VRII, NC, SWM
200mm f/4D ED-IF AF Micro	ED, CRC

Perspective control

24mm f/3.5D ED PC-E (manual focus)	ED, NC
45mm f/2.8D ED PC-E (manual focus)	ED, NC
85mm f/2.8D ED PC-E (manual focus)	ED, NC

Angle of view with D7000 (°)	Min. focus distance (m)	Filter size (mm)	Dimensions dia. x length (mm)	Weight (g)
61–18.5	0.5	72	78.5 x 82.5	545
61–13.5	0.45	77	84 x 103.5	710
53–22.5	0.7	77	88.5 x 121.5	935
53–5.2	0.5	77		800
22.5–8	1.4	77	87 x 209	1540
22.5–5.20		67	80 x 143.5	745
20–4	2.3	77	91 x 171	1340
8–4	2	52	124 x 365.5	3360
26.3	0.185	62	73 x 89	425
26.3	0.219	62	70 x 74.5	440
15	0.31	62	83 x 116	720
8	0.5	62	76 x 104.5	1190
56	0.21	77	82.5 x 108	730
34.5	0.25	77 x 94	83.5 x 112	780
18.9	0.39	77	82.7 x 107	650

» FILTERS *224-228*

» ESSENTIAL ACCESSORIES *228*

» OPTIONAL ACCESSORIES *229-230*

» CAMERA SUPPORT *230-231*

» STORAGE *231*

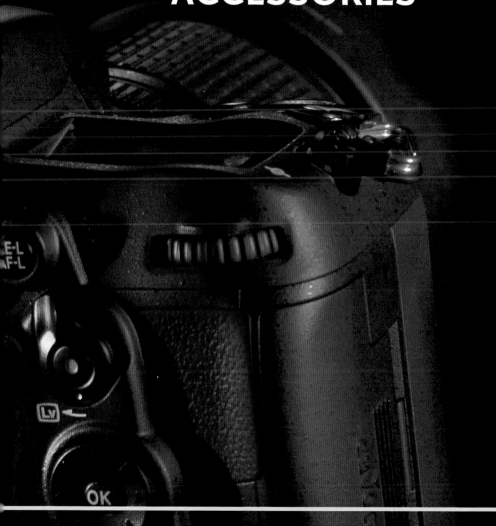

Chapter 8
ACCESSORIES

8 ACCESSORIES

A wide range of accessories is available for the D7000. In addition to Nikon's own products, there are many third-party items that extend the options. Accessories can be grouped under four main headings: image modification (e.g. flash and filters); camera performance; camera support; and storage.

» FILTERS

Flash and close-up accessories have already been dealt with in preceding chapters, leaving filters as the remaining main category for image modification. Some types of filter are almost redundant with digital cameras; variable white balance, for instance, has virtually eliminated the need for color-correction filters, which were essential for accurate color on film, especially transparency film.

As a general principle, avoid using filters unnecessarily. Adding extra layers of glass in front of the lens can increase flare or otherwise degrade the image. Stacking several filters makes that risk even greater, and that of vignetting.

It's prudent, however, to keep a UV or skylight filter attached to each lens as protection against knocks and scratches— filters are cheaper to replace than lenses.

› Filter types

There are three main classes of filter: round, screw-in; slot-in; and rear or drop-in.

Round filters screw to the front of the lens and normally are made of high-quality optical glass. The filter thread diameter of most Nikon lenses is specified in the tables on *pages 216–21*, and usually marked around the front of the lens, next to the Ø symbol. Nikon produces screw-in filters in sizes matching the range of Nikkor lenses and to the same high optical standards. Larger ranges are offered by Hoya and B+W.

Slot-in filters are more economical and convenient for those who use filters extensively. Normally square or rectangular and made of optical resin or gelatin, they fit into a slotted holder. With a simple adapter ring for each lens, one holder and one set of filters can serve any number of lenses. The best-known maker is Cokin, while the Lee Filters range is highly respected by demanding users.

POLARIZING FILTER **«**
A polarizing filter can intensify colors.

UV OR SKYLIGHT FILTER **»**
A UV or skylight filter helps to protect the lens from spray, dust, dirt, and other hazards.

› UV and skylight filters

A few specialized lenses, such as super-telephotos with huge front elements, or extreme wide-angle and fisheye lenses with protruding front elements, require equally specialized filters, that either fit to the rear of the lens or drop into a slot in the lens barrel. A few lenses, like the 14–24mm f/2.8G ED AF-S Nikkor, make no provision for attaching filters. These filters are almost interchangeable: both cut out excess ultraviolet light, which can cause a blue cast in images. The skylight filter also has a slight warming effect. As already suggested, a major benefit is in protecting the front element of the lens.

› Polarizing filters

The polarizing filter, much loved by landscape photographers, cuts down reflections from most surfaces, intensifying colors in rocks and vegetation, for instance.

Note:
Polarizing filters come in two types: linear and circular (although all polarizing filters are circular in shape). The terms refer to the direction of polarization. Only circular polarizers are suitable for the D7000.

It can make reflections on water and glass virtually disappear, restoring transparency; this is most effective at an angle of around 30°. Rotating the filter in its mount strengthens or weakens its effect.

The polarizer can also "cut through" atmospheric haze (although not mist or fog) like nothing else, and can make blue skies appear more intense. The effect is strongest when shooting at right angles to the direction of the sunlight, vanishing when the sun is directly behind or in front. Sometimes results can appear exaggerated, and with wide-angle lenses can be conspicuously uneven across the field of view. The polarizer should be used with discrimination, and certainly should not be permanently attached. However, many of its effects cannot be fully replicated in any other way, even in digital post-processing. You may only use it occasionally, but then it can be priceless.

NEUTRAL DENSITY FILTER ⌄
A plain neutral density filter may be useful when you want to use really low shutter speeds, such as necessary in this photo taken near Harrop Tarn, Lake Distrcit, UK.

› Neutral density filters

Neutral density (ND) filters reduce the amount of light reaching the lens. "Neutral" simply means that they don't shift the color of the light. ND filters can be either plain or graduated.

A plain ND filter is useful when you want to set a slower shutter speed and/or wider aperture, and can't reduce the ISO setting any further. A classic example is when shooting waterfalls, where a long shutter speed is often favored to create a silky blur from the falling water. The strength of ND filters is specified on a scale where 0.3

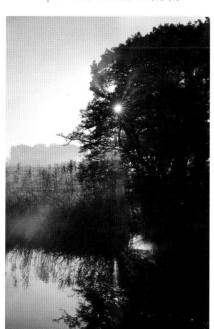

POST CAPTURE TREATMENT **« ⌄**
There was a huge difference in brightness levels here, but a graduated filter wasn't really the solution *(below)*, since the boundary was irregular. For a more natural result, two separate RAW conversions were combined using Photoshop Layer Masks *(left)*.

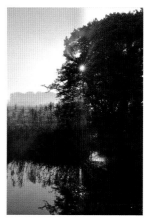

8 represents a reduction of one full stop (1 Ev) of light, 0.6 is two stops, and so on.

Graduated ND filters have neutral density over half their area, the other half being clear, and a gradual transition in the center. They are widely used in landscape photography to compensate for wide differences in brightness between sky and land.

› Special-effects filters

Special-effects filters take many forms, but two common types are soft-focus filters and starburst filters. The soft-focus filter is widely used in portrait photography to soften skin blemishes, but its effects can be replicated and extended, precisely and reversibly, in digital post-processing.

Much the same is true of the starburst and most other special-effects filters. There was a great rash of "effects" images in the 1970s, when the Cokin system first became available to stills photographers, but their gimmicky effects soon palled, and such images now look dated. It's usually better to capture the image without such filters and apply effects digitally. That way, you can always change your mind!

» ESSENTIAL ACCESSORIES

Numerous add-ons are available to improve or modify the performance of the D7000. Nikon supplies several items with the camera, but these are really essentials, not extras.

› EN-EL15 battery

Without a battery, your camera is useless. While the D7000 is economical with batteries, it's always advisable to have a fully charged spare on hand. This is especially true in cold conditions, when using the monitor extensively, or when shooting movies.

› MH-25 charger

Vital to keep the EN-EL15 battery charged and ready.

› BM-11 LCD monitor cover

It's wise to keep the monitor cover permanently attached. If it becomes scratched, it's easily and inexpensively replaced, whereas replacing the monitor itself is a complex and expensive business.

› BF-1A body cap

Keeps the interior of the camera free of dust and dirt when no lens is attached.

» OPTIONAL ACCESSORIES

A selection from Nikon's extensive range is listed here.

› Multi-Power Battery Pack MB-D11

The MB-D11 delivers extra power and improves the camera's handling in portrait orientation. It provides an extra shutter-release button, Main command dial, Sub-command dial, and **AE-L/AF-L** button. It can be loaded with a second EN-EL15 battery or with AA cells.

› AC Adapter EH-5a/EH-5

Either of these adapters can be used to power the camera directly from an AC supply, allowing uninterrupted shooting during, for example, long studio sessions.

› Wireless transmitter WT-4

This enables the camera to connect to Wi-Fi and Ethernet networks, allowing photographs to be viewed on any computer on the network (e.g., using Nikon View NX2) and also saved

> ### Tip
>
> *For simple transfer of images over a WiFi network, an EyeFi card offers an inexpensive alternative (see page 239).*

immediately to a computer (e.g., using Nikon Transfer). Nikon Camera Control Pro 2 software (available separately) allows camera functions to be controlled directly from any Mac or PC.

› Wireless remote control ML-L3

This inexpensive unit allows the camera to be triggered from a distance of up to 16ft (5m). Nikon states that it should be fired from in front of the camera, but in indoor use the beam can be bounced off walls and ceilings, allowing operation from a wide range of positions.

› Remote Cords

Nikon's 3ft (1m) long MC-DC2 remote cord can be attached to the terminal on the left side of the D7000, allowing shutter release without touching the camera. This helps to minimize vibration.

› GPS Unit GP-1

Dedicated Global Positioning System device *(see page 243).*

> ## Diopter Adjustment

The D7000's viewfinder has built in dioptric adjustment, between -3 and +1 m-1, to allow for individual variations in eyesight. If your eyesight is outside this range, Nikon produces a series of viewfinder lenses between -5 and +3 m-1, with the designation DK-20C.

> ## Magnifying Eyepiece DK-21M

Magnifies the viewfinder view by about 10%, which may be of help to some users with framing.

> ## Magnifier DG-2 and Eyepiece Adapter DK-22

In combination, these provide a 2x magnified view of the central portion of the viewfinder image. This is useful for critical focusing in close-up photography, but has been largely superseded by the absolute focusing accuracy of Live View.

> ## Right-Angle Viewing Attachment DR-6

Allows the D7000's viewfinder image to be seen from above—useful when the camera is in an awkward position (e.g., very close to the ground). Also partly superseded by Live View.

> ## CAMERA SUPPORT

There's much more to camera support than tripods, although these remain a staple.

> ## Tripods

Although the D7000's image quality at high ISO settings facilitates handholding, there will be many occasions when a tripod will be invaluable. A good tripod is an investment and should last for many years. Tripods come in various sizes, weights, and materials; the best combination of low weight and good rigidity comes—at a price—in materials like titanium and carbon fiber. Carbon fiber tripods are made by Manfrotto and Gitzo, among others. The distinctive design of Benbo tripods gives exceptional flexibility, prized by nature photographers who frequently

STURDY FRAMES ⌄
Tripods are useful for photographing a variety of subjects, such as these mountain bike frames.

need to shoot in awkward positions.

When you're shooting movies, a tripod is essential, and many are designed specifically for this purpose.

› Monopods

Monopods can't offer the ultimate stability of a tripod, but they are light, portable, and quick to set up. They are particularly favored by sports photographers, who often have to react quickly while using heavy telephoto lenses.

› Other camera support

There are many other solutions for camera support, both proprietary products and improvised alternatives. It's hard to beat the humble beanbag, which can be homemade to your exact needs, or bought from various suppliers.

BAG OF BEANS　　　　　　　　❯❯
This simple homemade beanbag has served me well for many years.

» STORAGE

› Memory cards

The D7000 stores images on Secure Digital (SD), SDHC, and SDXC cards. On long trips, it's easy to fill up even large-capacity memory cards, which are remarkably cheap, so it's advisable to carry a spare or two. Fast card-write speeds can speed up the camera's operation.

› Portable storage devices

Memory cards rarely fail, but it's always worth backing up valuable images as soon as possible. Onboard backup is one option, while many photographers use some sort of mobile device. Dedicated photo storage devices like the Vosonic VP8870 and Epson P-7000 comprise a compact hard drive along with a small screen. Many of us already own something that will also store images, however, in the shape of an iPod. Not all iPod models are suitable, so investigate carefully. The iPad (but not the iPhone) also works well for this: you'll also need an Apple iPad Camera Connector.

» CONNECTING TO A TV *234*

» CONNECTING TO A PRINTER *235–236*

» CONNECTING TO A COMPUTER *237–239*

» NIKON SOFTWARE *240–241*

» THIRD-PARTY SOFTWARE *242*

» CONNECTING TO A GPS UNIT *243*

Chapter 9
CONNECTION

9 CONNECTION

Connecting to external devices is not an extension of digital photography: it's an essential part of the process, enabling you to store, organize, view, and print your images. The D7000 is designed to facilitate these operations, being supplied with the correct connecting cables.

» CONNECTING TO A TV

The supplied EG-D2 cable is used to connect the camera to a normal TV or VCR. You can also connect the camera to a HDMI (High Definition Multimedia Interface) TV, but you'll need an HDMI cable (not supplied). In other respects, the process is the same.

PORTS TO THE LEFT ⌄
Connection ports on the left side of the D7000.

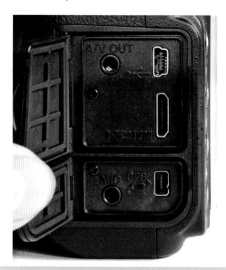

1) Check that the camera is set to the correct mode in the Setup menu (NTSC or PAL for standard TVs and VCRs; or HDMI.

2) Turn the camera off. This is important: always do this before connecting or disconnecting the cable.

3) Open the cover on the left side of the camera and insert the cable into the appropriate slot (Video-out or HDMI).

4) Tune the TV to either the Video or HDMI channel.

5) Turn the camera on and press the playback button. Images remain visible on the camera monitor as well as on the TV, and you navigate using the Multi-selector in the usual way. The D7000's slide show setting can be used to automate playback.

> **Note:**
> Use of an AC adapter is recommended for lengthy playback sessions. No harm should result if the camera's battery expires during playback, but it is annoying.

» CONNECTING TO A PRINTER

The most flexible and powerful way to print photographs from the D7000 is to transfer them to a computer. This is the only option where RAW files are concerned, although you can always create JPEG copies.

The memory card can also be inserted into a compatible printer or taken to a local photo printing outlet. Finally, the camera can be connected to any printer that supports the PictBridge standard, which allows JPEG images to be printed directly.

1) Turn the camera off.

2) Turn the printer on and connect the supplied USB cable. Open the cover on the left side of the camera and insert the cable into the USB slot; the smaller end of the cable connects to the camera.

3) Turn the camera on. A welcome screen should appear, followed by a PictBridge playback display. You are offered a choice between **Printing pictures one at a time** or **Printing multiple pictures**.

Printing options

Option name	Options available	Notes
Page size	Printer default	Options will be limited by the maximum size the printer can print.
	3.5 x 5in	
	5 x 7in	
	A4	
No of copies	1–99	Use ▲ ▼ to choose number, then press **OK** to select.
Border	Printer default	If **Print with border** is selected, borders will be white.
	Print with border	
	No border	
Time stamp	Printer default	Prints time and date when image was taken.
	Print time stamp	
	No time stamp	
Crop	Crop	Prints selected area only to size selected under **Page size**.
	No cropping	

› Printing pictures one at a time

This process is very straightforward, particularly if you are already familiar with navigating the D7000's playback screens.

1) If the photo displayed is the one you wish to print, press **OK**. This brings up a menu of printing options; see table for details. Use the Multi-selector to navigate through the menu and highlight specific options; press **OK** to select the highlighted option.

2) When the required options have been set, select **Start printing** and press **OK**. To cancel at any time, press **OK** again.

› Image cropping

If **Crop** is selected, the image is displayed with a border delineating the crop area. Use the zoom buttons (⊖✍ and ⊕) to change the size of the crop area, and use the Multi-selector to reposition it if you don't want it centered. When satisfied, press **OK**.

› Printing multiple pictures

You can print several pictures at once. You can also create an index print of all JPEG images (up to a maximum of 256) currently stored on the memory card. NEF (RAW) images cannot be printed. With the PictBridge menu displayed, press **OK**. The following options are displayed (below):

Print Select	Use the Multi-selector to scroll through pictures on the memory card (displayed as six thumbnails at a time). To see an image full screen, press ⊖✍. To choose the currently selected image for printing, hold ◙⌐ and press ▲. The picture is marked with a **PRINT** and the number of prints set to 1. Keep ⊖✍ depressed and use ▲ to change the number of prints.
	Repeat the above to select further images and choose the number of prints required from each. Finally, press **OK** to display the PictBridge menu and select printing options, as in the table on *page 235*.
	Only the options for **Page size**, **Border**, and **Time stamp** will be available. Select **Start printing** and press **OK**.
Print (DPOF)	Prints images already selected using the Print set (DPOF) option in the Playback menu.
Index Print	Prints all JPEG images (up to a maximum of 256) on the memory card. If more than 256 images exist, only the first 256 will be printed. Options for **Page size**, **Border**, and **Time stamp** can be set as already described. If the selected page size is too small for the number of images, a warning will be displayed.

» CONNECTING TO A COMPUTER

Connecting to a Mac or PC allows you to store and backup your images. It also helps you exploit more of the power of the D7000, including the ability to optimize image quality from RAW files. The supplied Nikon Transfer software allows you to control this process, while Nikon View NX2 has a range of image enhancement tools. Nikon Capture NX2 (optional) has greater capabilities, especially when working with RAW files. The optional Nikon Camera Control Pro 2 software allows camera operation to be controlled directly from the Mac or PC.

› Computer requirements

Most modern computers are more than capable. You'll need a USB port for connecting the camera (or card reader), unless you use a WiFi link. You can install Nikon software from the supplied CD or download it from the Nikon web site.

Nikon Transfer and Nikon View NX2 require one of the following operating systems: Mac OS X (Version 10.4.11 or later); Windows 7; Windows Vista (Service Pack 2); Windows XP (Service Pack 3).

Older computers will still be able to transfer and view images using third-party software, but such systems may run very slowly when dealing with the large image files produced by the D7000, and may have particular difficulty in opening RAW files.

› Backing up

Until backed up, your precious images exist solely as data on the camera's memory card. Memory cards are robust, but not indestructible, and in any case you will surely wish to reformat them for future use. However, when images are transferred to the computer and the card is reformatted, those images still exist in only one location, the computer's hard drive. If anything happens to that hard drive, you could lose thousands of irreplaceable images. The simplest form of backup is to a second hard drive.

Note:
If your computer runs slowly when working with large image files, the most likely cause is insufficient memory (RAM). RAM can usually be added relatively cheaply and easily. A shortage of free space on the hard disk may also cause a slowdown.

9

Note:
The supplied USB cable allows direct connection to a computer. However, it's often more convenient to transfer photos by inserting the memory card into a card reader. Many PCs have built-in SD card slots, but separate card readers are cheap and widely available. Older card readers may not support SDHC or SDXC cards.

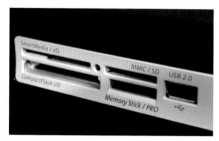

Built-in card reader slots ⤨

External card reader ⤨

› Computer screen calibration

A major headache for digital camera users is that images appear differently on the camera monitor, on the computer screen, when you email them, and when printed. To achieve consistency across different devices, it's vital that your main computer screen is correctly set up and calibrated. This may seem complex and time consuming, but ultimately it saves much time and frustration. Detailed advice is beyond the scope of this book, but try searching your computer's Help system for "monitor calibration." There's more detail in the *Digital SLR Handbook* (from this author and publisher), while useful advice can also be found at www.cambridgeincolour.com/tutorials.htm.

CALIBRATION SOFTWARE ⤨

The Display Calibrator Assistant is included in Mac OS X. The Windows OS finally gained an equivalent with the Color Calibration Wizard in Windows 7. Vista and XP users still need a third-party solution.

› Connecting the camera

This description assumes that you have installed Nikon Transfer from the CD supplied with the camera. You may prefer to use Nikon View NX2, Nikon Capture NX2, or third-party software such as iPhoto to import images. The procedure with other software is similar, but differs in detail: consult the manual or Help menu.

1) Start the computer. Open the cover on the left side of the camera and insert the smaller end of the supplied USB cable into the USB slot; insert the other end into a USB port on the computer (not an unpowered USB hub or keyboard).

2) Turn the camera on. Nikon Transfer starts automatically, unless you have configured it differently, and a window *(below)* appears on the computer screen.

3) The Nikon Transfer window offers various options; see the Help menu in Nikon Transfer itself for full details. The following are among the most important.

4) To transfer selected images only, use the check box below each thumbnail to select/deselect as required.

5) Click the **Primary Destination** tab to choose where photos will be stored. You can create a new subfolder for each transfer, rename images as they are transferred, and so on.

6) Click the **Backup Destination** tab if you want Nikon Transfer to create backup copies automatically during transfer.

› Wireless connection (Eye-Fi)

Eye-Fi operates like a conventional SD memory card, but includes an antenna that enables it to communicate with WiFi networks, allowing speedy transfer of images to a computer without cables.

Eye-Fi cards are supplied with a reader: when card and reader are connected to any recent Mac or PC, the software should install automatically, making the computer the default destination for Eye-Fi upload. You can select a destination folder on your computer, or configure the system to upload photos to sharing sites such as Flickr.

After configuration, insert the card in the camera. Use **Eye-Fi Upload** in the Setup menu, and the camera will upload images as they are taken, provided you remain within signal range of the network.

9 » NIKON SOFTWARE

The D7000 is bundled with Nikon Transfer and Nikon View NX2 software. Nikon Transfer is a simple application that does one job well. Nikon View NX2 is a broader package covering many of the main functions that digital photographers require. Specifically, it allows you to transfer images, view them individually or browse through them, to save them in other formats, and to print them. Although View NX2 is much better than View NX, editing and enhancing images (including RAW files) is still limited, slow, and not very intuitive, comparing poorly with apps like iPhoto. Results might be technically superior, but obtaining them is not for the impatient. Nikon Capture NX2 has much wider functionality, but still seems awkward compared to mainstream applications such as Adobe Photoshop.

› Using Nikon View NX2

1) From a browser view such as the thumbnail grid (choose view mode from the View menu), click on an image to highlight it. Image Viewer shows the image in more detail, plus a histogram, and Full Screen allows you to see the image full size.

2) Panels on the right of the screen reveal Metadata (detailed information about the image) and Adjustment palette, which allows a range of adjustments, including exposure and white balance. It also provides access to Nikon Picture Controls *(see page 83).*

3) Click away from the image and you will be asked if you want to save any

Nikon View NX2 file format options

JPEG	Choose compression ratio: Highest Quality; High Quality; Good Balance: Good Compression Ratio; Highest Compression Ratio.	Suitable if extensive further editing is not envisaged. It's recommended to choose Excellent Quality unless storage space is at a premium, or the image is specifically intended for such use as an email attachment.
TIFF (8-bit)		Creates larger file sizes than JPEG, but is a better choice if subsequent editing is envisaged; however, 16-bit is advised for extensive retouching work.
TIFF (16-bit)		The best choice when further editing is anticipated. Images can be converted to 8-bit after editing, halving file size.

adjustments. You do not need to export or convert the file immediately.

4) To export the file as a TIFF or JPEG that can be viewed, edited, and printed by most other applications, choose Convert Files from the File menu. Here you can set a new size for the image if required, and also change its name.

5) The File Format drop-down menu in the Convert Files dialog offers three options: JPEG, TIFF (8-bit), and TIFF (16-bit).

› Nikon Capture NX2

Nikon Capture NX2 is a far more complete editing package than Nikon View. For access to a full range of editing options, especially in relation to RAW files, Capture NX2 or one of its third-party competitors is essential. One point to consider is that, unlike rivals such as Adobe Photoshop, Capture NX2 cannot open RAW files from non-Nikon cameras. Photoshop has a much wider feature set, but is typically around four times more expensive.

› Camera Control Pro 2

In the studio and other controlled settings, Camera Control Pro 2 allows almost all functions and settings of the D7000 to be operated directly from a Mac or PC, known as "tethered" shooting. As soon as images are captured, they can be checked in detail on the large, color-corrected computer screen; Live View integration allows real-time viewing.

9 » THIRD-PARTY SOFTWARE

The ultimate in image-editing software is Adobe Photoshop, the current version being Photoshop CS5. Its power is enormous, and it's the subject of many dedicated books and web sites. It offers far more than most users need, and many will prefer the much more affordable Photoshop Elements, which still has sophisticated editing features, including the ability to open RAW files from the D7000.

Photoshop Elements also includes something that Photoshop itself does not, namely its Organizer module, which allows photos to be sorted into Albums and also tagged in different ways. Some sort of organizer or cataloging software will become essential as you begin to amass thousands of images.

Mac users have another excellent choice in the form of iPhoto, which is preloaded on new Macs. There's no easier imaging software to grasp; the Adjust palette provides quick and flexible image editing. iPhoto can open RAW files from the D7000, but—unlike Photoshop Elements—cannot edit in 16-bit depth, which is recommended for best results.

Finally, for those who regularly use the RAW format, there are two solutions: Apple's Aperture (Mac only) and Adobe Lightroom (Mac and PC). Both combine powerful organizing and cataloging features with sophisticated and nondestructive image editing. Essentially this means that any changes you make to your image, including color, density, and cropping, are recorded alongside the original RAW (or DNG) file. TIFF or JPEG versions, incorporating all the edits, can be exported as and when needed. Recent versions of Aperture and Lightroom support tethered shooting, as do several other apps. Sofortbild is a free tethered shooting app for Mac OS X.

PHOTOSHOP ELEMENTS ≫
Raw file conversion in Adobe Photoshop Elements.

LIGHTROOM LIBRARY ≫
Adobe Lightroom's Library module.

» CONNECTING TO A GPS UNIT

Nikon's GP-1 GPS (Global Positioning System) Unit can be mounted on the hotshoe, or clipped to the camera strap, and linked to the camera's accessory terminal using a supplied cable. It allows information on latitude, longitude, altitude, heading, and Coordinated Universal Time to be added to image metadata. This information is displayed as an extra page of photo information on playback.

When the camera has established a connection and is receiving data from the GPS, a GPS icon will be displayed in the Information Display. If this flashes, the GPS is searching for a signal, and data will not be recorded.

Nikon GP-1 GPS Unit

› GPS Options

The GPS item in the Setup menu has three options:

Auto meter off

If enabled, exposure meters switch off automatically after a set period (see Custom setting c2). This reduces battery drain. Ensure that meters are turned on by depressing the shutter-release button halfway before taking shots, otherwise GPS data may not be recorded. If this option is disabled, the meters will remain on as long as a GPS unit is attached, and GPS data will always be recorded.

Position

Displays the current information reported by the GPS device.

Use GPS to set camera clock

Self-explanatory, and should ensure that the time is always correct.

» BASIC CAMERA CARE 246–249

» MEMORY CARD CARE 249

Chapter 10
CARE

10 CARE

The D7000 is a rugged, well-made camera, but it is packed with complex electronic and optical technology. The simple commonsense precautions outlined here should ensure that it functions perfectly for many years.

» BASIC CAMERA CARE

Keeping the camera clean is essential. Remove dust and dirt from the body with a blower, then wipe with a soft, dry cloth. After exposure to salt spray, wipe off with a cloth dampened with distilled (deionized) water, then dry thoroughly. Keep the camera in a case when not in use.

Lenses require special care. Their glass elements and coatings are easily scratched. Remove dust and dirt with a blower; fingerprints and other marks using a proprietary lens cleaner and optical-grade cloth. Fitting a skylight or UV filter to protect the lens is advisable, and lens caps should be replaced when lenses are not in use.

Protect the playback monitor by keeping its cover in place. If the monitor itself needs cleaning, use a blower, then wipe the surface with a soft cloth. Do not apply pressure.

› Storage

If the camera will not be used for any length of time, remove the battery, close the battery compartment cover, and store in a cool, dry place. Avoid extremes of temperature, high humidity, and strong electromagnetic fields, such as those produced by TVs and computers.

› Cleaning the sensor

Strictly speaking, it's not the sensor itself, but the low-pass filter that covers it that can attract dust and require cleaning. Dust and dirt on this will appear as dark spots in an image.

Fortunately, the D7000 has a self-cleaning facility. This works by vibrating the low-pass filter. It can be activated manually at any time or set to occur automatically when the camera is switched on and/or off. Select between these options using Clean Image Sensor in the Setup menu. Experience suggests that this is highly effective preventative maintenance.

Occasionally, however, stubborn spots may appear on the low-pass filter, which will need cleaning by hand. This is best done in a clean, draught-free area with good light, preferably using a lamp that can be shone into the camera's interior.

Make sure the battery is fully charged: use a mains adapter if you have one. Remove the lens, switch the camera on,

and select Lock mirror up for cleaning from the Setup menu. Press the shutter-release button to lock up the mirror. First, attempt to remove dust using a hand blower—not compressed air or other aerosol. If this appears ineffective, try a proprietary sensor cleaning swab, carefully following the instructions supplied.

Do not use other brushes or cloths, and never touch the low-pass filter with your finger. It is very delicate, the sensor even more so. When you've finished cleaning, turn the camera off, and the mirror will reset.

CLEANING THE SENSOR ⮛
This is strictly for the confident!

Warning!

If the low-pass filter is damaged by inappropriate cleaning methods, it could void your warranty. If in doubt, consult a dealer or camera repairer.

› Coping with cold

Nikon specifies an operating temperature range for the D7000 of 32–104°F (0–40°C). This does not mean that it cannot be used in temperatures below freezing, but as far as possible it should be kept within the stated range. Placing the camera in an insulated case or under outer layers of clothing between shots will help to keep it warmer than the surroundings, but don't put it too near your skin, since condensation can become a problem. If it does become chilled, battery life may be severely reduced. In extreme cold, the LCD display may become erratic or disappear completely, and ultimately the camera may stop working. If allowed to warm up gently, no permanent harm should result.

FROST ENCRUSTED ⮛
A hard frost offers wonderful photographic opportunities, but such intense cold can be challenging for a camera.

› Heat and humidity

Extremes of heat and humidity (over 85%) can be even more problematic, since they are more likely to lead to long-term damage. In particular, rapid transitions from cool environments (an aircraft cabin, say) to hot and humid ones (the streets of Bangkok) can lead to condensation within the lens and camera. If such conditions are anticipated, pack the camera and lens(es) in airtight containers with bags of silica gel, which will absorb any moisture. Allow the equipment to reach the ambient temperature before unpacking.

› Water protection

The D7000 has a degree of weatherproofing, such that it can be used with reasonable confidence in light rain; even so, it should be exposed no more than absolutely necessary and wiped regularly with a microfiber cloth. Avoid using the built-in flash in the rain or if it is likely to be splashed. The hotshoe cover should also be in place, and all access covers properly closed.

Salt water is particularly hostile to electronic components, so take extra care to prevent any contact. If this does occur, clean the camera carefully and immediately with a cloth lightly dampened with fresh water, preferably distilled (deionized).

Protect the camera with a waterproof cover. A plastic bag will provide reasonable protection, but purpose-made rain guards are available. A waterproof case like the Aquapac provides complete protection, but when used above the water, splashes on the lens can be very obvious.

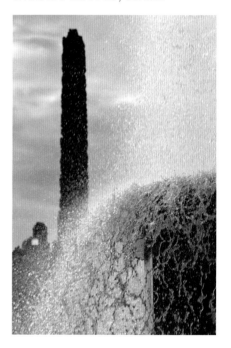

VIGELANDSPARKEN, OSLO, NORWAY ≫
Despite the D7000's weatherproofing, you should beware of splashes in extreme conditions such as this!

» MEMORY CARD CARE

› Dust protection

To minimize ingress of dust into the camera, take great care when changing lenses. Aim the camera slightly downward and stand with your back to any wind. In really bad conditions, avoid changing lenses at all, and protect the camera with a waterproof, and therefore dustproof, case. Dust that settles on the outside of the camera is relatively easy to remove, using a hand or compressed-air blower. Do this before changing lenses, memory cards, or batteries.

› Camera cases

In all conditions, some sort of case is highly advisable to protect the camera when not in use. The most practical is a simple drop-in pouch, which can be worn on a belt. Excellent examples are offered by Think Tank, Camera Care Systems, and LowePro.

If a memory card is lost or damaged, your images are lost too. SD cards are quite robust, but it's still wise to treat them with care. Keep them in their original plastic cases, or something more substantial, and avoid exposing them to extremes of temperature, direct sunlight, liquids, and strong electromagnetic fields.

Note:
There is no evidence that modern airport X-ray machines have any harmful effect on either digital cameras or memory cards.

DROP-IN POUCH **«**
A padded pouch combines good protection and easy access.

» GLOSSARY

8-bit, 12-bit, 16-bit *see* bit depth.

Accessory shoe *see* hotshoe.

Aperture The lens opening that admits light. Relative aperture sizes are expressed in f-numbers (*see below*).

Artifact Occurs when data or data produced by the sensor is interpreted incorrectly, resulting in visible flaws in the image.

Bit depth The amount of information recorded for each color channel. 8-bit, for example, means that the data distinguishes 28 (256) levels of brightness for each channel. 16-bit images recognize over 65,000 levels per channel, which allows greater freedom in editing. The D7000 records RAW images in 12- or 14-bit depth; they are converted to 16-bit on import to the computer.

Bracketing Taking a number of otherwise identical shots in which just one parameter (e.g., exposure) is varied.

Buffer On-board memory that holds images until they can be written to the memory card.

Burst A number of frames shot in quick succession; the maximum burst size is limited by buffer capacity.

Channel The D7000 records data for three separate color channels (*see* RGB).

CCD Charge-coupled device; a type of image sensor used in many digital cameras.

Clipping Complete loss of detail in highlight or shadow areas of the image, leaving them as blank white or solid black.

CMOS Complementary Metal Oxide Semiconductor; a type of image sensor used in many digital cameras, including the D7000.

Color temperature The color of light, expressed in degrees Kelvin (K). Confusingly, "cool" (bluer) light has a higher color temperature than "warm" (red) light.

CPU Central Processing Unit; a small computer in the camera (also found in many lenses) that controls most or all of the unit's functions.

Crop factor *see* focal length multiplication factor.

Diopter Unit expressing the power of a lens.

dpi (dots per inch) A measure of resolution: should be applied only to printers (*see* ppi).

Dynamic range The range of brightness from shadows to highlights within which the camera can record detail.

Exposure Used in several senses. For instance, "an exposure" is virtually synonymous with "an image" or "a photo": to make an exposure = to take a picture. Also refers to the amount of light hitting the image sensor, and to systems of measuring this. *See* also overexposure, underexposure.

Ev Exposure value; a standardized unit of exposure. 1 Ev is equivalent to 1 "stop" in traditional photographic parlance.

Extension rings/tubes Hollow tubes that fit between the camera body and lens, providing greater magnification.

f-number Lens aperture expressed as a fraction of focal length: f/2 is a wide aperture and f/16 is narrow.

Fast (lens) Lens with a wide maximum aperture, e.g., f1.8—f/4 is relatively fast for long telephotos.

Fill-in flash Flash used in combination with daylight; prevents dark shadows with naturally backlit or harshly side-lit subjects.

Filter A piece of glass or plastic placed in front of, within, or behind the lens to modify light.

Firmware Software that controls the camera: upgrades are issued by Nikon from time to time and can be transferred to the camera via a memory card.

Focal length The distance (in mm) from the optical center of a lens to the point at which light is focused.

Focal length multiplication factor Because the D7000's sensor is smaller than a frame of 35mm film, the effective focal length of all lenses is multiplied by 1.5.

fps (frames per second) The number of exposures (photographs) that can be taken in a second. The D7000's maximum rate is 6 fps.

Highlights The brightest areas of the scene and/or image.

Histogram A graph representing the distribution of tones in an image, ranging from pure black to pure white.

Incident light metering Measuring the light falling onto a subject, usually with a separate meter. An alternative to the in-camera meter, which measures reflected light.

ISO International Standards Organization. ISO ratings express film speed; the sensitivity of digital sensors is quoted as ISO-equivalent.

JPEG A compressed image file standard, from Joint Photographic Experts Group. High levels of JPEG compression can reduce files to about 5% of their original size, but there may be some loss of quality.

LCD Liquid crystal display; flat screen like the D7000's rear monitor.

Macro A term used to describe close focusing and close-focusing ability of a lens. A true macro lens has a reproduction ratio of 1:1 or better.

Megapixel *see* pixel.

Memory card A removable storage device for digital cameras.

Noise Image interference manifested as random variations in pixel brightness and/or color.

Overexposure When too much light reaches the sensor, resulting in an image that is too bright, often with clipped highlights.

Pixel Picture element; the individual colored dots (usually square) that make up a digital image. One million pixels = 1 megapixel.

ppi Pixels per inch: should be applied to digital files rather than the commonly used dpi.

Reproduction ratio The ratio between the real size of an object and the size of its image on the sensor.

Resolution The number of pixels for a given dimension, for example 300 pixels per inch. Resolution is often confused with image size. The native size of an image from the D7000 is 4928 x 3264 pixels; this could make a large, but coarse print at 100 dpi or a smaller, finer one at 300 dpi.

RGB Red, Green, Blue. Digital devices, including the D7000, record color in terms of brightness levels of the three primary colors.

Sensor The light-sensitive, image-forming chip at the heart of every digital camera.

Shutter The mechanism that controls the amount of light reaching the sensor by opening and closing to expose the sensor when the shutter-release button is pushed.

Speedlight Nikon's range of external flashguns.

Spot metering A metering system that takes its reading from the light reflected by a small portion of the scene.

Telephoto lens A lens with a large focal length and a narrow angle of view.

TIFF (Tagged image File Format) A universal file format supported by virtually all image-editing applications.

TTL Through The Lens, like the viewing and metering of SLR cameras such as the D7000.

Underexposure When insufficient light reaches the sensor, resulting in an image that is too dark, often with clipped shadows.

USB (Universal Serial Bus) A data transfer standard, used to connect to a computer.

Viewfinder An optical system used for framing the image; on an SLR camera like the D7000, it shows the view as seen through the lens.

White balance A function that compensates for different color temperatures so that images may be recorded with correct color balance.

Wide-angle lens A lens with a short focal length and a wide angle of view.

Zoom A lens with variable focal length, giving a range of viewing angles. To zoom in is to change focal length to give a narrower view; to zoom out is the converse. Optical zoom refers to the genuine zoom ability of a lens; digital zoom is the cropping of part of an image to produce an illusion of the same effect.

» USEFUL WEB SITES

NIKON

Nikon Worldwide
Home page for the Nikon Corporation
www.nikon.com

Nikon UK
Home page for Nikon UK
www.nikon.co.uk

Nikon USA
Home page for Nikon USA
www.nikonusa.com

Nikon User Support
European Technical Support Gateway
www.europe-nikon.comsupport

Nikon Info
User forum, gallery, news, and reviews
www.nikoninfo.com

Nikon Historical Society
Worldwide site for study of Nikon products
www.nikonhs.org

Nikon Links
Links to many Nikon-related sites
www.nikonlinks.com

Grays of Westminster
Legendary Nikon-only London dealer
www.graysofwestminster.co.uk

EQUIPMENT

Adobe
Creator of photo-editing software, including
Photoshop and Lightroom
www.adobe.com

Apple
Creator of photo-editing software, including
Aperture, plus notebook and desktop
computers
www.apple.com

PHOTOGRAPHY PUBLICATIONS

**Photography books & Expanded
Camera Guides**
www.ammonitepress.com

Black & White Photography magazine
Inspiration and information for
monochrome enthusiasts

Outdoor Photography magazine
Features, tests and techniques for lovers of
the great outdoors
www.thegmcgroup.com

EOS magazine
Print and digital magazine for Canon SLR
users
www.eos-magazine.com

» INDEX

3D color matrix metering II 54

A
aberration 146
accessories 224-231
 essential 228
 filters 224-228
 flash 177
 optional 229-231
AC power 228-229
Active D-Lighting 82, 92
active folders 90-91
AF see autofocus
AF-assist illuminator 63
aliasing 148
ambient light 152
Aperture Priority (A) mode 48-49
artifacts 148
artificial light 143
attachment
 lenses 26
 speedlights 168
 strap 24
Auto-area AF 61
auto bracketing 105-106
Auto distortion control 92
auto-exposure lock (AE-L) 99
autofocus (AF) 59-63, 96-97
 area modes 60-61
 assist illuminator 63
 fine tune 114
 Live View 74-77
 movies 192
 points 61-63
Autumn colors mode 45

B
backlighting 140
basic functions 29-33
batteries 27-28, 104, 112, 228
Beach/snow mode 43

beep 101
bellows 184
black and white 117
Blossom mode 45
blue intensifier 117
blur 131-132
bounce flash 168
bracketing
 exposure 57-58
 flash exposure 167
 settings 105-106
brightness, Live View 77
brightness of LCD display 103
buffer 11, 31
built-in flash 11, 105, 160-161, 164-165
buttons settings 106-109

C
Calendar view 80
camera
 accessories 228-231
 button settings 106-109
 care 246-249
 cases 249
 layout 12-17
 on/off 29
 preparation 24-28
 shake 132
 supports 230-231
 user settings 52-53
Camera Control Pro 2 241
Candlelight mode 44
caring for camera 246-249
center-weighted metering 54
Child mode 40
cleaning the sensor 246-247
clipping 148
CL mode shooting speed 102
close-up 180-187
Close-up mode 41

color 142-143
 balance 118
 retouch options 117-118, 120-121
 spaces 71-72, 92
 temperature 66-69
 tone 46-47
color outline 120
color sketch 120
command dials 32-33
compatibility 11
compensation
 exposure 56-57
 flash 166-167
composition 133, 150-155
computer connection 237-239
connection
 to GPS 243
 to printers 235-236
 to television 110, 234
Continuous low-speed release mode 102
continuous release modes 102
Continuous-servo AF (AF-C) 59
contrast 138-139
Control Panel 31
controls settings 106-109
copying images 88
copyright information 112
crop factor 206-208
Custom Setting menu 19, 95-109
cyanotype 117

D
deleting images 80-81, 86, 88
depth of field 127-129
Digital Print Order Format (DPOF) 89
diopter 25, 230
direction of light 140-141

displays
 brightness 103
 Control Panel 31
 highlights 81
 histograms 81
 information 103
 menus 18-21
 settings 101-104
 timings 99-100
 viewfinder 16, 99-100, 101
distortion 120, 145-146
D-lighting 116
Dusk/dawn mode 43
dust 111-112, 249
DX-sensors 9, 10
Dynamic-area AF 61
dynamic range 138-139

E
editing movies 121, 200-201
electronic rangefinder 60
enhancing images 82-84
erasing images 80-81, 86, 88
exposure 10-11, 34-58
 analog display 52
 bracketing 57-58
 compensation 56-57
 flash 162
 ISO 70-71
 manual modes 48-53
 metering 54-55
 movies 192
 multiple 93
 Scene modes 38-47
 settings 98-99
 warnings 37
extension tubes 183
Eye-Fi 114, 239
eyepieces 230

F
Face priority AF 76
field of view 208
files
 folders 90-91

formats 11
numbering 90–91, 102
size 66
types 64–65, 92
fill-in flash 159
filter effects 117
filters 224–228
firmware 114
fisheye effect 120
flare 144
flash 158–177
 accessories 177
 built-in 11, 105,
 160–161, 164
 characteristics
 158–161
 compensation
 166–167
 diffusers 177
 exposure 162, 167
 guide numbers 158
 macro 185–186
 modeling 105
 ranges 163
 settings 104–106
 speedlights 168–177
 synchronization
 104–105, 164–165,
 170
 warning 103
 wireless 170
flicker reduction
 110–111
focal length 206–208
focus 10, 59–63
 autofocus 59–63
 depth of field 127–129
 electronic
 rangefinder 60
 Live View 74–77
 lock 63
 modes 59–61
 movies 198–199
 points 61–63
folder settings 90–91
Food mode 46
formatting memory
 cards 27, 110
formats, files 11

framing 134–136
freezing action
 130–131
front lighting 140
Full Auto modes 36–37
full features 12–17
functions 24–123
 basic 29–33
 color/tone settings
 66–72
 exposure 34–58
 focus 59–63
 image enhancement
 82–84
 Live View 73–77
 menus 85–123
 metering 54–55
 playback 78–84
 quality 64–66
 Release modes 29–31
 User Control modes
 47–53
 FV lock 167

G
GPS 114, 229, 243
green intensifier 117
guide numbers 158

H
HDMI 110, 234
hiding images 87
high ISO noise
 reduction 93
High Key mode 46–47
highlight display 81
high speed flash sync
 170
histogram displays 81
history 8–9
humidity 248
hyperfocal distance
 128–129
hyperopia 25, 230

I
image processor 10
images
 comments 111

copying 88
deleting 80–81, 86, 88
dust off ref photo
 111–112
enhancement 82–84
hiding 87
information view
 78–79
overlay 118
playback 78–84
properties 144–149
protection 81
quality 64–66, 70–71,
 91–92
resizing 119
rotation 88, 111
sharpening 148–149
size 66
importing movies
 199–201
in the field 127–155
Information display
 31, 103
interval timer 94
ISO 70–71, 92–93, 101
i-TTL flash 159–160

J
JPEG files 11, 64–65, 92

L
landscape mode 39
landscapes 135–136
language settings 111
layout of camera 12–17
LCD display 11, 17
 brightness 103
lens charts 216–221
lenses 205–221
 aberration 146
 AF fine tune 114
 attachment 26
 close-up 183–184
 distortion 145–146
 flare 144
 focal length 206–208
 macro 187
 Non CPU data 114
 perspective 209

technology 205–206
 types 210–221
 vignetting 146–147
lens hoods 215
light 137, 151–152
 artificial 143
 direction 140–141
Lightroom (software)
 242
Live View 73–77
 focus 74–77
 screen brightness 77
long exposure noise
 reduction 92
long-sightedness 25,
 230
Low key mode 47

M
macro flash 185–186
macro lenses 187
macro photography
 181–187
main command dial
 32–33
main features 10–11
mains power 228–229
Manual (M) focus 59–60
Manual (M) mode 51–52
memory cards 26–27,
 110, 231, 249
 Eye-Fi 114, 239
 slot 2 91
menus 18–21, 85–123
 Movies 193
 navigation 85
 Playback 86–89
 Retouch 115–121
 Setup 110–114
 Shooting 90–94
metering 54–55, 98–99
metering modes 54–55
miniature effect 121
modeling flash 105
monochrome 117
monopods 231
motion 130–132
movies 11, 190–201
 editing 121, 200–201

focus 198–199
importing to computer 199–201
panning 195–197
quality 190–191
shooting 192–193
sound 192
techniques 195–199
zooming 197–198
multiple exposures 93
My Menu 21, 122–123
myopia 25, 230

N
naming files 91
navigating menus 85
NEF files 11, 64–65, 92
processing 118–119
neutral density (ND) filters 226–228
Night landscape mode 42
Night portrait mode 41
night shooting 153
Nikkor lenses 216–221
Nikon Picture controls 83–84, 92
Nikon software 240–241
noise 70–71, 92–93, 147–148
noise reduction (NR) 92–93
Non CPU lens data 114

O
oblique lighting 140
off-camera flash 169–171
on/off 29

P
painting with light 170–171
panning 131
movies 195–197
Party/indoor mode 42
perspective 209
perspective control 121

perspective control lenses 214
Pet portrait mode 44
photo information 78–79
Photoshop 242
Picture controls 83–84, 92
playback 78–84
zoom 79
Playback menu 18, 86–89
polarizing filters 225–226
portable storage 231
portrait mode 39
preparing camera 24–28
Pre-shoot controls 82
printing 235–236
DPOF 89
Programmed Auto (P) mode 47–48
protecting images 81

Q
quality of images 64–66, 91–92

R
rangefinder 60
RAW files 11, 64–65, 92
processing 118–119
rear-curtain sync 165
Recent Settings 21, 123
Red-eye correction 116–117
Red-eye reduction 164–165
red intensifier 117
reflectors 139
Release modes 29–31
remote control 94, 100, 229
reproduction ratios 181–182
reset user settings 53
resizing images 119
Retouch menu 20,

115–121
reversing rings 184
rotating images 88, 111

S
Scene modes 38–47
Screen tips 102
self-timer delay 100
sensors 9, 10
cleaning 246–247
sepia 117
Setup menu 20, 110–114
shaking 132
sharpness 129, 148–149
shooting
movies 192–193
settings 101–104
Shooting menu 18, 90, 90–94
short-sightedness 25, 230
shutter 11, 29
Shutter-Priority auto (S) mode 50
Silhouette mode 46
Single-area AF 60
single-servo AF (AF-S) 59
size of images 66
skylight filters 117, 225
slide show 88–89
slot 2 91
slow sync 164–165
software 240–242
sound 192
sources of light 137, 151–152
special-effects filters 228
Speedlights 168–177
Sports mode 40
spot metering 54–55
standard lenses 210
storage 231
see also memory cards
storyboarding 201
Straighten 120
strap attachment 24

sub-command dial 32–33
Subject tracking 77
Sunset mode 43

T
teleconverters 215
telephoto lenses 212
television connection 110, 234
temperature 247–248
thumbnails 80
time/date settings 111
tripods 194–195, 230–231
turning on/off 29

U
User Control modes 47–53
user settings 52–53
UV filters 225

V
viewfinder display 16, 99–100, 101
vignetting 146–147
virtual horizon 114

W
warm filter 117
water protection 248
white balance 46–47, 66–69, 92
wide-angle lenses 211
Wide-area AF 76
wireless flash 170
wireless transmitters 112, 229

Z
zooming
movies 197–198
playback 79
zoom lenses 213